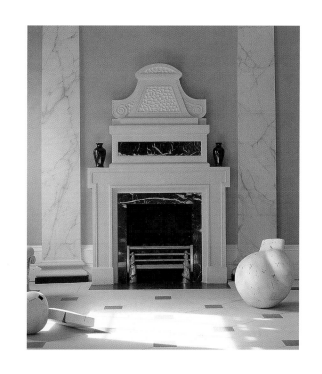

John Stefanidis

DESIGNS

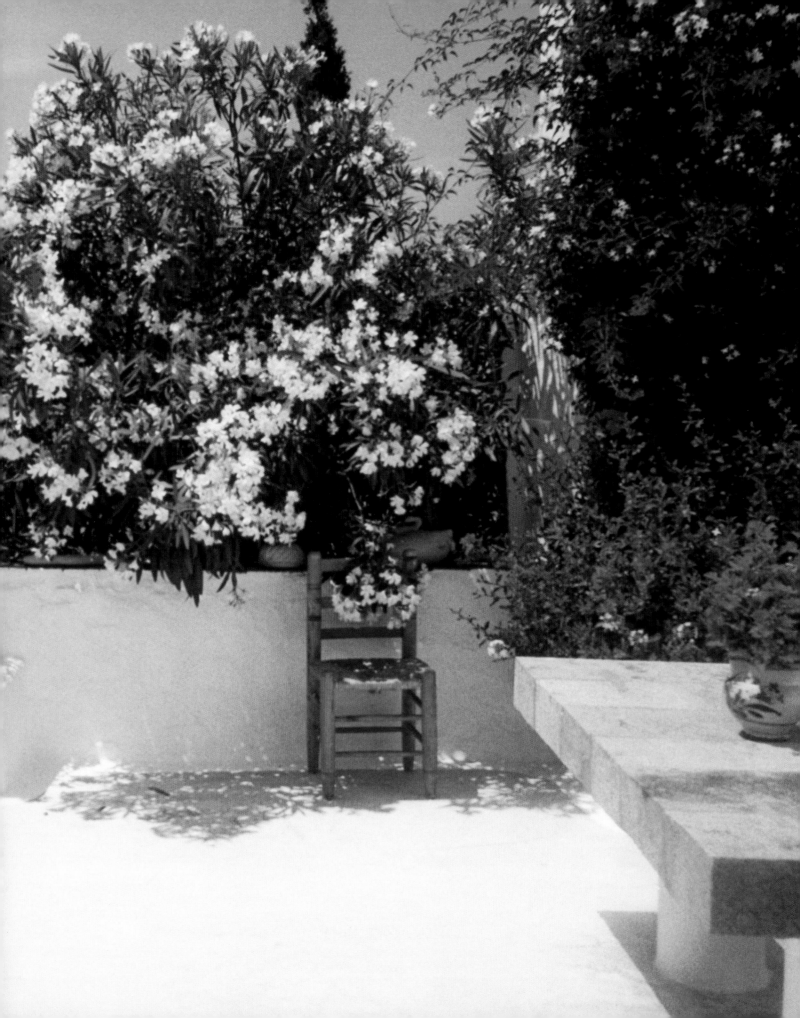

John Stefanidis

DESIGNS

CREATING ATMOSPHERE, EFFECT AND COMFORT

THE VENDOME PRESS

CONTENTS with house

New York, Florida, Californ

the Caribbean, France, Sw

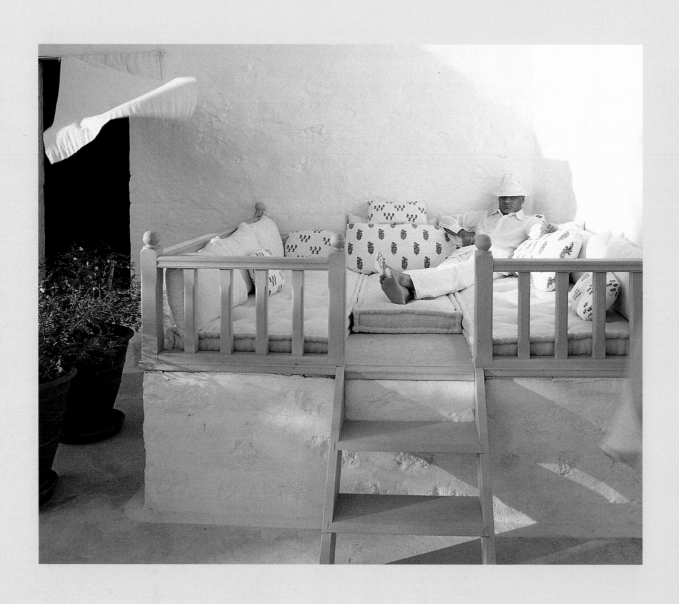

...nd rooms in London,
..., Rhode Island,
...erland, Italy and Greece

ALEXANDRIAN KINGS

The Alexandrians came in a crowd
To see the children of Cleopatra,
Kaisarion, the Kaisarion's little brothers,
Alexander and Ptolemy; who for the first
Time were being taken to the Sports Ground
In a wonderful military parade.

Alexander – him they called King of
Armenia, and of Media, and of the Parthians,
Ptolemy – they called him King
Of Kilikia, of Syria, of Phonikê.
Kaisarion was standing a little forward,
Dressed in pink tinted silk,
On his breast a garland of hyacinths,
His belt a double row of sapphires and amethysts;
His shoes were tied with white ribbons
Embroidered with rosy-coloured pearls.
They called him rather more than the little ones,
Him they called King of Kings.

The Alexandrians understood of course
That this was only words and play acting.

C.P. CAVAFY (TRANSLATED BY JOHN MAVROGORDATO)

ΑΛΕΞΑΝΔΡΙΝΟΙ ΒΑΣΙΛΕΙΣ

Μαζεύθηκαν οἱ Ἀλεξανδρινοὶ
νὰ δοῦν τῆς Κλεοπάτρας τὰ παιδιά,
τὸν Καισαρίωνα, καὶ τὰ μικρά του ἀδέρφια,
Ἀλέξανδρο καὶ Πτολεμαῖο, ποὺ πρώτη
φορὰ τὰ βγάζαν ἔξω στὸ Γυμνάσιο,
ἐκεῖ νὰ τὰ κηρύξουν βασιλεῖς,
μὲς στὴ λαμπρὴ παράταξι τῶν στρατιωτῶν.

Ὁ Ἀλέξανδρος – τὸν εἶπαν βασιλέα
τῆς Ἀρμενίας, τῆς Μηδίας, καὶ τῶν Πάρθων.
Ὁ Πτολεμαῖος – τὸν εἶπαν βασιλέα
τῆς Κιλικίας, τῆς Συρίας, καὶ τῆς Φοινίκης.
Ὁ Καισαρίων στέκονταν πιὸ ἐμπροστά,
ντυμένος σὲ μετάξι τριανταφυλλί,
στὸ στῆθος του ἀνθοδέσμη ἀπὸ ὑακίνθους,
ἡ ζώνη του διπλὴ σειρὰ σαπφείρων κι ἀμεθύστων,
δεμένα τὰ ποδήματά τον μ' ἄσπρες
κορδέλλες κεντημένες μὲ ῥοδόχροα μαργαριτάρια.
Αὐτὸν τὸν εἶπαν πιότερο ἀπὸ τοὺς μικρούς,
αὐτὸν τὸν εἶπαν Βασιλέα τῶν Βασιλέων.

Οἱ Ἀλεξανδρινοὶ ἔννοιωθαν βέβαια
ποὺ ἦσαν λόγια αὐτὰ καὶ θεατρικά.

6

PREAMBLE

a song of lamentation

TO BE AN ALEXANDRINE GREEK at the beginning of the 21st century is no bad thing. To have been born in 1937 means that one's life encapsulates a time before the War – when the world had an innocence it has since lost.

I was born of Greek parents whose families had lived in Egypt, in the Mediterranean city of Alexandria, for four generations. They were Sephardic Jews from Corfu and Constantinople on my mother's side; Greek and Orthodox from Lemnos and Corfu on my father's side. In order to marry my father, my mother had to convert to Greek Orthodoxy, a rare Greco-Judaic mix in those days. (After her wedding, when my mother met the Grand Rabbi on the staircase of the building where she lived, he asked why he had not been invited to the wedding.) My mother, admired for her good looks, manners and sensibility, and her clothes and embroidery, was never assimilated into her husband's family. My father, on the other hand, with his *joie de vivre*, his ability to make people laugh and his generosity, was popular with the large clan of my mother's family who, lately agnostic, tended to be more broad-minded.

Life in Egypt was cosmopolitan and Alexandria, with its *douceur de vivre* and different cultures, was like no other place: a city of the imagination. All this has been amply documented by novelists such as Lawrence Durrell (virtually unreadable years after publication) and E. M. Forster; also by Artemis Cooper in her book on Cairo during the War, and in *Cairo, A Portrait of the City* by

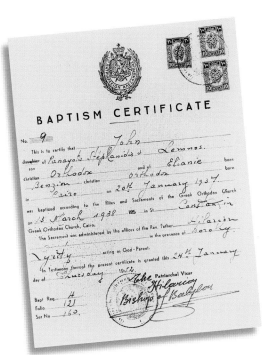

MY CERTIFICATE of baptism signed by the Bishop of Babylon.

Max Rodenbeck. And, of course, by the poet Cavafy, an Alexandrian Greek to the core, for whom antiquity and the present fused seamlessly. Among the childhood memories that crowd my mind are the Shepherd's Hotel in Cairo with its Islamic architecture – burnt to the ground by fundamentalists in 1952; the terrace of the Semiramis Hotel overlooking the wide, sparkling Nile with its line of white houseboats tied to the shore and *feluccas*, their sails gliding past as we sipped lemonade; trips to the pyramids at Giza; rides on camels with bleached curls galloping into the coolness of the desert at dusk. After such rides, respites awaited us at the Mena House Hotel, set in an oasis of palms, where we were attended with courteous haughtiness by Nubians in dark blue *galabias* embroidered in magenta red. *Inshallah* – God willing. *Mashalla* – God has willed it. These exhortations were a part of daily speech, and the sound of Arabic, so melodious and expressive, was always a backcloth to life. The calls to prayer were incantations moaned to remind us that God was Great.

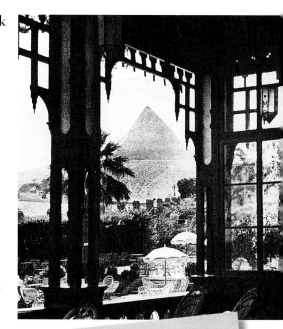

In the last decade, there has been an outpouring of autobiographical literature which tends to make former inhabitants raise an eyebrow. Among these slightly tiresome annals of exile from Egypt there are two factors which are often neglected: the light that is so particular to a country on the edge of an African desert, and the teeming streets with their acrid smells, full of the most humorous and warm-hearted people in the world (among many, my golden-skinned nurse, Naima, possessed these qualities in full measure).

THE GREAT PYRAMID at Giza; view from the Mena House Hotel (*top*). The sunset colours of this postcard (*above*), picturing a *felucca*, domes, minarets and palm trees with the pyramids in the background, is for real, not idealized.

In 1940, the momentum of war took its course. The Italians were defeated in Ethiopia, a counter-manoeuvre against Mussolini's Abyssinian campaign. My father went to Eritrea to join the OETA (Occupied Enemy Territory Administration) with the honorary rank of a British major. My mother followed and, so as not to be 'an illicit wife' (a term used in the War – leisured wives were an embarrassment), she obtained a

8

job with BOAC, the only airline flying, as I remember, Dakota aircraft, sometimes with seats and sometimes without. Against all regulations, she took me, aged four, with her. We arrived in Khartoum by seaplane and spent the night in a large colonial hotel on the water with a zoo next door – a tantalizing foretaste of what was to come. Our arrival was a complete surprise to my father.

Eritrea had been Italy's model colony. The Italian masters had given the country a respite from the endless tribal wars that continue to this day. We had a house in the capital, Asmara, at 2,000 metres. Its climate was cool and it abounded in cared-for villas and gardens built by the Italians; its population was predominantly Coptic. There was no equivalent to the Lycée Française kindergarten I had attended in Cairo and I found myself in a Greek school with a *papas* who freely wielded the cane. The alternative was to go to an Italian school but not only were the Italians the enemy in those days, they were also somewhat cool to representatives of the occupying forces. However, circumstances changed and rules loosened. The Italians reverted to their customary charm and an English school was scratched up to cater to the needs of such children as myself. Having spoken French, Greek and the essentials of Arabic, I now learned to speak English.

My father had another house in the ancient port of Massawa on the Red Sea, which was reached by a winding road where 'VV Mussolini' was not infrequently painted on the towering rock face. The journey to Massawa was always excitingly fraught with the fear of *shifta*, the local bandits.

Massawa was hot. The house was on two floors with very wide verandas on all four sides. High trellises reaching from the ground to the roof formed the outer walls. Before air conditioning, this was a most ingenious design. In the yard was a run where four of my pet gazelles, captured on one of my father's safaris, were kept. These hunting trips were exemplary in their organization. The desert and its dry thorn trees, the crisp high tents and the deep quiet of the night were an enthralment only shattered by the screams of hyenas; these are happy memories… not so the dead doe with its startled progeny which reduced me to tears.

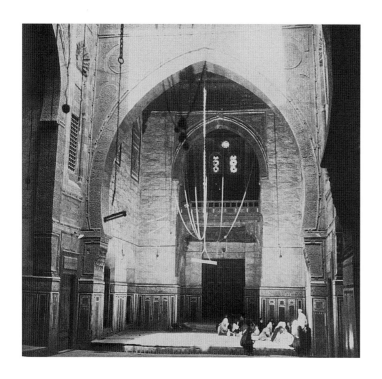

In Asmara, my nurse was replaced by Britta, a young black Eritrean whose hair, tightly plaited to the nape of her neck, burst forth in a nimbus round her shoulders. She wore flowing white dresses and shawls and a heavy Coptic cross at her breast. She remained with our family for 30 years. An Italian major taught me to ride on event horses. I was driven everywhere in a *calessino*, a small, fast, two-wheeled carriage pulled by one horse. The driver wore a khaki safari jacket, long matching shorts and khaki leggings with sandals; on top of his head was a tall *tarboush* with a cockade. Beside me on the leather seat were two dogs. It was a shade too spoiling.

After the British victory at El Alamein (2,500 kilometres to the north), another phase in the war was reached. The war effort for my parents, as I recollect, turned into a party with my mother in a white, halter-neck, shantung evening dress and my father in a dinner jacket. Lots of officers in khaki with brass stars on their epaulettes and red-banded hats came to lunch.

By the end of the war, my father had decided not to return to Egypt (had he recognized the warning signs?) and occupied himself with mining potassium and salt. A decision had to be made as what to do with a child of eight who needed to be

A LIWAN (*above left*).

THE COLLEGE OF SULTAN Guari, 1503 (*above right*). The minaret has three quadrangular stories surmounted by a quadruple pinnacle which was greatly admired at the time. The interior is in the form of a cross.

educated… but in what language? As England, grim with postwar-austerity in full swing, was considered too remote, it was decided to put me in the care of my maternal uncle and aunt, who were brother and sister and lived in Cairo. They were initially bewildered by a silent, well-behaved small boy and joyfully relieved by his first tantrum. My uncle was an intellectual, a kind and gentle man whose destiny was to be a cotton-broker. All his life his bedside reading was Dante. His Arabic was fluent. His diversions were the Egyptian popular theatre, where I was never taken, and the Cairo Museum, which I came to know so well that thirty years later I knew what I would find if I turned left or right in this mausoleum of ancient treasures. My aunt, brought up in France because of tuberculosis of the hip (but that is another story), read to me in French. A doctor at the *Croissant Rouge* hospital (the Egyptian Red Cross), she was not above picking up infirm men and women in the street whom she would cajole into

ERITREAN MUSICIANS in the mountains (*below*) and an ancient obelisk with an Eritrean in traditional costume (*bottom*).

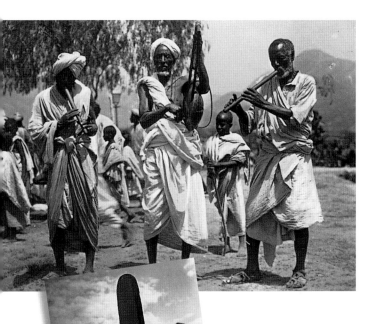

being x-rayed and treated. As English was chosen as the language in which I would be taught, I attended the Gezira Preparatory School where we danced, most incongruously, around a maypole. I was soon baffled by the dictum that the majority is always right, although ironically, it was to become the cornerstone of my democratic leanings. I next attended the English School in Heliopolis, City of the Sun. Pharaonic and Greek, it had become by then a Cairo suburb at the edge of the desert. This was a coeducational day school with a large contingent of boarders. If there had not been a rule that we only spoke English, the school would have turned into a Tower of Babel. Although Nomads tethered their coughing camels at the school gates, our teachers were English – their clothes and demeanour a constant source of amusement. These men and women saw no irony in the school motto '*Honor Amor Patria*', nor in the house names: Frobisher, Drake and Raleigh.

11
—

We travelled from Cairo to Alexandria on the desert road, mirages shimmering on the horizon. Sometimes I travelled alone by train, sitting luxuriantly in a red velvet armchair with lace antimacassar, eating succulent yellow mangoes. I was never hot in Egypt because we had a three-month holiday in the summer. This was spent in Asmara, with dogs and horses in Europe, or on the beaches of Alexandria. Shorter holidays, especially Greek Easter, were always spent in Alexandria at Ramleh with my paternal grandmother who surrounded herself with icons. She took me to church services where the Orthodox incantations put me into a melancholy trance – appropriate for someone baptized by the Bishop of Babylon. I also stayed with my mother's first cousin who, in the winter, lived in the sleek and luxurious rue Fuad in a large apartment decorated by Jansen. In bathing weather, she moved farther down the Corniche to an Art Deco house on a promontory overlooking Stanley Bay with its wooden bathing huts in ordered tiers and vendors selling sugared buns – a *madeleine* I have never rediscovered.

Before the current plethora of cookbooks, food was prepared from family recipes handed down from mother to daughter. We ate French food at its best, and what I later discovered were Greek and Sephardic dishes. The fruit and vegetables from the black soil of the Nile Delta played no small part in making the food delicious. The delectable *foul mesdames*, beans in flat bread, and *falafel* were eaten as a treat on the street. There are smells that will haunt me forever: jasmine offered by vendors whose arms were strung to the elbow with fragrant garlands; the charcoal used to grill corn; the fresh round bracelets of bread covered in sesame seeds; heaps of grapes and plums – the fresh and delicious produce of the Nile Valley. The street cries of vendors such as *roba bechia* – a distortion of the Italian *roba vecchia* – selling second-hand goods were daily chants. The pâtisserie Baudrot in Alexandria and Groppi's in Cairo provided children with mouth-watering ice cream and cakes and – my favourite – strawberries with *crême Chantilly*. In Eritrea, we were spoilt with homemade pasta, salami and mozzarella, which remain in my memory as incomparable. Perhaps they were more delectable for having been eaten under an African sky.

12

A BOOK PLATE inspired by the remarkable *La Description de L'Egypte*, the work of *savants* who accompanied Napoleon's expedition and gave birth to the study of Egyptology. My name is in Greek letters. On the ledge with the books is the Egyptian sky god Horus – identified with Apollo – portrayed as a falcon. Beyond are a broken Greek column, giant cliffs topped by a whitewashed monastery and a sailing boat on a sea dotted with islands. In the background is a mirage – palm trees and the Pyramids.

Coming from his little village, that lies just

Near the suburbs, still covered with the journey's dust,

The trader arrives. 'Frankincense', and 'Gum', his ware,

And 'Best Olive Oil', and 'Perfume for the Hair'

He cried along the streets. But in the noisy herd,

The music, the processions, how can he be heard?

The moving crowd around him jostles, hustles, thunders.

At last bewildered, What's the madness here? He wonders.

And someone tosses him too the gigantic piece

Of palace fiction – Antony's victory in Greece.

C.P. CAVAFY, IN ALEXANDRIA, 31 BC

The last years of school were overshadowed by revolution. Cairo was set afire; King Farouk sent into exile and Neguib took power, quickly followed by Nasser. There were many times when the transport of the day-boys and -girls in the blue buses emblazoned with the school crest (a thistle, a rose and a daffodil) and Latin motto was considered too dangerous. Competing to educate the children of the motley elite, the schools of the Jesuits, the French lycées; the English School (the pride-of-empire); and the all-male Victoria College in Cairo and Alexandria were all besieged.

Nasser was giving Egypt back to the Egyptians. The revolution was bloodless but firm: never more than a day or two in prison or house arrest. The European elements were to be pushed out, their newspapers and businesses appropriated, and the Egyptian landowners deprived of their land. Under this Islamic onslaught, the Copts were yet again victims of discrimination. In our classroom, previously unknown differences began to emerge. We took stock that we were Catholic, Greek Orthodox, Protestant, Muslims, Copts or Jews, Syrians, Greeks, Egyptians, Lebanese, Armenian, Maltese, Polish, Yugoslav, German, Russian, Jordanian, Hungarian, and even an exotic

breed of Greeks (twin sons of a landowner growing cotton in the Nile Delta). The children of ambassadors, including Chinese and Japanese, sat next to the children of Egyptian politicians and generals; some in the flush of power, others deposed and locked inside their houses.

We passed our O and A levels, innovations in those days, which enabled us to go to the universities to which we aspired in America, France or England. At the age of fifteen, I knew I would not live in the country where I was born. I left to go to England. In those days, you were thought too young at seventeen to go to university and as a result I had a year mostly in London where I crammed for Latin, my weak subject (it would have been more appropriate had we been taught ancient Arabic or Greek in Egypt). When I went to take my entrance exam at Brasenose, in Oxford, I looked at the dripping walls of the stone stairs leading to the room where I was staying, and prayed that I would fail.

Armed with cautious optimism and curiosity, a sense of humour (fortunately inherited from both sides of my family), and a slender education compared to my contemporaries, I became an undergraduate. My rooms overlooked the Radcliffe Library by James Gibbs and All Souls by Hawksmoor. My academic application was minimal, but I had a very good time. It was my first sniff of freedom and, in retrospect, it was a relief to be away from the aftermath of revolution at a university brimful with amusing, clever people. I was a little restless, however, in my third year.

London had its attractions – even in the 1950s – but I had no precise ambitions. I was at a loss at what to do. André Deutsch, the publisher, and Nicolas Bentley – even funnier in life than in his cartoons – suggested that I meet Jack Bennington, the chairman of an advertising agency, a very suave, distinguished and elegant man who rode around London in a chauffeur-driven Bentley. The interview was brief and

14

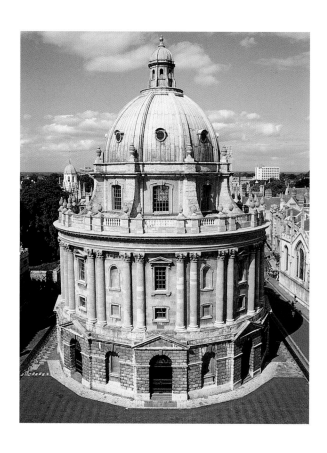

THE RADCLIFFE LIBRARY –
also called the Radcliffe Camera –
was opposite my windows at
Brasenose College, Oxford.
Designed by James Gibbs, this is
an unimpeded round building,
unique in England in showing the
influence of Italian Mannerism.

friendly: I was instructed 'always to do what can be done today, not tomorrow' – very good advice indeed – and warned that I might encounter antagonism because of my looks – the latter more mystifying. The supreme confidence of youth was suddenly questionable in the real world of Coleman, Prentis & Varley, London's leading advertising agency.

After a year, devastating news: CPV had obtained the wrong permit for me, the possessor of a Greek passport, and it could not be renewed. An appeal to the Home Secretary of a Conservative government for whom the agency did the campaigning and advertising was not successful. An Italian CPV, equally hot and new, was happy to interview me. I went to Milan and was offered a job. At twenty-two, I packed my bags and left my English friends behind. Mercifully, I was welcomed by friends of my parents from Eritrea with whom I stayed for three months before moving dead into the centre of the city. My flat in Via Sant' Andrea was in a palace whose *portone* contained a dwarf door for access at night (shades of Oxford). I was determined not to lead an expatriate life, and my Italian became fluent. I plunged into advertising as an account executive for Colgate Palmolive, Maidenform Bra and Borotalco Roberts (an old Italian brand name) – quite a juxtaposition to 3M, another client, with its granite-faced American representatives.

Milan in those days was dour and provincial, not the fashion capital that it is today, but there was La Scala and Strehler's remarkable productions at the Piccolo Teatro. At La Piccola Scala, Berio's operas were booed, much to my youthful indignation. Italy was experiencing 'Il Boom'; Milan was the literary, theatrical and business centre of the country and attracted young Romans, Florentines, Neapolitans and Genovese whose different pronunciations of their mother tongue and very dissimilar temperaments contrasted with the more Nordic, landlocked, fog-bound Milanese.

Cold in the winter, hot in the summer, the city was not one I ever grew to love. After three years of valuable experience, I had had enough of advertising although I stuck it out for another two years. I missed England – up to a point. Italy improved my eye, and helped me not only to look but to see. My Milanese friends included a high-minded

DEFINITION of Curiosity from the Oxford Dictionary .

Curiosity [a.OF. *curioseté*, ad. L. *curiositatem*; see CURIOUS and -TY] †**1.** Carefulness–1747; scrupulousness, accuracy–1694; ingenuity –1772; undue niceness or subtlety –1776; **2.** Desire to know or learn; inquisitiveness ME. inquisitiveness about trifles or other people's affairs 1577. †**3.** Scientific or artistic interest; connoisseurship–1781. **4.** A hobby –1661 †**5.** A fancy, a whim–1718. †**6.** Careful or elaborate workmanship; a nicety of construction –1807. **7.** Curiousness 1597. †**8.** A curious matter of investigation–1700. †**9.** A vanity, refinement–1705. †**10.** A curious detail or feature–1747. **11.** Anything curious, rare or strange 1645.
 2. A noble and solid c. of knowing things in their beginnings 1632. Curiositie, which I take to be a desire to know the faults and imperfections in other men HOLLAND. Rotterdam, where the c. of the place detained us three days 1686. 11. Japanese goods, lacker ware and curiosities SEMMES

15
—

industrialist and his beautiful green-eyed Neapolitan wife (who subsequently bought Jacopo Sansovino's Villa dei Vescovi near Padova); a Genovese and a Roman, both lawyers; and a Milanese antique dealer whose brother, Alessandro Orsi, was the leading antiquaire in Italy. Orsi's furniture and pictures were a feast to the eye. We would meet in his courtyard to decide whether to hit the town or to have a quiet dinner. In 1961, I was invited to an exhibition of paintings by Teddy Millington-Drake at the Galeria delle Ore. I had already heard of Teddy, a predecessor at Oxford. To my question, 'Is he nice?' a contemporary who had been with him at Oxford answered, 'I wouldn't say *nice*'. But he was very nice and very charming. His moods would swing from melancholy to joy. I would often go with my Milanese friends for weekends at Teddy's house, the Villa Albrizzi, at Este at the foot of the Eugenean Hills. In winter, the villa was wrapped in the thickest of fogs, but in the long summers it was a temple of fun. There was a detached rococco ballroom, an English garden, a pavilion and swimming pool. Venice was near enough to visit for the day and even for dinner. The canals and villas of the Veneto surrounded us. Teddy and I, my Italian friends and sometimes a stream of English friends who had come to stay, visited every villa by Andrea Palladio, as well as his predecessors and followers. There was not a garden or villa where we had not eaten – or at least swarmed through.

16

The light is bold and it is young. It is the mental image of youth. Until now, I held water to be the most wonderful epitome of changelessness. Yet this light is ageless in a more penetrating way

Whoever lives in this light, lives truly: To leave this light for existence among the shadows – that was the terrible inconsolable thing.

HUGO VON HOFMANNSTHAL, *GRIECHENLAND*

After my fifth year in Milan, my green-eyed Neapolitan friend and I were asked to go on a sailing yacht whose owner was fraught by an impending divorce and who, more importantly, did not get on with his surly captain. Soon into our voyage, we knew that we must abandon ship. We sent ourselves a telegram necessitating an urgent departure and a second telegram to Teddy, then in Italy, to join us in Greece. After a night of *bouzouki* in Athens, we were relieved, in spite of a full-blown gale, to find ourselves on a ferry to Mykonos. After several days, my Neapolitan friend, flushed with triumph at having been elected Miss Mykonos at an open air nightclub, had to leave us to pursue other sorts of pleasure at her house in Capri, and Teddy and I went on to Rhodes. In Lindos, we were told that the island of Patmos was very beautiful. Together with goats and chickens, we embarked on a very small ferryboat which weekly served the twelve islands of the Dodecanese. The passengers were seasick as they said their prayers — a manifestation of respect for the Aegean that has been out of fashion for years.

17

A pot of basil may symbolise the soul of people better
than a drama by Aeschylus.

DRAGONIS, *GREEK CIVILISATION*

Patmos, one of the islands of the Dodecanese, was a Turkish domain for four hundred years before being ceded to the Italians in 1912. The islands only reverted to Greece in 1947. The island had been slowly forsaken. Colonies of Patmiots had emigrated to Texas and New South Wales. Young men in search of a livelihood traditionally joined the merchant navy, eventually returning to marry and perhaps to father a child.

By the 20th century, Patmos had grown dormant. There was little cultivation even in the valleys of this biblical landscape. Before the dissolution of the Ottoman Empire, there had been fleets of ships and a thriving trade. Various nations had maintained consulates, their shields atop the doors. In the 18th century, mirrors and furniture, later to decay in abandoned houses, were imported from the Venetian Republic port of Senigallia on the Adriatic. On the highest point of the island, as on all Greek islands, was

a chapel to *Profitis Elias* – Prophet Elijah. To fire the imagination, it is said that these chapels with their magnificent prospects were always built on the site of temples to Apollo. On another lofty site is the burnt remains of a temple to Artemis. In a verdant little valley, half buried by the foundations of an hermitage – small and whitewashed, graced by two palm trees – lie the remains of a Roman bath.

With luck there was a ferry twice a week. There was no quay on Skala's port. One disembarked from the ferry in the dead of night in small wooden tenders, the faces of the waiting crowd suddenly looming as one crossed the black water between ship and shore. It was very romantic. One of the ferrys, the *Marilena*, had been the Kaiser's yacht; another, the *Mimika*, is now part of island legend because of its charm and discomfort. The inhabitants were dignified, friendly and poor. There was no starvation, but austerity was ingrained, born from dependency on loved ones away at sea, or on the kindness of friends or relations in distant places.

Chora, the capital, was a marvel of vernacular architecture, although in a state of near devastation. There were ruins everywhere – high walls and handsome houses yellow with age as they had not been whitewashed for decades. Nevertheless, there hovered over the island a great stillness and beauty. There was very little to eat: a plain cake in one café, but rarely a fish to fry. In 1965 on August 15, the feast of the Dormition of the Virgin, the sacred island was devoid of tourists. There was only myself, Teddy Millington-Drake and a charming Austrian *dramaturge* who was to die young by his own hand. We were the only representatives that summer of the world west of the Aegean. Patmos was to be a great catalyst in my life.

I returned to Italy, but after the clarity of Greece (a brush with the gods that confirmed my paganism), Milan was untenable. I resigned from CPV and, after an

Landscape with Cumulus Clouds
Gilles-François-Joseph Closson 1798–1842
Oil on paper, laid onto canvas, 24.5 x 29.3 cm
The Gere Collection, on long-term loan to the National Gallery
SOLD TO SUPPORT THE NATIONAL GALLERY, LONDON
860489. Printed in Great Britain.

POSTCARD from a friend in Paris.

interlude in Rome, set up in Athens. My chosen career was to find land for the nascent tourist industry. I had an apartment on two floors with terraces; behind was Mount Lycabetus, in front the Parthenon, and beyond it, the sea. Athens was old-fashioned still, with a sparkling sky streaming at night with shooting stars and, in those days, the cleanest air in Europe. I found myself invaded by light. The Greek temperament, more tempestuous and pleasure-loving than northern Italy, suited me. I embarked on my search, making my own odyssey.

AN ARCH IN PATMOS – pristine and pure vernacular, this is Greek island architecture without architects. Round and pointed arches appear on buildings on the island. The pointed arch is an earlier design.

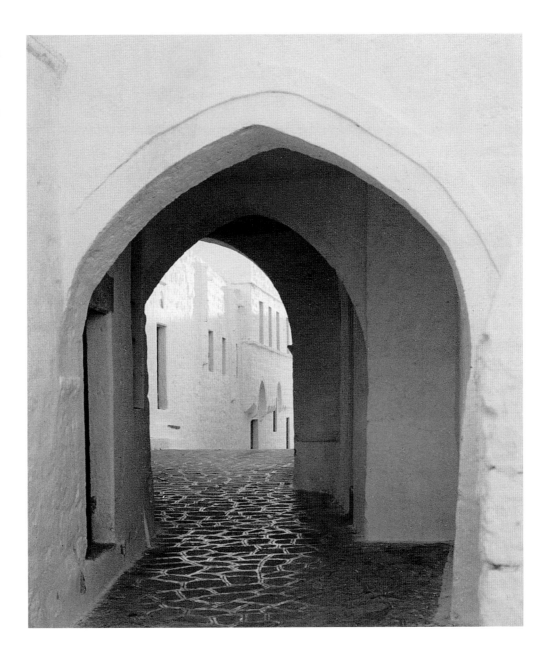

19

The asphodel has a certain reckless glory,

such as the Greeks loved.

DH LAWRENCE, *ETRUSCAN PLACES*

There were sweeps of glorious olive groves, titan rocks plunging into the sea, bays of pristine beauty with gentle lapping waves… and everywhere and unexpectedly, the sea – in shades of aquamarine, turquoise, emerald green, the deepest of purples. The old myths and symbols were everywhere – the pull of Orthodoxy remains strong farther east, closer to Asia Minor and Byzantium. The inhabitants of these sometimes woe-begotten places were invariably helpful, courteous and traditionally hospitable, with prompt offers of coffee and jam. There were clean rooms *chez l'habitant*, or in the newly built Xenia Hotels, each designed by a different Greek architect, often very successfully. The air was pure, the nights starlit to excess – I was overwhelmed by the beauty of Greece.

20

Fortunate he who's made the voyage of Odysseus.
Fortunate if on setting out he's felt the rigging of a love
Strong in his body; spreading there like veins where
The blood throbs.

A love of indissoluble rhythm, unconquerable like music
And endless
because it was born when we were born and when we die
whether it dies too neither we know nor does anyone else.

I ask God to help me say, at some moment of great happiness,
what that love is;
sometimes I sit surrounded by exile I hear its distant murmur like the sound of sea
struck by an inexplicable hurricane.

And again and again the shade of Odysseus appears before me,

his eyes red from the waves' salt,

from his ripe longing to see once more the smoke ascending

from his warm hearth and the dog grown old

waiting by the door.

GEORGE SEFERIS, *REFLECTIONS ON A FOREIGN LINE OF VERSE*

I began to renovate an abandoned house in Patmos. There was a builder called Ypsilantis, as dashing as his namesake in the Greek War of Independence, who had an elegant white moustache and hair to match. Always accompanied by his mongrel dog, he had an instinctive understanding of how the houses had been built, clustered around the fortress walls of the monastery in the 13th century and spreading over the next two hundred years to form a large village. When pirates became a lesser threat, it was no longer necessary for people to barricade themselves behind the stalwart heavy doors of the monastery of St John. Building continued into the 19th century in an island style without architects – thick whitewashed walls inside and out with architectural features both Venetian and Ottoman.

The carpenter was as dashing as the builder. My exact contemporary, he was tall, with a black moustache and a quick smile. He proved over thirty-five years to be a very skilled interpreter of my sketches and thumb-to-finger measurements. There was no plumber; there was no electrician – for the first house, they had to be imported from Athens.

The Monastery of St John the Theologian is a dependency of the Patriarch in Constantinople to this day. The foundation of the monastery named after St John – also known as St John the Divine – was in 1088 AD. St John wrote Revelation in 95–97 AD in a cave that is now in the monastery of the Apocalypse on the island. There is the convent of *Evanghelismos* – the annunciation. The convent of *Zoodochosphighi* – Source of Life – is a pure gem of naïve architecture, now almost empty of nuns. From Roman times there are traces of a lyceum and a temple to Artemis. It is said there was a

temple to Diana, whose worshippers were the first converts made by St John when exiled to the island as a Christian troublemaker.

But in my time there was an eccentric character who suffered from Parkinson's disease; he benefited from a quick sense of humour. His plump wife was jolly, too, and they liked to reminisce about life in London where they had owned a tobacconist's shop in Shaftesbury Avenue and two beloved Pekinese. With admirable determination, this semi-crippled individual unravelled many Byzantine rivalries. There were sometimes ten owners of a property at a time, but this friend somehow produced contracts that could be presented to a notary public in Athens.

Some of the houses were bought by friends, several of them from my Oxford days. I found myself, to my pleased surprise, restoring and building, plumbing and electrifying houses – ten houses over a period of years. I would specify, contract and instruct in the summer months and return to the island in the spring to see how work had progressed. The houses would be renovated and habitable by the summer. I knew about deadlines from my days in advertising. The American expression 'drop dead date' is one of my favourites; a positive state of mind that manages to contain a lively threat.

I built a house for a great German publisher – a client who knew what he wanted. He told me the size of the living room he expected, but otherwise I had *carte blanche* to locate and build the house on a piece of land he had bought by the sea and to plant its terraces as I thought best. He confirmed my growing suspicion that the best client was one who knew his own mind.

Patmos had become a Greek ideal. Athens, on its stunning site with its ancient open-air theatres, its matchless museum, its life in the open and its dry clean air, gave of its soul and its past in the summer, but in the winter it turned into a melancholy Balkan capital, the people in the streets almost uniformly dressed in grey or black.

Over the years, I had gone a great deal to Rome where my life centred around the Palazzo Taverna with its Baroque fountain and huge gravelled courtyard. In this vast repository of layered civilisations there was a lot to see; a lot to learn. I had continued to

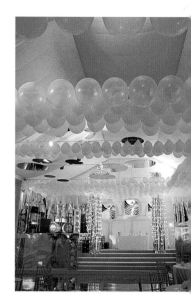

DECORATION FOR A BALL – a tent hung in graded variations of pink going to white gives the white balloons their colour. The great discs feature Kabuki-inspired designs. Streamers contained in ping pong balls cascade to brilliant gold and silver strips of paper which carpet the floor.

22

go to London and my references were still directed to England, the country where I had become an adult.

London in the 1960s was changing fast. There was a new and refreshing cult of youth. Clothes that had been worn in imitation of our parents were shed for velvet coats and satin trousers. This great city re-emerged after the trials of war and deprivation to become the metropolis that today surpasses all cities in its variety and sophistication. London was full of invention, energy and fun. The British have a greater gift for friendship than other Europeans (the Jesuits of Empire had done their job – anglophilia had kicked in). I chose London to use as a base. It had dawned on me that I might even create what I had seen other designers do. In those days, it was mandatory for a bearer of a non-British passport to prove oneself a bona fide resident. This meant starting a business whose accounts would be sent to the Home Office for four years. One of my first commissions, the acme of frivolity, was the design for a ball. Happily, it was a

MY FIRST JOB IN FRANCE. This apartment in the VII arrondissement looks over the Place Fürstemberg, the essence of 19th-century Paris. Delacroix's studio is next door. The sculpture by Jean Tinguely is electronically controlled. Beside it is a Niki de St Phalle sculpture on a lacquered JS table. Cane blinds hang behind the electrically controlled cotton blinds. The naked figures sculpted by Duane Hanson anticipated the Brit-pack movement of the 1990s.

23

success and a year later I was asked to do another ball – another success. In between, I had created a studio for a budding pop music entrepreneur and started a house on the shores of Lake Geneva for a charming and most civilized French couple. My learning curve took a sharp direction upwards. There was possibly the first swimming pool with overlapping sides directly on the lake, and a glassed-in terrace – that, too, was a success. Another early commission was an apartment in the 19th-century stage set of the Place Fürstemberg in the 7th arrondissement of Paris. The interior of the apartment

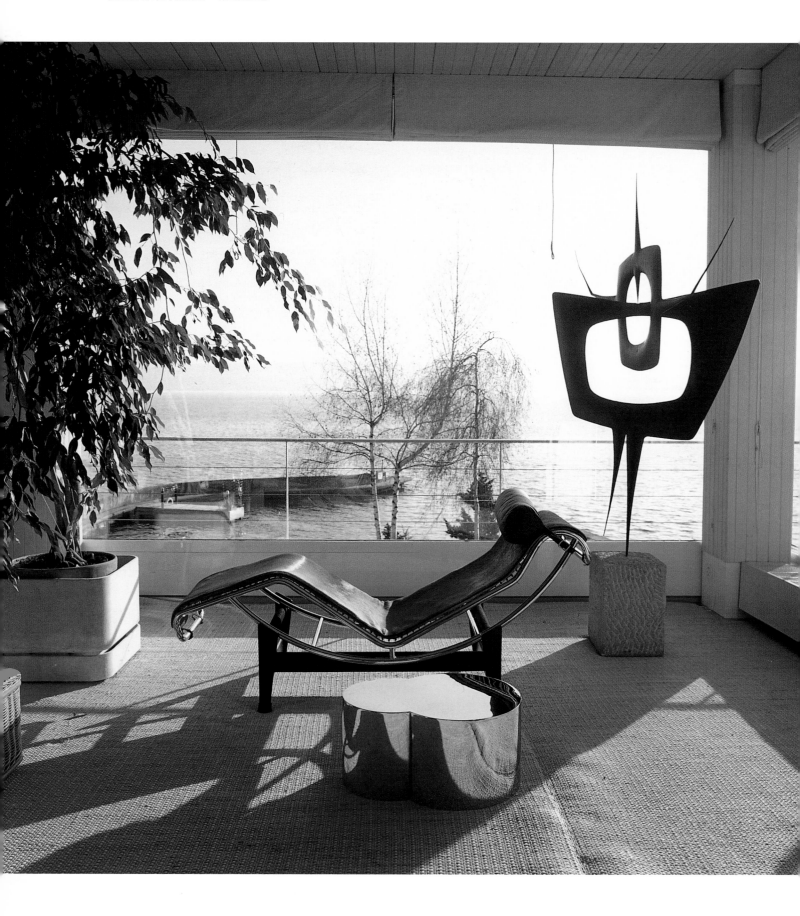

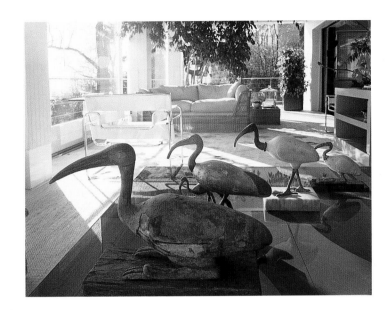

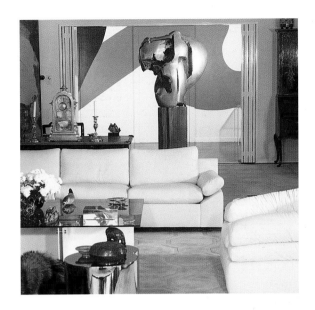

A HOUSE ON LAKE GENEVA
was one of my first commissions.
We built a terrace beyond the
drawing room which benefited
from the ever-changing light on
the lake (*left*). Certain elements
here have become part of my
repertoire – straw mats from the
South of France, a JS cloud table
in brass or chrome, cane blinds,
the mixing of rattan with other
furniture. The semi-mobile
sculpture is by Higuily. The low
table carries a flock of ancient
Egyptian ibises (*above left*).

IN THE ENTRANCE HALL
beyond the drawing room is a
sweeping mural by Millington-
Drake and a bronze by the Swiss
sculptor Rouillet (*above right*).

PIMLICO, SW1 – a terraced house
in Westmoreland Place (*right*).
On the plain French fireplace are a
multiple by Vassarely and a David
Hockney drawing. The Willie
Landels white plastic pouf went
with the armchair; both are
smartly saddle stitched. The
tulips sit on a perspex box which
pulsated in time to music – if one
wished – and turned the room
green, yellow, red or pink. JS is in
a grey pinstripe suit.

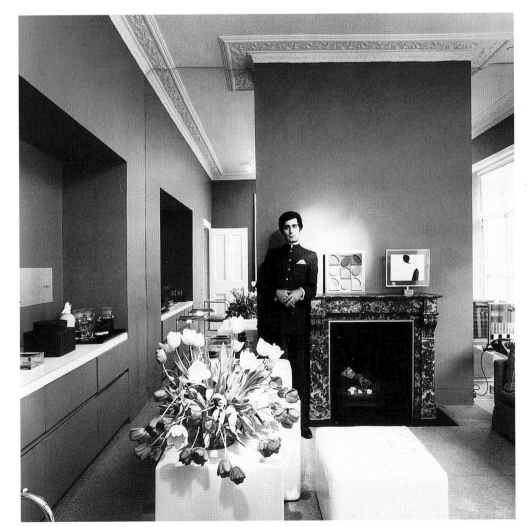

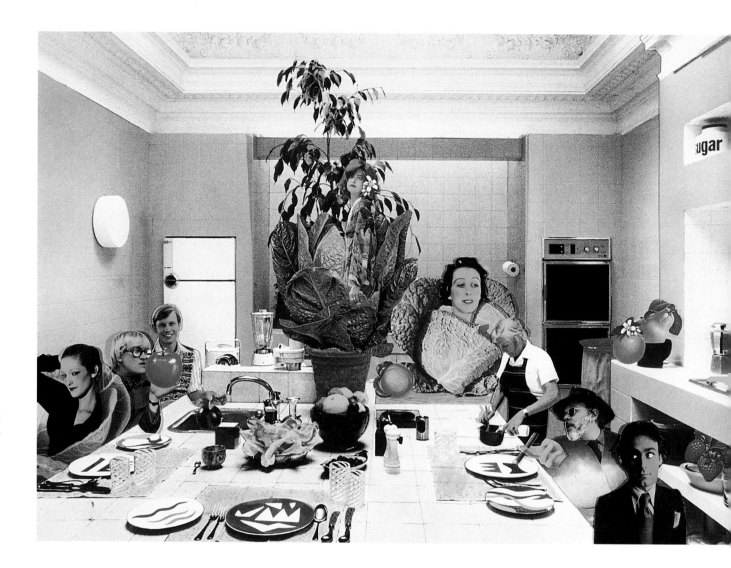

26

CHESTER SQUARE KITCHEN, 1974. From left to right: Lou Lou de la Falaise, David Hockney, Michael York, Nicky Waymouth, Violet Wyndham, Mr. Aubrey, Henry Geldzahler, John Stefanidis.

belied its setting; it thumbed its nose at the exterior. The style was minimal, the apartment's walls lined with contemporary art that today would be considered masterpieces of modernity.

I lived in a house in Pimlico, a part of London I still hold in affection, which had a dining room that converted into an office with a thick round glass table and a sideboard to match – both have miraculously accompanied me to my present offices in Chelsea. The house was painted in shades of beige, brown and grey. It had myriad invisible jib doors. The same plain beige carpet used throughout the house reached to the top floor where the insides of cupboards were painted in bright primary colours. My bedroom was white with a Millington-Drake mural of sweeping swirls in orange and blue set off

by a Soto sculpture. The sitting room had mirrors either side of the fireplace and opposite, and a vast canvas by Twombly. This caramel and brown house caused a stir. It was a pleasure to live in. (The joke among my friends was that my secretary was contained within the swinging metal doors of the cylinder that concealed her desk. It was not long before it became essential to move since paper invaded every corner of the house. Plans and boards were stacked under beds and sofas.)

Except for the stone staircase, I virtually gutted a house I then bought at 53 Chester Square. The top two floors became a double height room with a gallery – my office and studio. An elevator bypassed the drawing room and bedrooms. The house was comfortable – very comfortable; there was a great deal of space. The decoration was spare, but there was a Malcolm Morley blow-up of Vermeer's *The Art of Painting* in the hall. The dining room was a vibrant yellow with pinoleum blinds on the windows – these ubiquitous cane blinds filter the light and I have used them wherever I have lived. The drawing room on the second floor had a rug designed for the room, a Gorky and three Twomblys on the walls and a Caro sculpture. There was a Wesselman on the first floor landing and a Vassarely on the second floor landing.

On the third floor was my large square bedroom, the bed in the middle, with a white horse on the downs by Stephen Buckley behind it and a Lichtenstein mirror-painting over the flat stone chimney. One of the bedrooms was hung with batik; the other painted on four walls in earthy Indian colours by Millington-Drake. It was a very happy house where Mr Aubrey reigned as butler and cook. A veteran of El Alamein, he had carried a feather pillow throughout the Desert War – *o tempora o mores*! He died a happy death on the dance-floor seventeen years later, still in my employ.

Then came 1974 and its financial crash. I had eight commissions cancelled in three months. Retract and start again was my motto. Life had its preoccupations, but my travels continued and Patmos and Greece still engaged my enthusiasm. The Chester Square house was rapidly sold and replaced by an enchanted apartment on Cheyne Walk – which unintentionally, as leases fell free around my ears, turned into a very large house. 100 Cheyne Walk was my home for twenty years. Formerly Lindsay House, the

27

Moravian brotherhood had made it its headquarters in the 18th century. It retained very high doors and ceilings, perhaps so the brethren could feel nearer to God. An Italianate hall had been added by Sir Hugh Lane, who also commissioned the garden designed by Edwin Lutyens. This garden, a venerable and gnarled mulberry tree at its centre, was in ruins. I restored much of the house. As partitions came down, it became more what it had been two hundred years earlier. Hedges were added to the garden. Camellia trees blossomed year after year and their flowers filled the house. Roses proliferated, statues of monkeys enlivened the restored niches, a redundant pool became a circle of box, yew walls made a place to sit. I hoped that Lutyens, one of my heroes, would have been pleased.

My next offices were in Chelsea. My practice over the years had grown from five to fifteen people, sometimes twenty-five, but never more, and this deliberately so. Every new commission seemed to require one or more new fabrics to be designed specifically. A number of these grew to form collections named Rice, Bikaner, Iznik, Harvest, Grandee, Stripes and Foibles, Islands. Individual fabrics were named after friends and clients – Cosima, Josephine, Lady Anne, Allanah – or after painters from whose works they had been pilfered, such as Bronzino or Carpaccio.

When I made London my home, I thought that the counterpoint to urban life would be a house in the green and pleasant land of the English countryside. With its downs and meadows tamed and cultivated by man, its great trees, its soft light, the English landscape was rural life like nowhere else. This desire led to some cowsheds in Dorset and the making of a cherished house and garden (amply documented as an epitaph in a previous book, *Living by Design*).

Commissions here and there in the world, and most constantly in the USA, have been an excuse for new friendships. The American experience was an awakening awareness of a vast and great country. Different idioms and ways of working have all proved illuminating, but England has proved to be a wonderful place to live; my friendships deep and lasting. I remain a well-integrated outsider in a country with more freedom than most… an exile's consolation, and more.

Of course, over three decades the world has changed, and it would be hubris not to change with it. I embarked, to the surprise of an earlier self, on ten years of what Jungians call a *journey*, and the world could never be quite the same again. At the end of a millennium and the start of a new century, and hopefully as a wiser man, I have established a checkerboard of priorities which should serve me well in years to come.

What are they after, our souls traveling
on the decks of decayed ships
crowded in with sallow women and crying babies
unable to forget themselves either with the flying fish
or with the stars that the masts point out at their tips?
Grated by gramophone records
committed to non-existent pilgrimages unwillingly,
they murmur broken thoughts from foreign languages.

What are they after, our souls, traveling
on rotten brine-soaked timbers
from harbor to harbor?

Shifting broken stones, breathing in
the pine's coolness with greater difficulty each day,
swimming in the waters of this sea
and of that sea,
without the sense of touch
without men
in a country that is no longer ours
nor yours.

GEORGE SEFERIS

29

DEVELOPING AN EYE
Influence and Instruction

THE AIM OF DEVELOPING AN EYE is to achieve discernment. With time and experience, this leads to a sense of confidence in one's response to a building, a landscape or a work of art. The possession of this skill is immediately recognizable by other people who have it; a fraternity of sorts, although the esoteric approach is best kept to cults and kabbals rather than the world of design. After all, a man of taste can also be described as an aesthetic snob. It is often argued that possessing an eye is a gift. Disregarding hair-splitting theories, whatever the talent – whether visual, literary, musical or athletic – it has to be acknowledged, nurtured and trained. The same applies to an artist as it does to an athlete. Muscles of the eye and brain, as of the body, need to be exercised. Sensibility must be cultivated, questioned, defined and revised to avoid atrophy; *good taste* is an example of talent deadening into cliché. A musician's performance can be an exercise in virtuosity and yet remain a parody of what it might have been. If it fails to move the soul, it can be the result of too meagre a gift. Rarely is it a lack of application and discipline; technique alone will not suffice.

The Cairo Museum; the Ibn Tulun Mosque; the Giza Pyramids and the Stepped Pyramids of Saquara; the mausoleums; the *madrasas* such as the College of Sultan Ghauri; the 18th-century Gayer Anderson houses, evocative of Mahfouz's *Cairo Trilogy* and restored by an Englishman of that name; the palm groves in vivid contrast to the dry, yellow sand dunes of the desert; the meticulous husbandry of the land, irrigated by water wheels turned by buffalo – all influences in my childhood and adolescence. These play a role, but they are by no means enough.

30

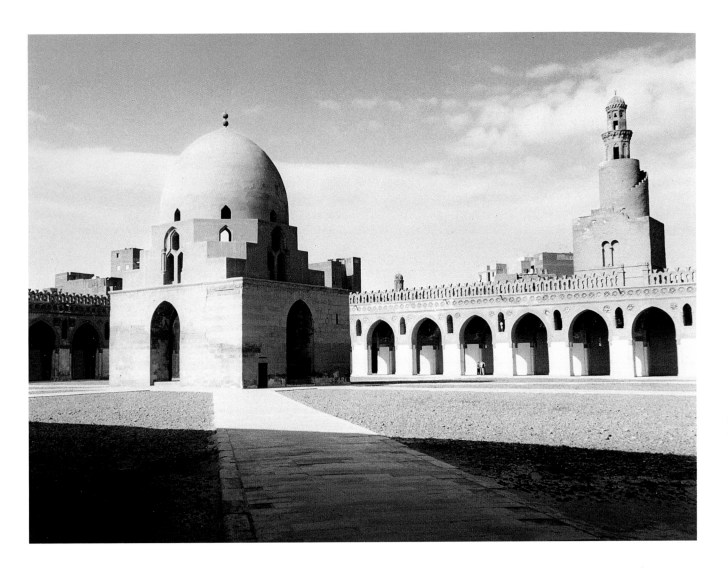

THE IBN TULUN MOSQUE is my favourite Islamic building, the simplest and grandest I know. Mesopotamian in inspiration, it was built in 876–9 by Ahmad Ibn Tulun, Governor of Egypt. The mosque covers two and a half hectares and is an inspired use of space. The minaret with its spiral staircase was modelled on the minaret of the Great Mosque of Samara in Iraq.

If the past were even past there would be little use in recalling it; but it lives with us in never-ending variation, as if it were a magic carpet on which we travel through the middle air. The contours of our destination were long ago woven in its fading colours and half obliterated images.

FREYA STARK, *PERSEUS IN THE WIND*

The sensuous experiences of childhood, what you have seen and what you have heard, are absorbed unconsciously. These impressions feed the emotions and the mind, but you must still exercise the intellect. In my case, this discipline took the form of looking with intent. When looked at again and again, sense-impressions are transformed into

recognition, interpretation and knowledge. The advantage of being curious is that you are pushed to look – and look some more. Ultimately, it is up to you.

> *I believe it was John Cage who once told me, 'When you start working, EVERYBODY is in your studio – the past, your friends, enemies, the art world, and above all, your own ideas – all are there. But as you continue painting they start leaving, one by one, and you are left, completely alone. Then if you're lucky, even you leave'.*
>
> PHILIP GUSTON

When I was at university, Professor Wind, a classical scholar and art historian, gave the Ruskin Lectures to packed audiences of undergraduates. Ahead of his time, without notes but using slides, he brilliantly and lucidly revealed how modern art was influenced by the old masters – Leonardo da Vinci juxtaposed with Miró. His revelations were astonishing and thrilling.

Living among the spires and ancient quadrangles that exuded centuries of civilized scholarship, I was soon aware that the buildings and, as important, the spaces that contained and surrounded them, would remain valuable to me. With this recognition came the certainty that the world is multi-faceted, varied and limitless.

> *If the history of modern art is taken to begin with such masters as David and Goya who, born in the mid-18th century, responded to the irreversible upheavals that marked the next revolutionary decades, then this precarious balance between respecting and destroying tradition is at the very roots of our heritage. The swift changes of modern history demanded constantly new solutions; yet to step into an uncertain future, one foot had to be kept in a secure past.*
>
> *For an ever growing audience of ordinary spectators and, of course, artists, the art of the past would become more and more accessible in the proliferating public sanctuaries which now sustained visual culture outside the world of kings*

32

and wealthy collectors. To be able to see countless originals long hidden from view was a thrilling boon to the welling population of artists.

It is telling, for example, that when the egalitarian dream of a Muséum Central des Arts (what we now call the Louvre) finally materialised on 10 August 1793, in the midst of the Reign of Terror, it was available to the public for only three days of the ten-day week of the new revolutionary calendar, with five days put aside for the copyists who rushed to study what was formally walled up in private collections. To be sure, artists had always copied earlier art – Rubens, for example, copied Leonardo's cartoon for The Battle of Anghiari *and Caravaggio's* Entombment *– but as one public museum after another opened in the early 19th century (Amsterdam's Rijksmuseum in 1815, Madrid's Prado in 1819, London's National Gallery in 1824, Berlin's Altes Museum in 1830), the availability of these time-capsules of beauty and history kept expanding, the visual equivalent of the vast new libraries opening to the growingly literate public. Within these new sanctuaries contemporary artists would learn from the past as well as rivalling it.*

CATALOGUE FOR 'ENCOUNTERS' AT THE NATIONAL GALLERY, LONDON

ROBERT ROSENBLUM (1999)

Our links to the cultures of previous centuries ensure that the past is ever with us. This recognition has permeated Europe and America in the last decades. The exhibition *Encounters* at the National Gallery in London in 1999 imaginatively illustrated how contemporary artists assimilate and interpret the past. It is an exhibition which will have made a lot of philistines think again and will, in its turn, permeate culture in the new century.

The eye is affected nowhere as much as in Rome. Leaving Palazzo Taverna for a stroll, you are confronted with treasures. Through a maze of narrow streets you come to the astounding space of Piazza Navona, past the fountains to the miraculous church of Sant'Ivo by Francesco Borromini, across to Tosca's church, Sant' Andrea della Valle and

out through a side door to the curved Mannerist façade of Palazzo Massimo before entering a tangle of streets that lead to the outdoor market in Campo dei Fiori. You continue on to the Palazzo Farnese – Tosca again – through the courtyard of the nearby Palazza Spada with its perspective by the ever astonishing Borromini and across the Tiber to the Villa Farnesina awash in Raphael. Everything that surrounds you ravishes the senses. You desist from going into Trastevere, but instead cross to the Isola Tiberina, once a waterhole if ever there was one, for a collation and the refreshingly brilliant company of its resident, Judy Gendal. You amble past Palazzo Marcello to Santa Maria in Cosmedin before climbing the most ceremonial and grandest of all steps to Michelangelo's *Campidoglio* and a glance of the Forum – best at dusk – then across to San Pietro in Vincoli to gaze at Michelangelo's *Moses* before cutting back to the Vittorio Emmanuele monument, the only ungainly landmark in this most beautiful of cities. Then down the Corso to the Piazza di Spagna with its joyous Roman fountains remodelled in the 15th century at the foot of the Scalinata of Trinità dei Monti. Past the Villa Medici with its Roman pines (the interior walls painted on Balthus' instructions to resemble the background of a David portrait) to the Piazza del Popolo with its twin churches; to San Luigi dei Francesi with its Caravaggios; then a twist and a turn and you're at Santa Maria della Pace; the cloisters by Bramante; and back once again to what was once a racetrack, the incomparable Piazza Navona. After this assault on the senses, you can reflect that you have seen only a small part of what Rome has to offer: its monuments, churches, piazzas, obelisks and fountains all a fact of daily life.

> *… a world that vast and filled with treasures, inspiring landscapes*
> *and the achievement of mankind. Ornamental or exquisite, the work*
> *of man remained to be explored is reason enough for travel.*
>
> ROGER FRY

The concept that travel broadens the mind is an *idée reçu*. Of course it does, but you need to look, to be receptive, and to not just strike another wondrous place from your

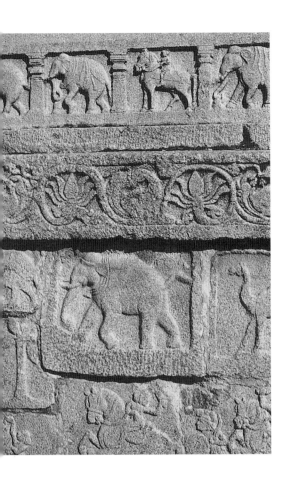

A STONE CARVING at Hampi, India. This is the site of the ancient capital of the Vijayanagar kings who dominated southern India from 1336 to 1565.

list. My travels have been incessant, by intent or in the course of duty, but there is much I have yet to see, let alone learn. The world has always inspired man's curiosity and spurred the desire for conquest. The Grand Tour for pleasure and instruction became a necessity for cultivated persons in 18th-century England. Now travel is easy and, as countries adapt to the requirements of tourism, the rare and wonderful is in danger of becoming debased and commonplace. But even in the age of speed, wonder remains.

The impact of India on my first visit in 1963 was cataclysmic. I returned to London with a new visual vocabulary. I had never been anywhere so exhilarating, and so manifestly alive with people. The English gave Indians a language to unite this mighty multi-racial sub-continent. Although the Muslims gave it Moghul architecture and a stark religion, the Hindu gods remain as mischievous as any on Mount Olympus. I was drawn to India again and again, some twelve times in all, north, south, east and west; to its forts, plains, rivers, the great cities of Calcutta and Bombay, and Benares – medievalism come to life. Beloved above all is the lovely valley of Kashmir, sadly closed to visitors since 1990. Most startling was the infinite grandeur of the Himalayas – where monastic Buddhism is advanced quantum physics compared to the religions of Europe. I was only as high as Bhutan and Ladakh, unfortunately. Colour is brighter there than anywhere. Reds and blues and brown, turquoise, black and ochre are startling in the vast, stark deserts of Ladakh; the same colours more harmonious against the dark mountains and lush vegetation of Bhutan's valleys.

I have been to Indonesia, Japan, China, Australia, Brazil (a samba heart-throb), Colombia, Venezuela, Peru, Equador, the Galápagos, Guatemala, Mexico, Burma, Russia, and repeatedly to the United States. America is different from any other place, if for no other reason than because its culture dominates the world. It bristles with contradictions; its people so well intentioned though racked with self doubt; a country

35

of supreme entrepreneurs. It breaks new ground in all fields – socially, culturally and commercially. The immensity of its landscape only confirms its power and domination.

Each and every country has (somehow, at some time) provoked my imagination by its architecture, landscape, colour – even the tempo of life – so that impressions were transmuted into ideas. An atmosphere could be re-created; a detail re-interpreted.

Is it lack of imagination that makes us come
to imagined places, not just stay at home?
Or could Pascal have been not entirely right
about just sitting quietly in one's room?

Continent, city, country, society:
the choice is never wide and never free.
And here, or there…No. Should we have stayed at home
wherever that may be?

ELIZABETH BISHOP, *QUESTIONS OF TRAVEL*

36

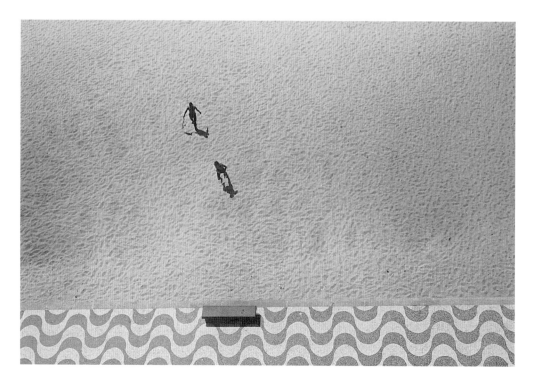

COPACABANA BEACH in Rio de Janeiro. The photograph is taken from my balcony on Avenida Atlantica. The pavements are waves of grey and white pebbles – a Portuguese influence.

Throughout my travels, both in Europe and away from Europe, the same curiosity made me look at museums as well as botanical gardens in places as diverse as Calcutta and Rio de Janeiro. Depositories of treasures such as Florence, Mantova and Naples are visited again and again; Venice in particular – the most oriental of European cities (the shimmering miracle of Venice has a beauty so haunting that it seems to belong to everyone who has ever been there). Visits to museums were always, and remain, a priority in any town or city – often the purpose of the journey – and a pleasurable discipline that always bears fruit. The Künsthistorisches in Vienna and the Rijksmuseum in Amsterdam, the Louvre in Paris, Museum Island in Berlin, the Prado in Madrid, the Kunsthaus in Zürich, the Zwinger in Dresden and Kunstmuseum in Basle, the incomparable National Gallery of Art in Washington, the great Metropolitan Museum and the Museum of Modern Art in New York – all of the things that you see become woven into your life, which is why living in a metropolis such as London is a privilege difficult to forgo. It has a cultural range that surpasses any other city – England can be parochial, but London is never provincial. Its very institutions and great museums stimulate creativity; artists and designers become recipients of London's energy. Thomas de Quincy in 1800 described London's magnetism as a force he experienced in an open carriage as he approached the great city.

At heart a Modernist, I believe that each age has to develop the art and craft of its time, and yet I never feel that the new should exclude the old. The pull of the times in which we live is strong. I remember Peggy Guggenheim's Pallazo Vernier dei Leoni before it became a stagnant display of 20th-century art. I much admired Gio Ponti's tower that soared up while I lived in Milan. Beneath me in the building where I lived, there were exhibitions at the Gallerie delle Ariete of contemporary American art – an eye-opener. Danese, a shop dedicated to objects designed by Italian architects, was a startling novelty. The Pop-Art exhibition at the American Consulate in Venice in 1964 was exhilarating – it seemed that new frontiers in aesthetics were being reached, and they were.

My first trip to New York in 1963 revealed to me the mastery of the new Seagram building by Mies van der Rohe; the snail-shaped interior of Frank Lloyd Wright's

Guggenheim Museum; the architecture of Louis Kahn, whose talent was corroborated at the Indian Institute of Management which I later visited in Ahmedabad. Also in India, Chandrigah by Le Corbusier trumpeted his great genius and revealed, despite his man-friendly theories, an unexpected lack of pragmatism. Oscar Niemeyer's modern shapes in Brasilia, high on a great and empty plateau, were a vision of optimism, their impact on the world not dissimilar to Frank Gehry's triumphant Guggenheim Museum in Bilbao. There was an exhibition in 1964 at the Museum of Modern Art in New York, with a book by Bernard Rudofsky – *Architecture without Architects* – which confirmed all that was best in the vernacular (among his examples some similar to the architecture of the Greek islands, which, by then, had become a not unfamiliar language).

I feel at ease designing houses in different styles with diverse atmospheres, simple or complex. I incline to the simple, but the more complicated are enrichments arrived at by application – developing an eye. There is no style that I revile and no example of any period which I feel does not deserve to be appreciated. There are, of course, decorative objects and furniture that exude a nauseating sentimentality or a perverse and evil spirit but, even so, *kitsch* has its point. The exception to this benign view is Art Nouveau. Whereas I am an admirer of the Secessionists, the Arts and Crafts movement which associated the decorative arts with architecture and was a direct precursor of Art Deco, I find it hard to admire the rooms of Proust's Odette. The exception to my prejudice is the architecture of Charles Rennie Mackintosh at the Glasgow School of Art which is *sui generis*.

It is necessary to look and see and absorb, even things that may not have an instant appeal. During my first years in London, I would go very often to the Victoria and Albert Museum library and spend a morning reading up on a subject that had caught my attention. In architecture and the decorative arts, I had long admired Vanbrugh and Hawksmoor. I savoured with relish the quintessential Englishness of Elizabethan architecture – it is then that I came to appreciate Inigo Jones and William Kent; the architecture of the Age of Reason so indebted to Italy; the Arts and Crafts and Sweetness and Light Movements. I admired Lutyens – unfashionable in the 1960s – for his wit,

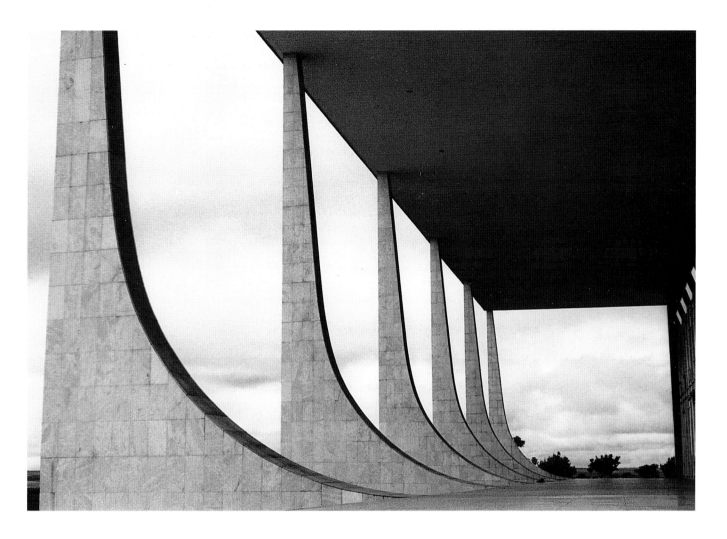

BRASILIA – the Federal Supreme
Court by Oscar Niemeyer.

variety and originality. The rooms and furniture he designed all over England and at

the Viceroy's house in New Delhi have been a frequent source of inspiration. Other love

affairs followed, notably Schinkel in Berlin and Potsdam. There is a domesticity, a

modernism in both 19th-century Schinkel and 20th-century Lutyens that always

makes me smile. Baragan was a great discovery, thanks to Bruce Chatwin's enthusiasm

and an obscure architectural review. When I took up my profession, there was not that

much information readily available. It was not until the 1970s and 1980s that a

plethora of books was published on architecture and the decorative arts – some

frivolous but others scholarly and helpful. At this time I looked with curiosity but very

warily at rooms decorated by Boudin. It is only later that I realized that his use of colour

and attention to detail had such an influence on me. Roderick Cameron lived in France

in the tradition of American and English expatriates who assimilated French *savoir vivre*. He added his own lightness of touch which was exemplified in the Fiorentina at St Jean Cap Ferrat; he had an unnatural talent for placing furniture and objects in a room. His colours were olive, taupe and white in all their manifestations – there was a sense of repose and luxury unlike anywhere else. He was a strong influence on David Hicks, who was nevertheless chromatically very much more adventurous. I learnt much from Rory and his book on India which gave me great incentive to travel. Luchino Visconti's sets for the opera and his films showed him to be a master of decoration – he had the grandest taste of his generation and a marvellous sense of scale.

Even when not strictly relevant, books on architecture, painters, decoration and fabrics all evoke memories of things seen. While the emotional impact of certain paintings would make too long a list, the recalled sensation of a picture that has moved me is enough to refresh my mind. Among so much that is dazzling in Europe (while I exclude Greece, I cannot resist recalling the excitement, shock and timelessness of walking among the columns of the Parthenon, where I intend never to return since this inestimable thrill is denied all visitors), my short list of wonders would include: the first view of Bramante's Tempieto in Rome; the staircase in the Bishop's Palace at Wurzbürg (despite all that I had seen of Tiepolo in the Veneto, I was open-mouthed at the scale and mastery of the murals); the light-hearted and astonished first sight of Giulio Romano's Palazzo Tè at Mantova; the thrill of witnessing the restoration of Michelangelo's Sistine chapel – climbing the scaffolding and daring to touch the frescoes; the moments of truth before paintings as well known as those of Vermeer or Rembrandt or Velásquez or Raphael; the excitement of finally getting into Sant' Ivo, so frequently shut in the past, and viscerally experiencing Borromini's vitality; the agonising beauty and tenderness of the Isenheim alterpiece of Mathias Grünewald; the joy of seeing the Gustav Klimt mural of the Palais Stocklet in Brussels when I knew little about him; the first David portrait at which I really looked; and the shock of opening a door and facing Jacomo Pontormo's *Deposition* at S. Felicità in Florence. And so I could go on – with Impressionists, Modernists and one's contemporaries. Although I know it is

a little debasing to art's muse, I derive a secret pleasure from using an element or colour from a painting; to having a fabric woven that is based on a Veronese silk stripe, a Bronzino breastplate of a dress, or a pattern on the robes of figures by Carpaccio – all are demonstrations of affection. From India, I took not only a palate of colours but a quantity of motifs, some Moghul, some Hindu. It would be impossible to tabulate these experiences by degrees of visual or emotional impact, let alone how they were later incorporated into sensibility. I can only point them out as they emerge in some of the photographs in this book.

The landscapes of the East are on a different scale to anything in Europe. Nowhere is this more evident than at Mandu, a Muslim stronghold on top of an immense flat rock in what used to be Indore in northeast India. This ranks among the most romantic places of my travels – a stunningly grand architectural complex; a majestic fortress blessed with mosques, lakes and gardens, suspended on a plain as vast as any dream could match. In the capital of Bundi in Rajastan, fortifications crawl majestically across

A GATEWAY in the battlements (*below*) and a water tank (*below right*) from Mandu, a 15th-century Afghan fortress in India.

41

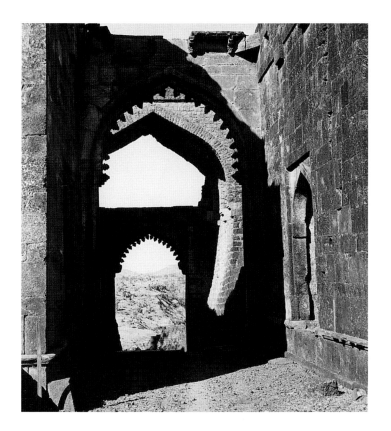

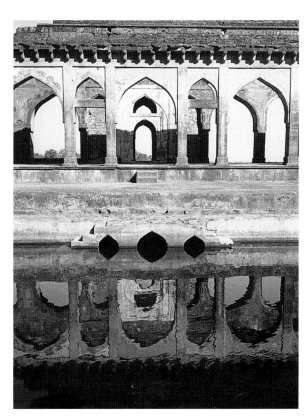

a crest of wild hills. From one of the towers, the sounds of the town, surprisingly loud, rise around you. A conglomerate of city palace and town, its density is interrupted by large and elaborate square wells, their steps cascading to the depths.

Expansion of the mind, without recourse to drugs, comes with the sudden awareness that the Shwe Dagon pagoda in Rangoon only appears to be a mirage of shimmering light; it is in truth an enormous luminous expanse of gold leaf pasted square by small square upon its surface by the faithful. Looming in an infinity of lime-green rice fields, the perfect cone of the great volcano of Sukohargo in Java makes one realize that the gods are playing with higher stakes than in the West. To a Greek raised in the Greco-Judeo tradition, it was a pleasant shock to come upon Ouro Preto in the state of Minas Gerais in Brazil, a perfect baroque town of the 18th century with gilded church interiors to match any in Europe. These miracles of survival are a contrast to Tikal in Guatemala – Mayan temples strangled by tropical vegetation so dense one dare not stray from the path hacked out of the terrifying jungle. Man's creations are called into question at the first sight of Waipio on the Big Island of Hawaii. The marvels of nature are revealed, not in painting, but in the lush tangled vegetation of this valley with its headland of rock that curtains the beach with its grand rolling surf. Black sheets of ancient lava are parted by a waterfall that cascades from a hardly credible height to splash and foam into the sea – a far cry from the niceties of mix and match in design magazines. Give us a break!

Seldom moved at a Protestant service in the country where I have chosen to live, I found the restraint and simplicity born of the Reformation in the Anglican St John's church in Bombay. The tombstones in the church graveyard are a testimony of the death in extreme youth of so many British soldiers in the early years of the 19th century – victims of a more idealistic generation. This was long before empire's later indulgences such as the houseboats on Lake Dal in Kashmir. Built for Englishmen in the Indian Civil Service, they are an education in luxury. The tranquil beauty (remember the Himalaya mountains form a backdrop) is undisturbed as the grocer rows quietly to your houseboat with its deck festooned with lace fretwork cut-outs,

42

shortly followed by the tailor and, of course, the florist whose boat overflows with enormous bunches of roses and tuberose. Or a veritable fleet of green parrots which suddenly flies past as you wait on a small island of carved marble rising from the water of the lake in Udaipur. These moments are a gratification of the senses, and they become a profound influence on you. But how do you transfer experiences such as these into the world of design?

> *Style is fundamentally a truthful statement, if we take for*
> *truth something more careful than the not telling of a lie.*
> *There are layers and layers of truth; and style, whether in*
> *dress or life, art or literature, is involved in their discovery.*
>
> FREYA STARK, *PERSEUS IN THE WIND*

Nothing matches nature in its diversity and the favours it grants. Travel to the world's exotic places confirms that good taste is a useless concept. A harmony of colours can never have the impact of colours that clash. The great contrasts of Eastern and Western culture are lessened the more you see and learn. They can be emulations of each other – the influences are multiple, interracial, intercontinental. Moreover, this has always been the case. There are many folk patterns, such as plaids, that repeat themselves worldwide. The individual creations of a sculptor or painter or decorative artist have direct counterparts and even metaphors for each other in the present as well as in previous centuries.

43

As in all things aesthetic, it is best to keep an open mind with regard to the decorative arts. After my life in Italy, I preferred Italian furniture of the 18th century above all else. Since in the 18th century French cultural influence was at its peak, I was led to look at French furniture of the same period. Little by little, you learn to recognize the best, or more spirited, of a kind, whatever the period. The liking you have for one period spreads to the next, and a sense of quality, a discernment, develops which whittles away prejudices and received ideas.

Style and Atmosphere

… accuracy is the basis of style… beauty walks along the edge of
opposites, between pattern and freedom. If pattern is too strong,
the play of fancy ceases, and beauty with it… Style – to renounce
all but the essential, so that the essential may speak.

FREYA STARK, *THE JOURNEY'S ECHO*

The difference in this new millennium is that innumerable styles in design and fashion travel at a greater speed than ever before, and with global communication every style quickly has its adherents. Each age seems to have a predominating religion (the worship of Mammon has never dominated as it does today), but the god of invention, the demi-gods of science and the arts, are with us still. They have energy and drive; they wage war on religious zealotry and the waning philosophies of the past.

In the world of design, style depends on instinct, invention and the interpretation of a specific period in time (the latter posing an interesting conundrum since any *period room*, however faithful to the original, has the indelible mark of the decade in which it was created). An academic approach can never equal what an artist does by instinct. It is the uniqueness of the individual that makes an impact.

There is a great amount of poetry in unconscious fastidiousness.
Certain Ming products, imperial floor-coverings of coach-wheel yellow,
are well enough in their way but I have seen something that I like better.

MARIANNE MOORE, *CRITICS AND CONNOISSEURS*

Creating an agreeable atmosphere emanates from a person's nature. Sometimes it is an instinctive ability to make life pleasurable, but it can also be an accomplishment. In a room, the purpose is to make yourself, a family, guests feel at home. The *petit soins* at

44

which the French excel appeal to the senses: fresh-picked flowers; scented greenhouse plants, such as pelargonium, the incense plant, frankincense and myrrh; in early spring, pot-grown tulips – encouraged, not forced; the first jasmine plant with its invasive fragrance; in summer (particularly in England), vases bursting with roses; and in Italy's mid-summer heat, great vases of tuberose, the most heady aroma of all; the tinkle of ice in a pretty glass; comfortable armchairs and sofas; a fire lit on a grey and drizzly morning; down cushions and pillows; food that is appetising – its simplicity real or deceptive; crisp, coloured, white or embroidered table linen or a scrubbed pine table; china plates of Meissen or rough-hewn pottery. The variations of comfort and what gives pleasure to the eye are infinite. But ultimately, however many wands are waved, webs spun and money spent, atmosphere depends on the people who live in a place.

JAPANESE GARDENS in Kyoto all appear traditional even though innovative features surfaced century after century. The seemingly traditional garden in Komioin shown in these photographs has a distinct aura of the 1920s – the time when it was first designed by Shiegemori.

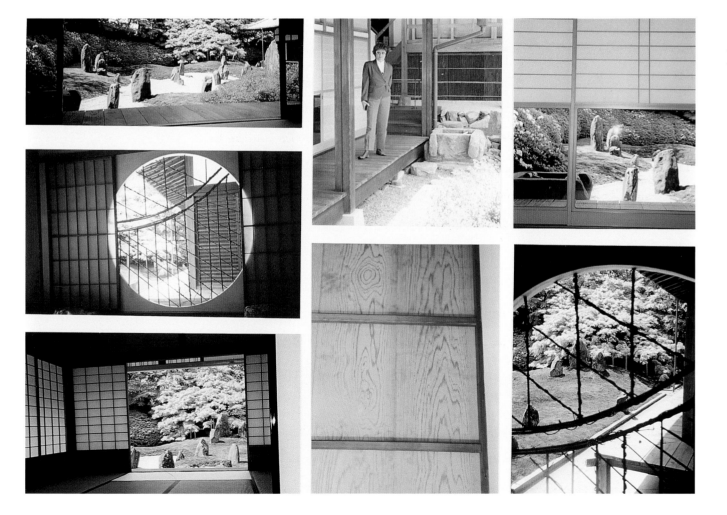

Volume, Space, Light and Colour

In the ancient world of King-Gods, governing according to religious conception, the deposition of the chiefs and leading priests leaves the country at once voiceless and mindless. The people are governed by the flower of the race. Pluck the flower, and the race is helpless.

D.H. LAWRENCE, *ETRUSCAN PLACES*

The market towns of England, and those with vast cathedrals surrounded by life on a human scale; the resplendence of castles and country houses add up to a way of life that is civilized (this is reflected in Georgian architecture, which has adapted remarkably well to contemporary requirements such as heating, plumbing and electricity, as in most Italian cities which have kept their buildings, piazzas, town halls and churches and put them to the use for which they were made). It is the notion of space without and within that makes the difference; if used wisely, interior and exterior space should be practical as well as comfortable.

Among the most spectacular spaces in architecture are Bernini's piazza opposite St Peter's in Rome and the Piazza San Marco in Venice. A more humble space (often the true measure of man) is the piazza by Bramante at Vigevano in Northern Italy. Perhaps the most breathtaking of all is the *maidan* at Isfahan which has a purity and simplicity that is unique. The mosques at Isfahan are juxtaposed in such a way as to be the only way; spectacular empty space is a prelude to the intense, crowded and pulsating life contained within the cowled and shaded bazaar, its portico strategically placed opposite the most brilliant of blue tiled domes. The contrast between inside and out is more subtle, part of a way of life in the pavilions of Kyoto. In garden after garden abounding with exquisite detail, perfect balance has been achieved in spaces that are either monumental or very small. It is volume poised and balanced; a most meticulous refinement and cultivation of the senses that belongs only to the East. The gardens of

46

Rather notice, mon cher,
that the moon is
tilted above
the point of the steeple
than that its colour
is shell-pink

Rather observe
that it is early morning
than that the sky
is smooth
as a turquoise.

Rather grasp
how the dark
converging lines
of the steeple
meet at the pinnacle –
perceive how
its little ornament
tries to stop them –

See how it fails!
See how the converging lines
of the hexagonal spire
escape upward –
receding, dividing!
– sepals
that guard and contain
the flower!

Observe
how motionless
the eaten moon
lies in the protecting lines.
It is true:
in the light colours
of morning

Brown-stone and slate
shine orange and dark blue.

But observe
the oppressive weight
Of the squat edifice!
Observe
the jasmine lightness
of the moon.

WILLIAM CARLOS WILLIAMS,
TO A SOLITARY DISCIPLE

the Moghuls, who venerated water, are poetic marvels of horticultural planning, but rough fare in comparison to those in Japan. These are analogies when imagining other spaces or creating dimensions, whether in making a garden or placing furniture in a room. In creating a house and a garden in Dorset from what had been humble cowsheds and a scrubby wood, I became conscious of my instinct for *weight*, *position*, *contrast* – the abstractions and conceptual tools of my trade.

Good design of any period will emanate a spatial sense. It will use space, and its decoration, in a way that transcends fads and fashion – this is what we aspire to when creating the structure and surroundings that are to become places in which to live. While the very nature of my profession is diversity and eclecticism, a space, a room, a house still needs coherence – there must be a conductive line which creates its own *genius loci* – this applies, in particular, to a new building in surroundings that may be banal and characterless.

The influence on the design and decoration of a space in, say, an apartment or a house, will often arise from what is seen from a window. The spirit of a place is evoked by the sweep of a stuccoed terrace, the bustle of an urban street or the stillness of a radiant landscape. Because it is contingent and tangent, it deserves cohesion.

In my profession, rooms may have to be stripped, reassembled or reinvented depending on the type of building – old or new, rustic or urban, by the sea or in the hills. All this and more must be taken into account and last, but not least, the wishes, aspirations, and fantasies (both known and unknown) of the future occupants carefully considered, even if I must sometimes encourage the conjuring.

With rooms in need of improvement or transformation, there must be an initial assessment of both volume and space and, most important, of potential light. All countries have varying light at different seasons or times of day. Egypt, Scotland, England, Holland, Italy – all have a particular light that has

47

most often been interpreted in painting. In Greece, one is intensely aware of light. It is remorseful, ambrosial. It caresses and dazzles. In my profession, light has to be tempered – it has to flatter and enhance as well as provide sufficient illumination to allow the middle-aged to read. Colour and light are correlated; they can love or destroy each other. Every colour has an emotive charge; the way colours contrast, marry, embrace and clash are like life itself. The use of colour is a subtle exercise in luminosity. Soothing and peaceful rooms can be monochromatic or a riot of colour. The room's *integrity* is arrived at not only by colour, but also by harmony and counterpoint. The theory of colour and its attributes has been written about – most notably by Goethe and Albers. It is a subject both scientific and mysterious. Journalists sometimes ask naïve questions – most typically, 'What is your favourite colour?' All colours are valid. There are infinite shades of colour in the spectrum, not excluding black, of which there are hundreds more. The answer to the journalist is, 'Every shade of blue is my favourite colour, as well as pink and grey and green and red'. On my first trip to India, I took a paper cornet of each coloured powder lined up in conical piles outside a Hindu temple – powders made from petals or leaves and applied to the forehead by the faithful: *bindi* for the women and *sindoor* for the men. These cornets contained the colours for the first fabrics I created and have served as inspiration ever since – but then so have stones, leaves, flowers, photographs, melodies, shells, magazine illustrations, paintings, scribbles on air journeys, and trucks on the freeway.

48

Harmony *n.* Just as *counterpoint may be defined as the element of disagreement between voices or parts in a composition, so harmony is the element of agreement. As with counterpoint a number of factors are to be considered. Referring back to Exx.1 and 2 of that article, Ex. 1 (Dufay) could be said to be harmonic to the extent that little actual dissonance is present – although the excerpt would normally be referred to as a piece of counterpoint, so so strong is the rhythmic disagreement – while Ex. 2 (Milhaud) is harmonic in that there is no rhythmic disagreement, although an element of counterpoint is present in the high degree of dissonance, which tends to cause the hearer to 'listen horizontally' in order to understand the progression.

Counterpoint (from Lat. *punctus contrapunctum*, 'note against note'; Fr.: *contrepoint*; Ger.: *Kontrapunkt*; It.: *contrapunto*). Counterpoint may be defined as the element of disagreement between voices or parts in a composition, harmony being the element of agreement.

Interior Design and Execution

This gentleman

takes his bath each morning

in the waters of the Dead Sea

then dons a bitter smile

for business and clients

GEORGE SEFERIS, *PSYCHOLOGY*

Unlike William Kent in the 18th century, architects of the 20th century lost interest in designing furniture and adornments for their buildings. There are exceptions, of course, such as Le Corbusier, Mies van der Rohe and, in particular, Lutyens. In past centuries, it was mostly upholsterers who provided the fabrics and trimmings and set up rooms with furniture from the master carpenters or *ébénistes* of the time.

49

Today with regard to architecture the average man is a fool

and the average architect is a snob.

JOHN BETJEMAN, *GHASTLY GOOD TASTE*

There are anomalies with the appellation 'designer'. It has different applications from store design to fashion. 'Interior designer' is somewhat equivocal and subject to interpretation. 'Decorator' in English is also a house painter; *décorateur* in French is not necessarily an *architecte d'intérieur*; and in the United States, these distinctions are further blurred. In many design practices, the principals are architects employing specialists in interior design who are assigned with 'packages' – sets of drawings and specifications ready for estimates before contracts are even signed. This works best in large commercial firms, whereas a small specialized practice such as mine has in-house architects whose expertise is an integral part of the design from the start, even though

'packages' – estimate and contracts – are mandatory procedure. This integration is more intimate in a small practice and results in individuality – a design that is tailor-made to suit the client. The recipe is one of imagination, an assimilation of a client's needs, a tabulation of comfort, and an assessment of the levels of luxury required and dictated by good design. For the designer, this is a role at times not unlike that of a dentist. This mix develops into a process which can be as stressful as divorce or as happy as a love affair. If, at the end of it all, the persons who commissioned the work think that they did it all themselves, this is a sure sign of success. For the duration of a contract, the proximity of interest between you and the client often leads to intimacy and may even turn to friendship. You end up knowing a lot (sometimes too much) about each other. Happily in my case, it is a source of pride that I first met a number of my most stalwart friends as clients.

50

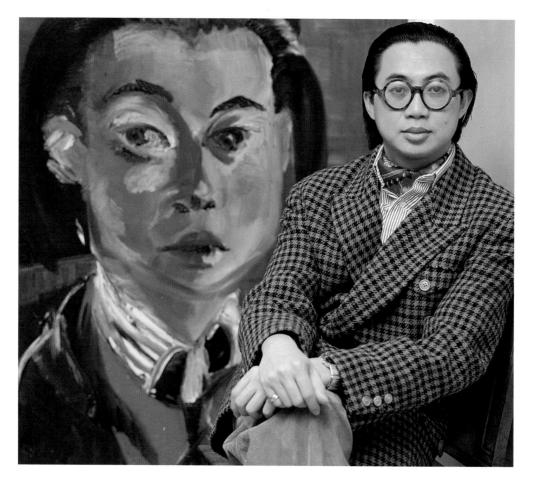

A CLIENT – the painting is by Rainer Fetting.

In a philosophy of design and decoration that has occupied me for three decades, the influences have been multiple, the discipline constant. Work has sometimes come from a friend or acquaintance, but the largest commissions often have come from people who have seen work published in the press or in my two previous books and, inevitably, by word of mouth. At the start of a commission, existing spaces are assessed and improvements envisaged. It is only then that there is a leap of the imagination – marshalled and contained by the site. The *locus vivendum* is formed – a genius re-invoked or a spirit of place newly invented. The process from beginning to end can soon be gauged within a period of time, and the capabilities of human resources assessed to arrive at a programme – a process speeded up immeasurably by the magic of computers. When cut to size, the tried formulas applied to designs for corporations and world businesses are not inapplicable to a small Chelsea studio – both must answer the needs of creativity and practicality. Dancing the rumba has to be well co-ordinated so as to please both dancers and spectators.

51

The lifelong stimulus of choice both in thought and
action…in the hands of people whose life has trained them in
the inestimable art of making up their minds.

FREYA STARK, *THE JOURNEY'S ECHO*

One of my most successful, although difficult, commissions started with the question, 'What shall we do?' My reply was, 'We must invent'. If the client is on a learning curve, the result can be astonishing. There are examples in this book of clients who have pushed me to further endeavour and to break conventions – not the other way around – and this deserves celebration. *Chacun à son mauvais goût* implies that an individual's taste is paramount, confirming the old dictum that *les goûts et les couleurs ne se discutent pas* – hardly applicable to my practice. The product, the result, has to undergo an alchemical process for it to be not only an aesthetic success but, in the most simple sense, the client's home. The best houses possess layers of reference to people's lives, as

well as their aspirations (which in part explains the appeal of the English country house and the veneration of the past to an extent never before reached in these islands).

A good house needs careful preparation, and this requires time. In order to implement a commission, I have a studio of some twenty people – project managers, architects and CAD workers led by a head of design, a soft furnishings department and a financial administrator – all under the expert guidance of a managing director.

Programmes, schedules and estimates must be respected. The 'drop dead date' becomes a priority. We have an obligation to deliver on time and on budget. Hotel and commercial work are instant-style, a sleight-of-hand not entirely unwelcome after the complexity of creating a world for a client not always well enough informed or with enough self knowledge to express himself in colour, furniture or paintings. People tend to think predominately about their careers or their children. They perhaps have never questioned the surroundings of their upbringing; never had the time or inclination to look around them until the moment occurs when they want a change. The world has to be reinterpreted, or created anew, to fulfill these new ambitions. There is a chrysalis stage when a person must be transformed in order fully to enter another sphere. Not to be confused with happiness, these new surroundings are nonetheless a background, a stage set for life – not life itself. Courtesy, hospitality and good manners make a house alive; its design and decoration are merely a prelude. (I suspect, though, that no decoration, however pleasing, can replace the courtesy of the East. Where manners and hospitality are paramount, standards of Western aesthetics become irrelevant.)

> *The abstract world is surely one of the essentials*
> *for living in the East: it gives an oasis always at*
> *hand wherever one may be.*
>
> FREYA STARK, *THE COAST OF INCENSE*

The easiest people to work for are those who know their own minds and can state clearly what it is that they require. They have healthy egos; perhaps past experience.

Some of them own multiple possessions; others are keen to acquire furniture and objects to embellish their house and enrich their lives. I have had virtual *carte blanche* on a few notable occasions when desires and requirements were most clearly defined; the norm, however, more closely resembles dancing that rumba.

Specialist painters, master carpenters, lacquer workers, upholsterers and curtain makers are all trades that perpetuate the traditions of centuries. It has been most encouraging to witness the resurrection of skills in carpentry, in carving wood and stone, scagliola, and good metal work. Thirty years ago, these crafts were disappearing in Britain. A good rapport with craftsmen and artisans is imperative. Their worth must be acknowledged, and their work praised. Involving them in the creation of something unique is essential; an elasticity with instructions gives a craftsman the freedom to express his talents.

Most men harbour a secret creativity – if they contribute to the making of a design, if a suggestion is taken and developed, this participation can only enhance a painting or a piece of furniture. I have sometimes given directions which the craftsmen believe they conceived themselves – I take this as a compliment.

> *The great task of life – sustaining culture – is to keep*
> *the invisible attached, the gods smiling and*
> *pleased… As the Greeks said of their gods: they ask*
> *for little, just that they not be forgotten.*
>
> JAMES HILLMAN, *THE SOUL'S CODE*

Following are two remarkable examples that were a great influence on me (I make an exception to the dictum of this book that no-one alive be mentioned by quoting from a diary I kept in Rome in the 1960s). The two interiors illustrated are both examples of high art of their kind. One, a sleight-of-hand, the irrepressible expression of a painter who was later to become a grand master in his field; the other, an assiduous application of wealth, a most *raffiné* way of enhancing possessions, contrived to please

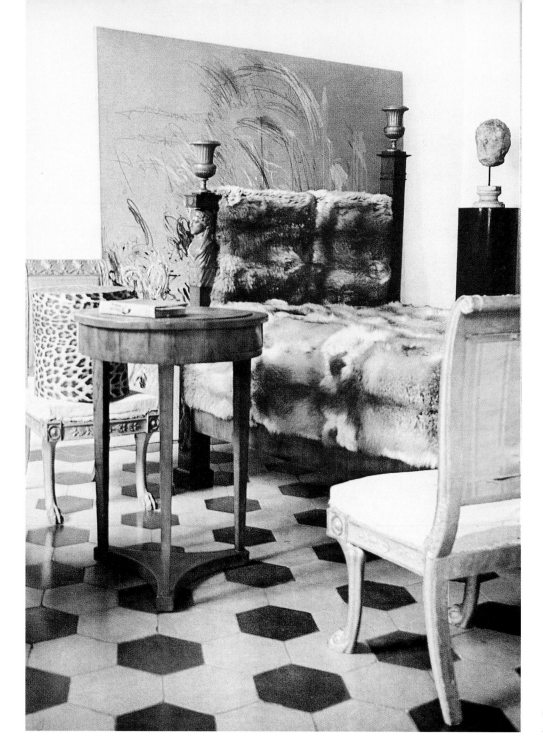

CY TWOMBLY'S
apartment in Rome.

the owners in their daily lives as well as to indulge their friends (a more laudable

ambition than some).

Cy Twombly's apartment and studio in Rome constitute a great enfilade of large

high rooms, an assertive conjunction of a painter's eye with a very specific

elegance: sparse furniture of great presence. Gold and white chairs stand

decoratively, almost as if by chance, before his vast poetic canvases. The eye is

*caught by Roman busts, then a marble-topped console holding just-made
chalky plaster sculptures. Shutters partly drawn, the still-cool air of Rome
enhances one's progress through a room where sparse metal beds are crowned
with ostrich plumes. The stark beauty is a moveable feast. Rooms appear
overnight – heavy tables and even heavier busts are moved to create another
tableau. The result of a powerful intelligence, this is artistic taste unsullied.*

Impressive in quite a different way is the Hôtel Lambert in Paris. It is the quintessence
of *le style Rothschild*, a co-operation between a member of the family and Renzo
Mongiardino, whose panache was only equalled by that of Charles de Bestegni in
an earlier generation. Mongiardino was famous for his attention to detail and
meticulously researched cultural references. Here, the lavish juggling of the decorative
arts reaches a pinnacle of luxury; a kaleidoscope of the best examples of the applied
arts of several centuries.

55

HÔTEL LAMBERT,
Île St Louis, Paris.

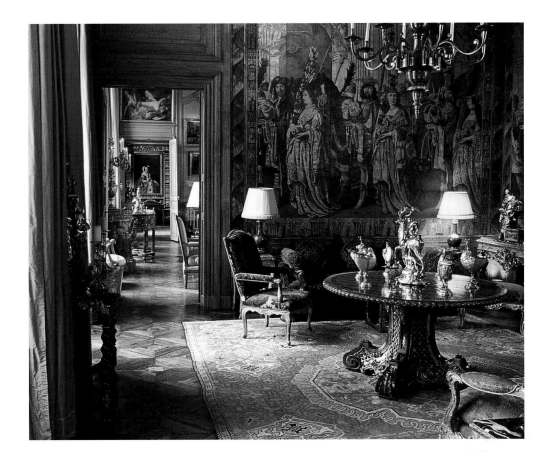

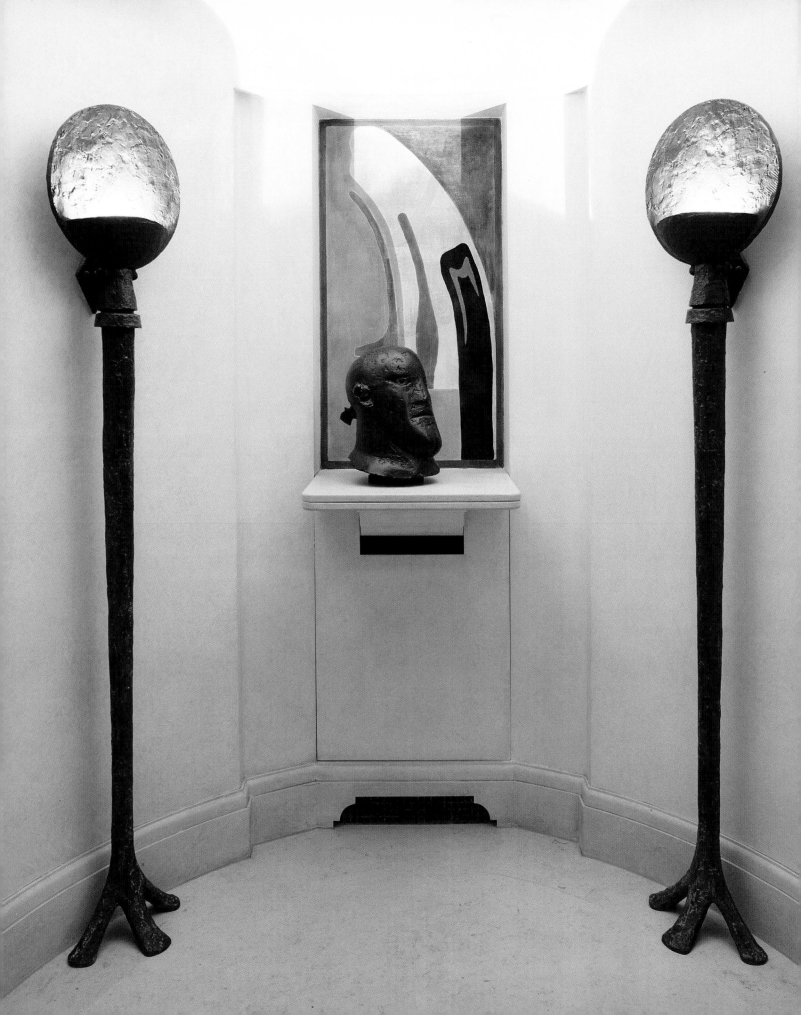

LONDON SW1
on a top floor

A FAMILY PIED-A-TERRE which on occasion has to accommodate six to eight people, this top floor apartment stretches across four houses . The space existed but its planning was dire; the fittings worn, the plumbing and heating out of date. Off came the roof and after twelve months of scaffolding – from which there were enviable views from the metal lift that took you clanking to the top – the building and fittings contract was completed. The fine-tuning took a while – everything that is hi-tech does.

We were very demanding of the contractors – the simplicity of design and detail is deceiving. To achieve this the workmanship has to be fastidious and it was.

This habitation was to be a contrast to the family house filled with possessions that is a mark of duty. It was to be of today; to house modern and contemporary pictures yet to be bought.

The requirements for the apartment were that there should be a large space in which to play music. The floor was to be leather (as we knew from a previous leather floor put down for the same client it is very practical – think polished boots).

THE CIRCULAR ELEVATOR lobby has a stone floor with walls painted to match (*left*). The bronze lights were designed for the space by Philippe Anthonioz – a pupil of Diego Giacometti. The bronze sculpture of a soldier's head which stands on the shelf is by Elisabeth Frink; behind it is a small mural by Zia Pushkin.

A DETAIL of the drawing room wall (above).

THE FLOOR OF the music room
and hall is covered with squares of
polished leather which ages like a
well-polished saddle. The
parchment walls and ceilings
conceal insulation – music can be
played as loudly as it deserves.
The room contains a large sofa, a
piano and little else, but it can be
turned into a concert hall or
dining room ready for a feast.
Chairs are folded and stacked in
cupboards behind the elm shutters.

58

The apartment is an unusual size for London, but it has low ceilings.
Despite removing the roof to house new services, and in certain places
to pierce the heavens with skylights, planning regulations forbade us
from raising the ceiling heights. The solution was to curve the walls
and mould them into the ceilings where appropriate to give the illusion
of height.

We knew from the start that this apartment had to have its own
vernacular; the fun and invention of compromise in an old house was
denied us. I decided that my chief designer should be given free rein.
Using her sketches and the inspiration drawn from the best craftsmanship
of the last seven decades, we kept to a philosophy of integrating the old
with the new – the antiques, if the client consented, were to be of the
1920s and 30s, and so it proved to be. The design developed; the
meetings took place with disciplined regularity once a month.

The planning took three months. This kind of design demands that
you heed the discipline it imposes; attention to detail and minutiae is

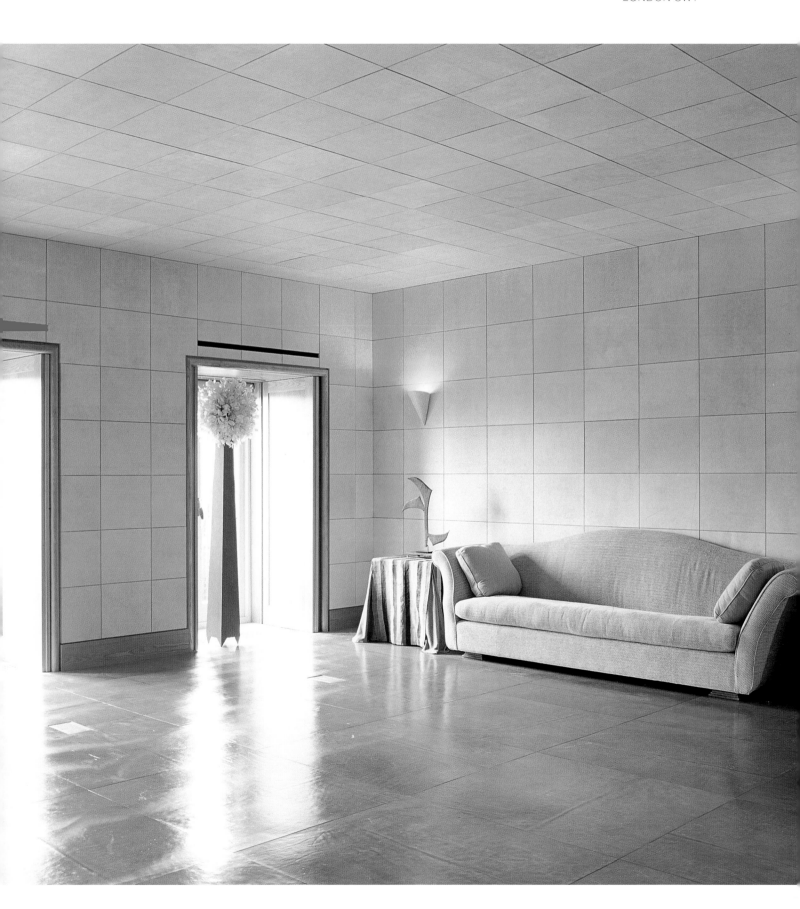

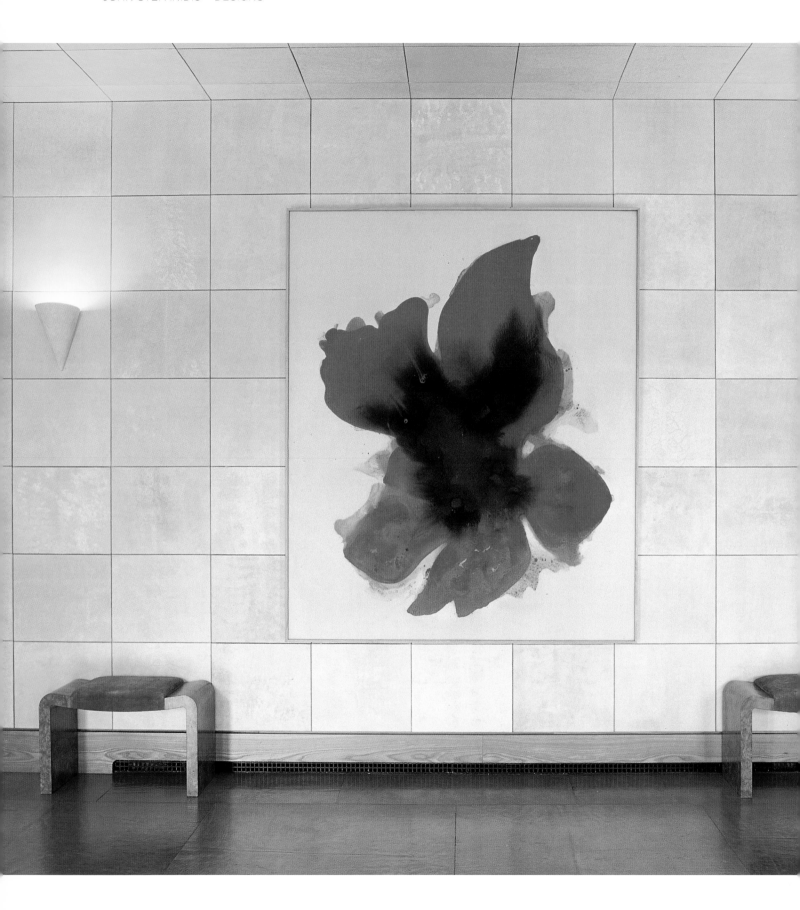

PARCHMENT is both translucent and opaque (*left*). The inspiration for these walls comes from Jean-Michel Frank; the stools are also his. The contemporary painting (oil on beeswax) is by José-Maria Cecilia.

imperative. The drawings, the estimate with the building contractors and all the other trades took ten months. A total of thirteen months and then we were off – hard hats and the contractual world of project managers took over. It was hard to believe that this site, open to the skies in the centre of London, would ever rid itself of scaffolding, pipes, conduits and the movie extras – crowds of workmen – to become an urbane and luxurious retreat. It is a place of repose where a few friends may be invited or it can rapidly become the background for a large party.

A DETAIL OF the door leading to the elevator lobby with lock and handle by Anthonioz (*above*).

A VIEW THROUGH to the drawing room where the floor changes to elm wood (*right*). Another timber, oak, was used for the back of the curved sofa, shelving and cupboards. The rug, made for the room, is white hand-knotted wool. The table is covered in African fibre bark fabric in stripes. The sculpture is 19th-century *oshele* – an adaptation of an African knife from Zaire.

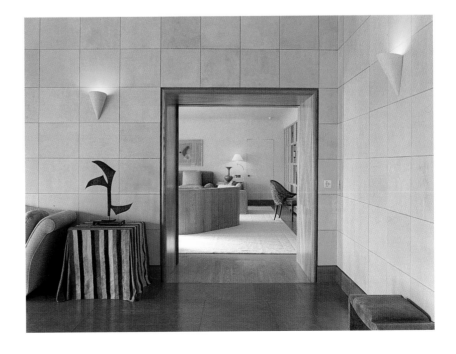

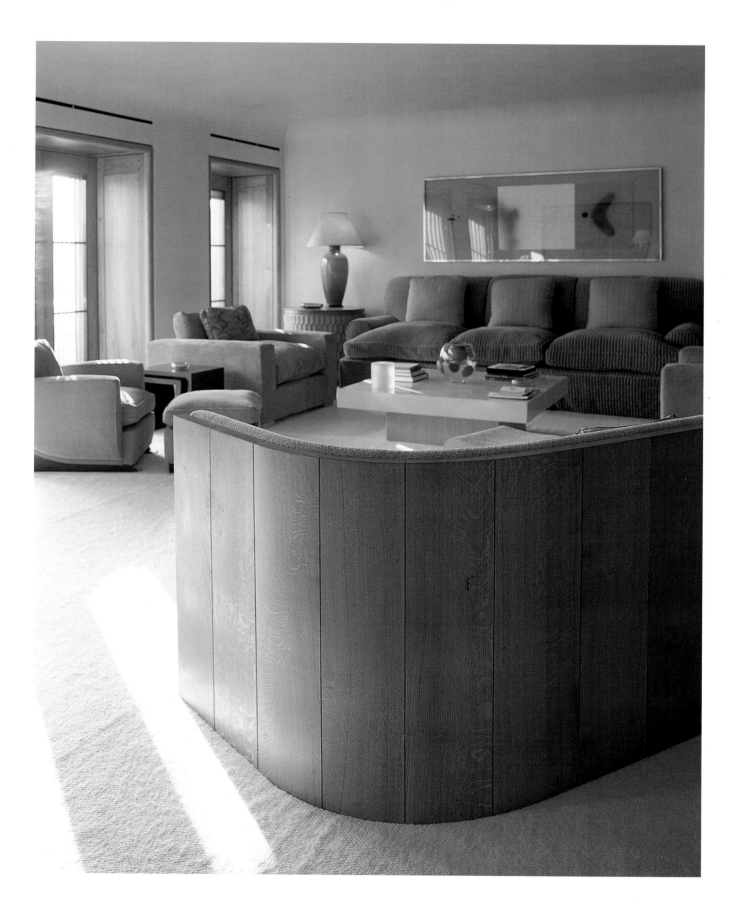

THE WOODEN BACK of a sofa stands in the foreground; beyond are giant armchairs and another sofa (*left*). There is a low JS crackled ochre lacquer table. The round table is carved out of solid oak in a fishscale pattern and on top stands a pale cyclamen pink glass lamp. The wall surface is a special plaster finish with pigments of yellow ochre and mica – there is no cornice and the walls meld into the ceiling.

A WALL OF OAK. The central panel is veneered in the shape of the sun, a technique called slip-matching (*right*). Square shelves house a collection of glass and sculpture and provide storage for CDs. The glass lamp was made by Laura de Santillana in Venice. The 1930s chair is stamped Pelletier & Chanaux. Far right is the bar (see page 65).

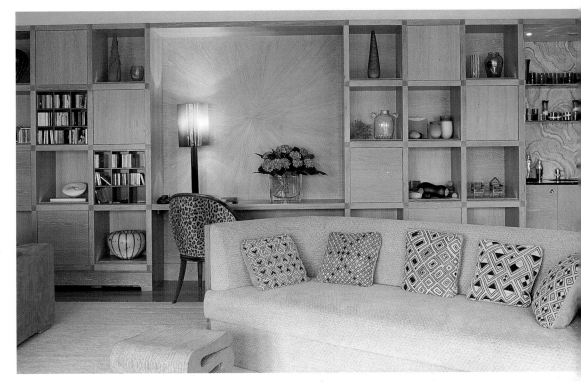

63

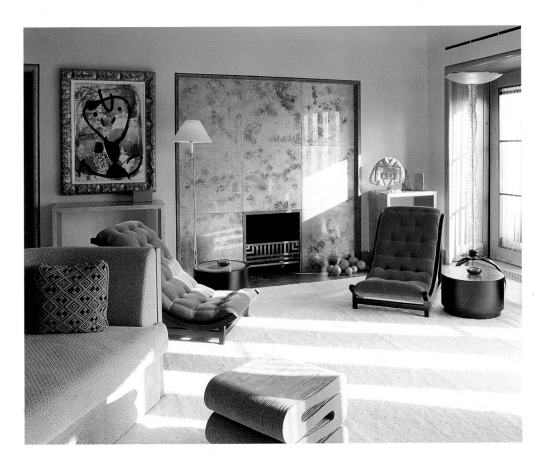

THE CHIMNEY PIECE is *verre egglomisé* – glass backed in gold and copper leaf (*left*). To the left and right are JS tables in gilt with red lacquer visible underneath. A Joan Miró painting in a gilt frame hangs left of the fireplace. A jagged cut-glass torchère stands in front of the window. Instead of curtains, there are vertical glass rods, held in a bronze and elm frame, which glitter in sunshine and filter light. The low chairs are ebonized with buttoned velvet in the manner of Louis Süe.

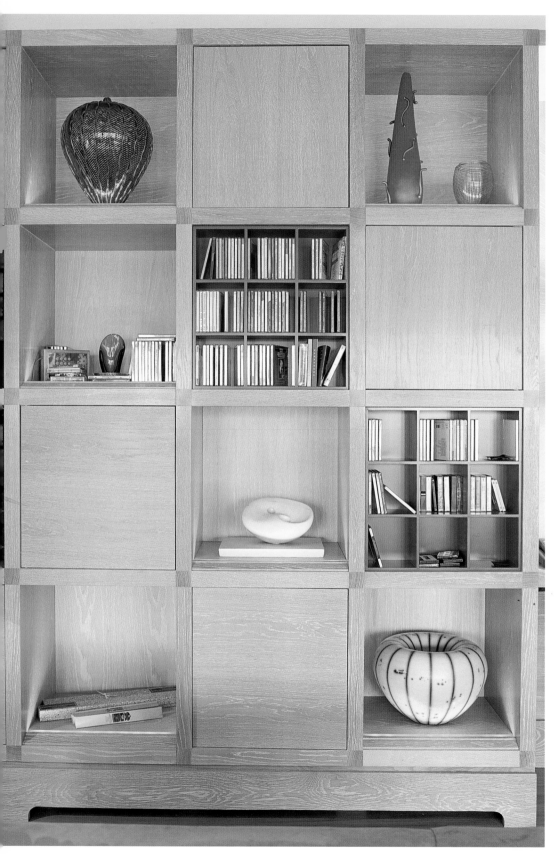

SHELVING made to contain a collection of glass objects and sculpture as well as providing storage for CDs – the closed panels open at the mere touch of a finger (*left*).

A DETAIL of the oak panels with the sun-shaped slip-matching (*below*).

THE BAR is painted to look like onyx (*right*). The shelves are lit; the bar top and basin are both glass. The thinnest Venetian glasses await cocktails – shaken or straight up.

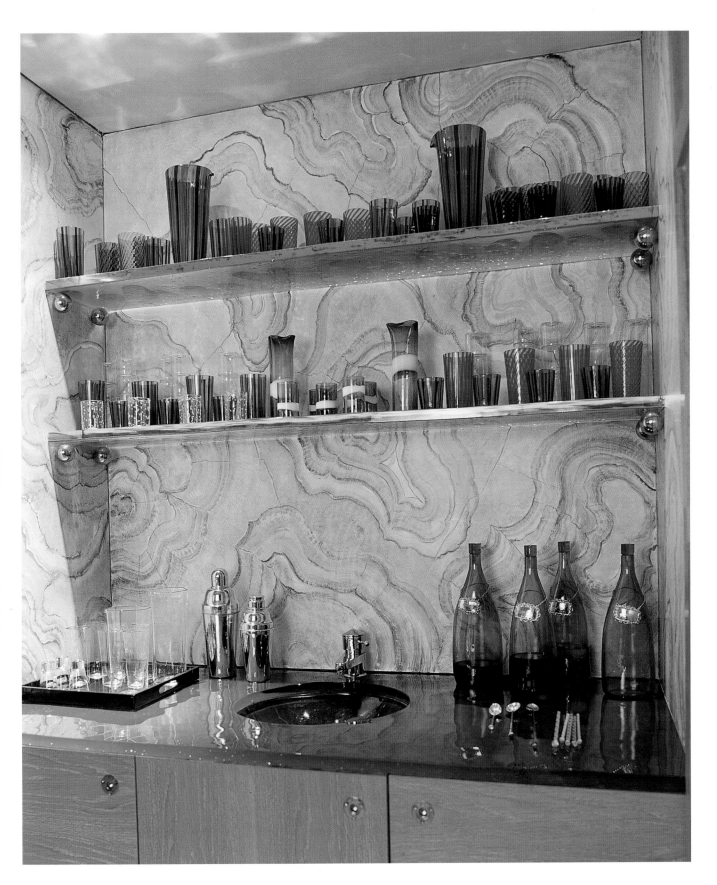

THE BOOK-MATCHED elm shutters are here shown closed (*left*). The wooden grille hides the radiators strategically placed at each French window.

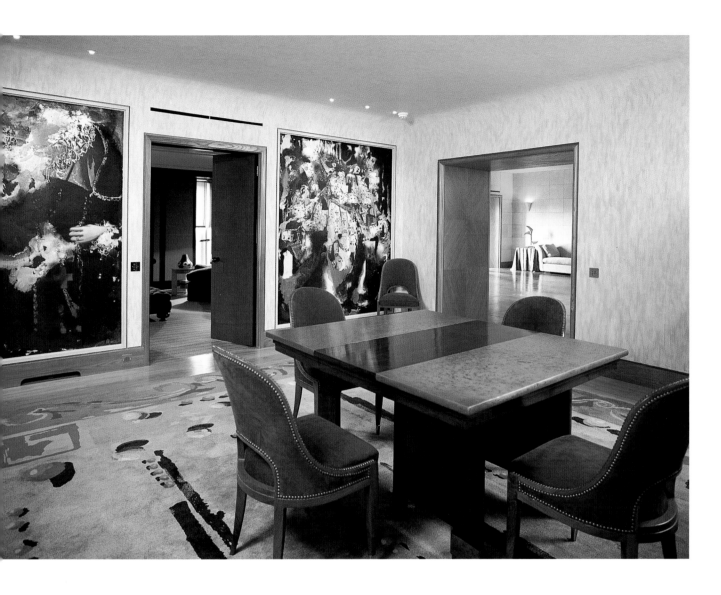

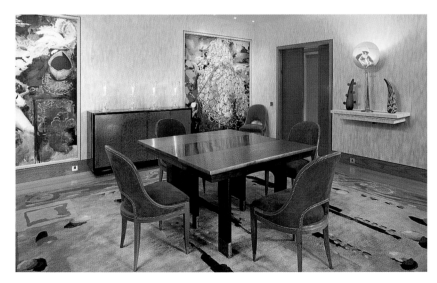

THE DINING ROOM contains 1920s furniture; the table and sideboard by Eugene Printz (*top and left*). The dining chairs are by Emile Ruhlmann. There is no cornice and the walls are painted to set off the four paintings. The carpet was commissioned from Stephen Farthing. The glass sculptures are by Emmanuel Babled and the JS light was specially made for the room.

THE STUDY bookshelves are made of wenge wood, the grained panels arranged in alternating directions (*left and below*). The shelves are lined in red felt.

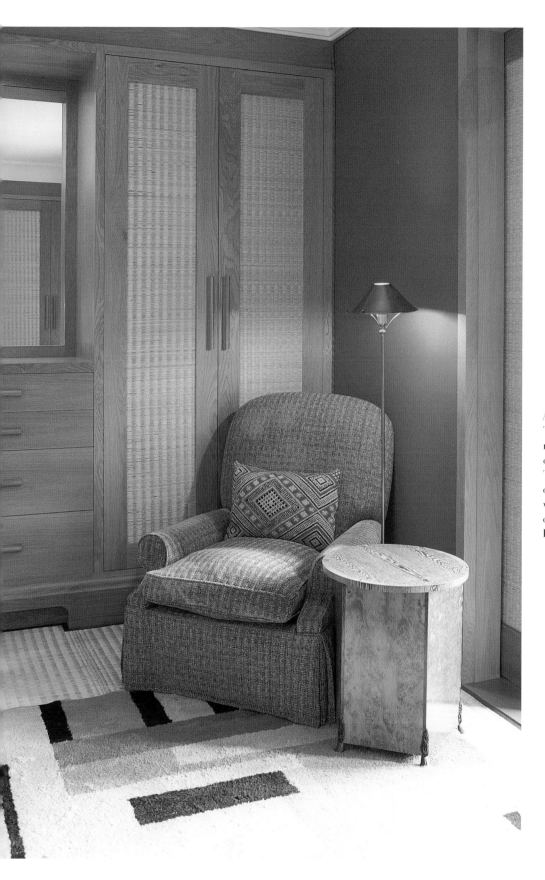

A CORNER OF a bedroom (*left*).
The wood is oak and tatami
matting is used as panels on the
cupboards and also on the floor.
The rug is 1930s by an unknown
designer. The JS table, made of
wenge and burr walnut, has metal
claw feet; the chair is a JS
Beistegui.

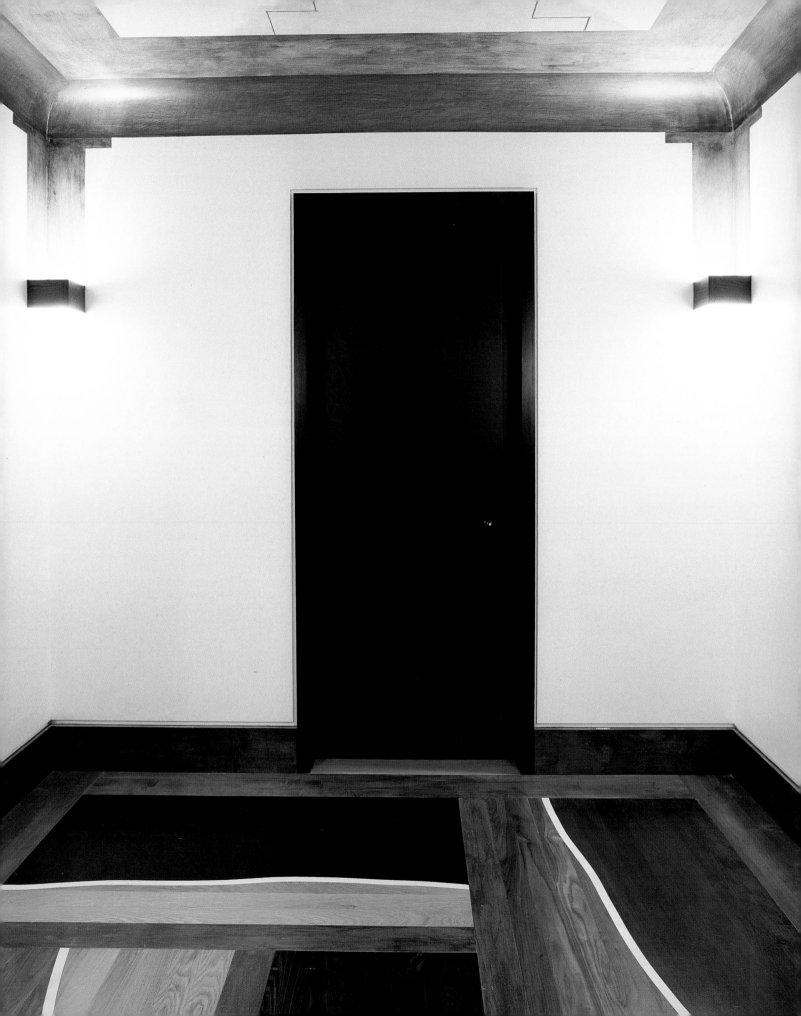

THE LOBBY TO the master bedroom and bathroom (*left*). David Tremlett was given this space to make a composition. The floor is to his design and made in various coloured woods; the ceiling and walls are painted. The work is called 'Eritrea', which is written in small metal letters on the skirting board.

A COAT CUPBOARD off the entrance lobby (*right*). A mirror on faux 'snow leopard'.

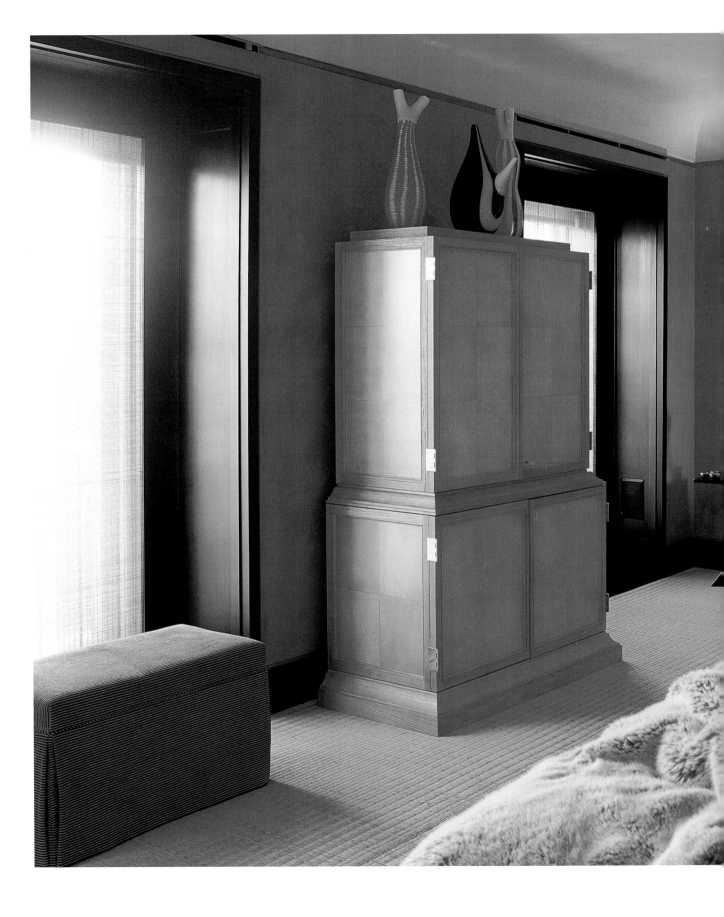

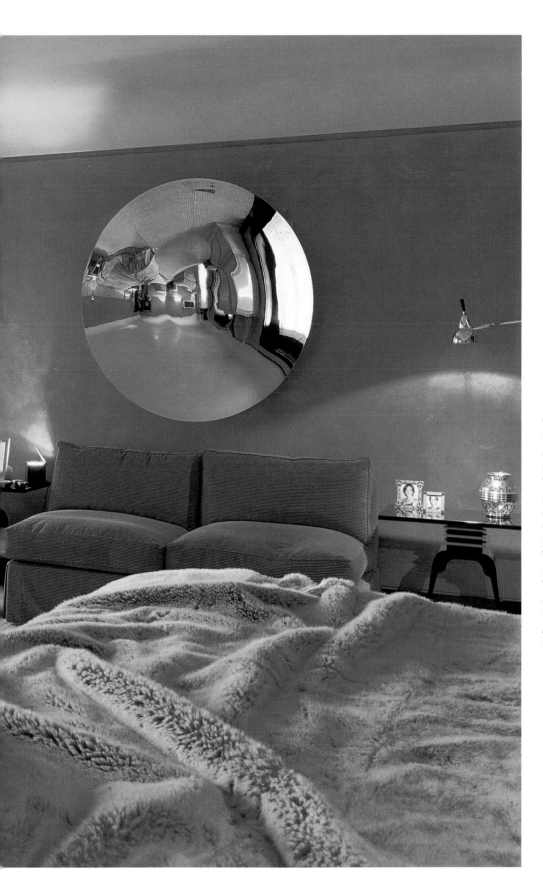

THE MASTER BEDROOM
windows are shielded by
electrically controlled pinoleum
straw blinds as well as shutters.
The two cabinets – JS designed –
are painted to look like shagreen;
one of them contains a television.
On top of the cabinets are various
pieces of modern, gourd-shaped
Venetian glass. The matting is
tatami; the bedcover fake fox.
The tables either side of the sofa
date from the 1920s – designer
unknown. The circular sculpture is
Anish Kapoor. The walls are dark
peony pink polished plaster.

73

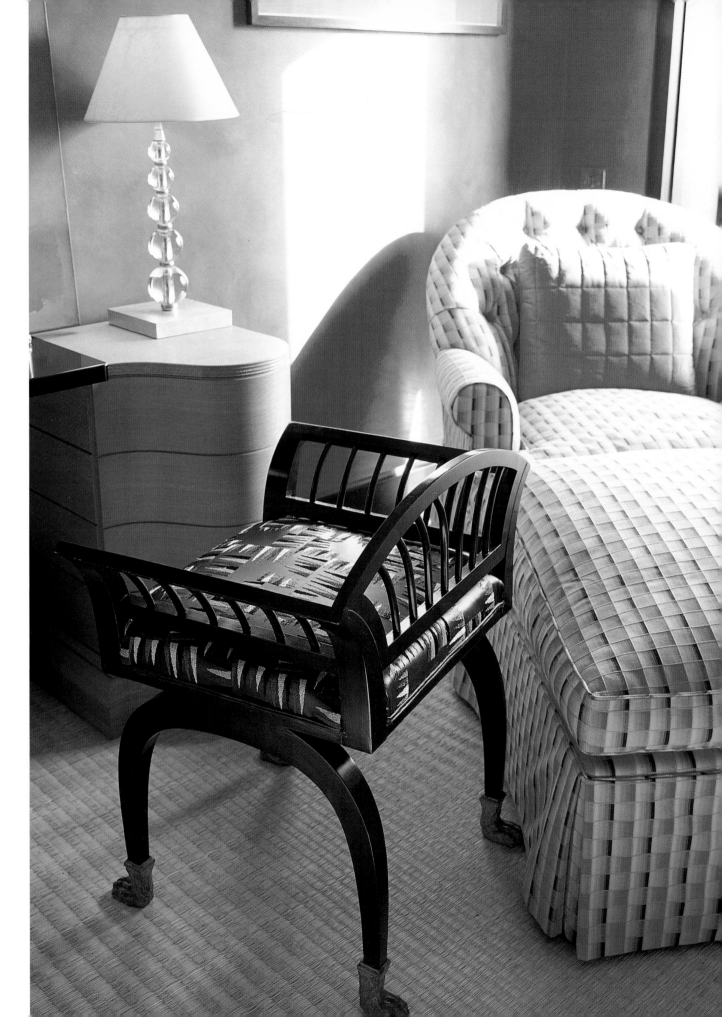

THE MASTER BATHROOM
wash basin is carved out of stone
(*left*). Floor and walls are in the
same Serpegiante marble.

IN THIS CORNER of the master
bedroom (*left*) stands a JS-
designed dressing table and an
Austrian 1910 chair – the seat is
covered in embroidered leather.
The chaise longue cushion is
quilted in rectangles.

ANOTHER BATHROOM has a carved limestone basin, lacewood panelling and walls in Cornish cream gloss paint (*left*). The mirror is lit from behind and has cupboards on either side.

IN THE GUEST BATHROOM is a carved basin in blue pearl granite (*above*). The *verre egglomisé* panels in incandescent blue, pyrrolo red and flickers of gold are edged in gilt frames.

THE SHOWER belonging to another bathroom is grey terrazzo with the panels edged in stainless steel (*right*).

77

ELDON

a sporting estate in the English country

CARVED DORIC PILASTERS rise to the full height of the façade of this honey-coloured, 18th-century stone house to give it a certain grandeur. The garden side is equally handsome with stone steps leading to a sloping garden and a lake below. Cascading all around is English countryside at its most romantic – a rural idyll in the depths of Herefordshire.

Eldon's interior is Regency, but its restrained details exhibit none of the Prince Regent's flamboyance. Originally, the house had three staircases; it now has four and an elevator. The Regency additions somehow excluded a separate passage or hall so that from the entrance hall it was necessary to go through the dining room or small sitting room to reach the kitchen wing, itself an addition. This idiosyncrasy remains and proves perfectly comfortable.

The rooms are well-proportioned but not large, with the exception of the entrance hall which now also happily serves as a sitting room. There was a large tall room – the remains of a neglected Roman Catholic chapel with a gaping hole leading to the stable yard – which housed a tractor or two. The land was neglected; the shooting in decline.

ELDON'S FRONT DRIVE leads up to the house with its grand but friendly face (*left*).

THE PASSAGE (*above*) leading from the hall to the main staircase – see page 81.

79

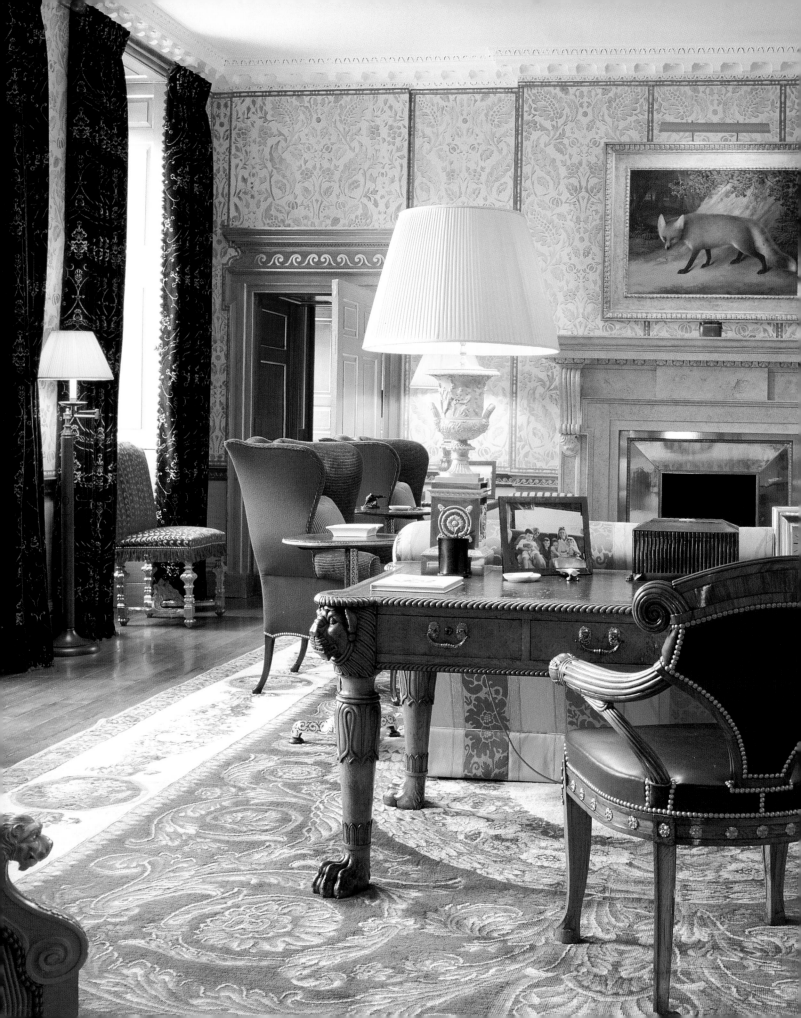

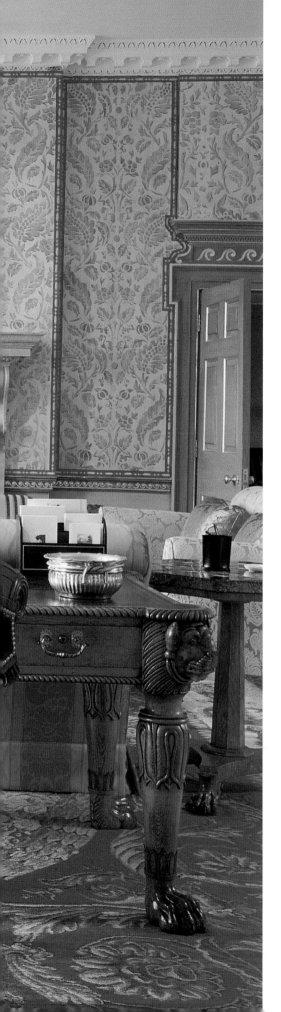

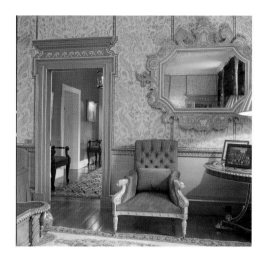

THE HALL had swathes of very indifferent plasterwork now invisible behind stencilled panels (*left*). Curtains are of bark brown cut-velvet woven in Venice – as they would have been in the 17th century – and lined in scarlet. The fireplace is made of wood painted to look like fossilized stone.

SICILIAN MIRRORS flank the door leading to the library and main staircase (*right*). They harmonize with the ochre and raw umber colours of the stencilling.

It was decided at purchase that the stonework of the house would be repointed, the garden tended, its walled garden resuscitated, and the woods and copses pruned and re-planted. The house was to have a prime shoot and all would be as orderly as the family who built the house might have wished. All came to pass and more, with the skilled and professional assistance of Donald Insall Associates for the building and Elisabeth Banks Associates for the garden and landscaping.

Our role was to be busybodies – which is not unusual. We were to attend all meetings, design all but one of the bathrooms and interpret the needs of a client we knew well or, should I say, well enough.

There was a problem – the bedrooms. The Eldon estate had houses for a gardener and head keeper; house staff could be accommodated in the stable block. There were five bedrooms on the first floor of the main house – bathrooms did not matter since new ones had to be put in even if one straddled a secondary staircase. The top attic floor, despite another six rooms, had no plumbing – it had last been inhabited by Victorian domestics. Again this did not matter. Some of the rooms had

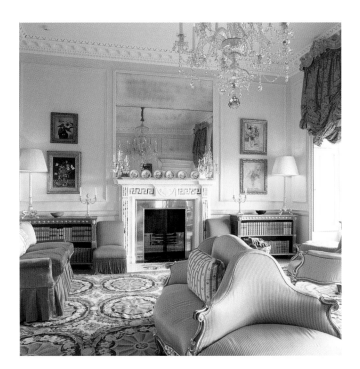

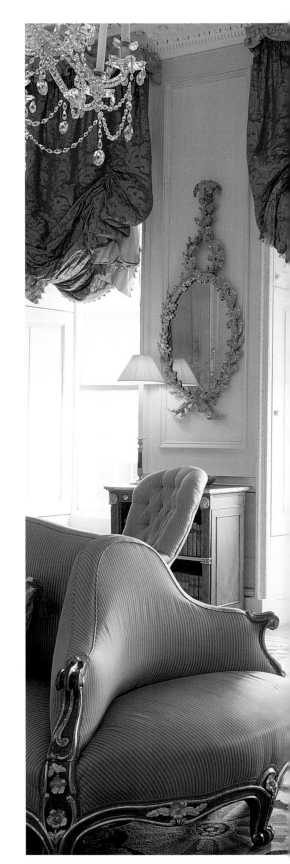

82 charmingly shaped windows and small but happy proportions. The trouble was that the windows were too high and you could not see out. The solution was to raise the floor. Steps lead to each of the rooms or there are platforms that lead into the bathrooms; this instigated a difference in style and atmosphere in the decoration of the bedrooms which also required the commodities expected of contemporary life.

With zest, vigour and American enthusiasm the work started under the highly experienced eye of a New York Tartar: organizational pressure was brought to bear, craftsmen summoned, drop-dead dates met. The house was finished, nearly. One day a great debate took place – could the house be occupied within a week? Transatlantic telephone calls were made, and with much trepidation and a huge effort the owners had their first shooting party. The guests had a grand time. Afterwards, the stage-set returned to a building site and all was soon finished. The house, in its restrained opulence, was ready to receive family and friends. From start to finish, it had taken just eight months.

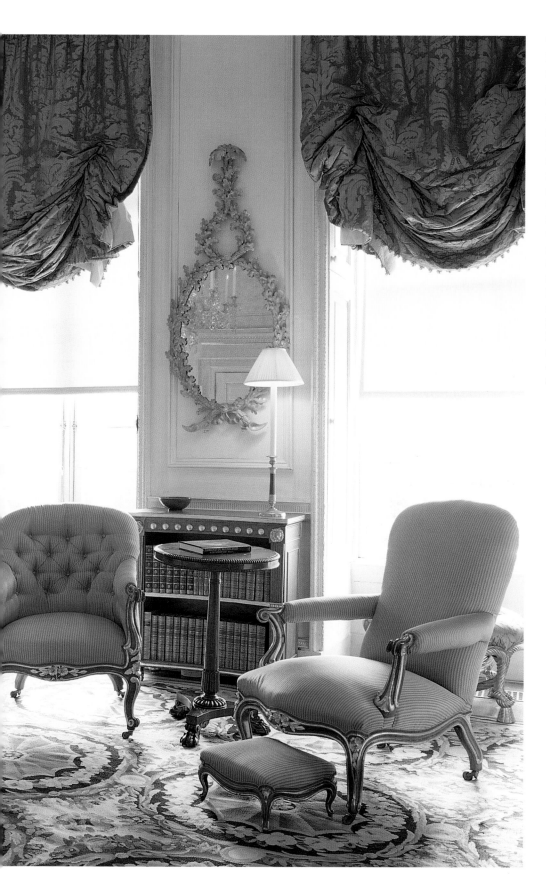

THE DRAWING ROOM (*left*) has triple windows overlooking the garden (*left*). An 18th-century chandelier holds centre stage and the fireplace (*far left*), which is original to the house, is of the same period. The parcel-gilt bookcases were made for the room. They stand to the left and right of the fireplace and either side of the central French window that leads to a terrace and steps to the garden. Above the French window bookcases hang a pair of late 18th-century gilt-wood mirrors. The armchairs, stool and conversation piece are part of the Louis XV-style parcel-gilt set and are all covered in the same silk – plum pink with fine Eisenhower-brown stripes. The French 19th-century carpet has an 18th-century design. The walls are a dragged caramel colour.

THE 18TH-CENTURY panelled anteroom to the dining room is painted cerulean blue with an unlined pull-up blind in cobalt-blue silk (*left*). The early 18th-century gilt-wood side chair has its original vermilion red covering.

A ROOM FOR COATS off the passage from the hall (*right*). The JS-designed cupboards are in parcel-gilt with pleated green silk behind the doors. A 19th-century Swedish chair is covered in a green and white stripe. The walls are painted a clear pistachio. The emerald silk pull-up blind is lined in red. Above the George I gilt-gesso side table hangs a George I gilt mirror.

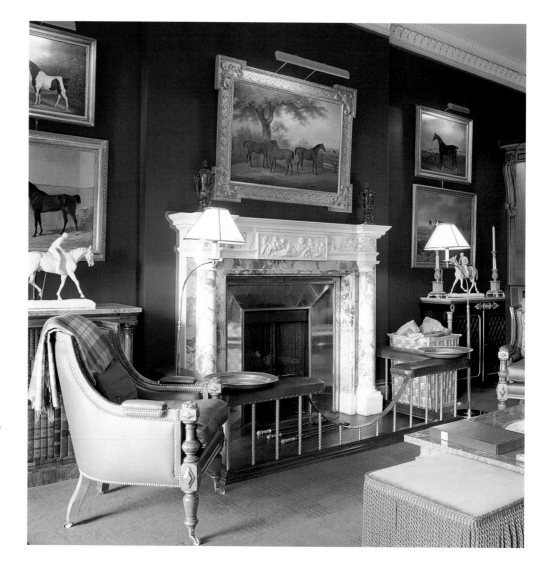

86

THE IRISH MARBLE fireplace, dating from the late 18th century, is surrounded by horse paintings (*right*). The fireplace has a stainless steel register grate; and the club fender with its dip does not obscure the fire. The 19th-century chairs are covered in sap green leather. The standing brass lights have parchment shades.

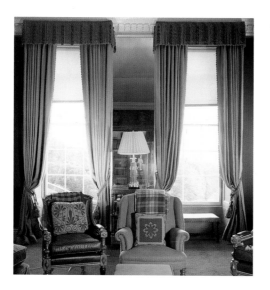

A PAIR OF WINDOWS has silk linen curtains (*left*). The pelmets are fringes of red and green passementerie and there are tassels to match on the ropes holding back the curtains. The space between the windows is faced with antique mirrored glass.

GREEK VASES stand atop the Regency bookcases (*right*). The appliqué beige felt cushion – one of several in the room – has a neo-classical honeysuckle design. Stools, adorned with fringes from the very top, stand either side of a marble inlay table. The walls are covered in brown broadcloth and the floor with a red and green tartan carpet that was woven for the room.

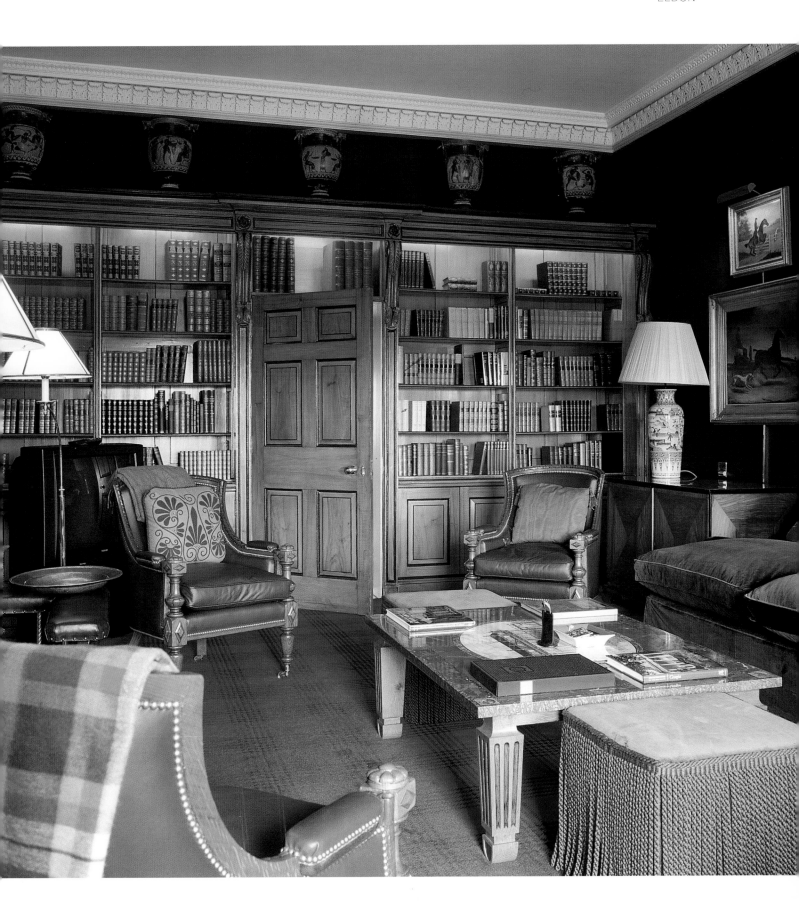

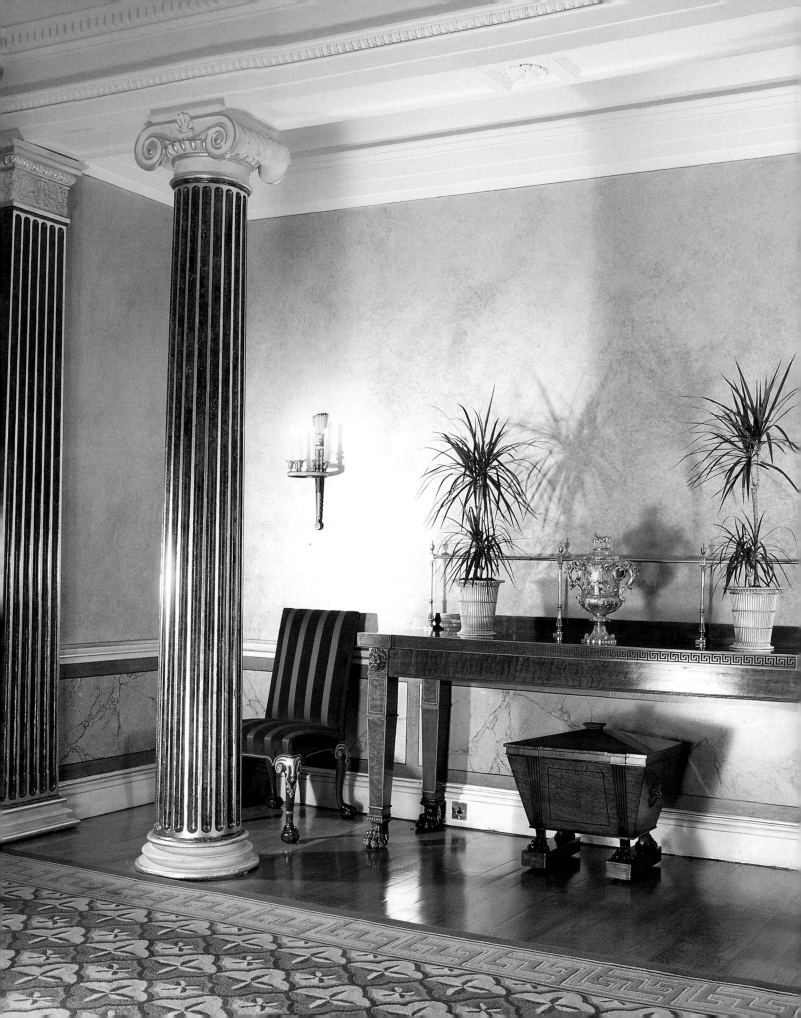

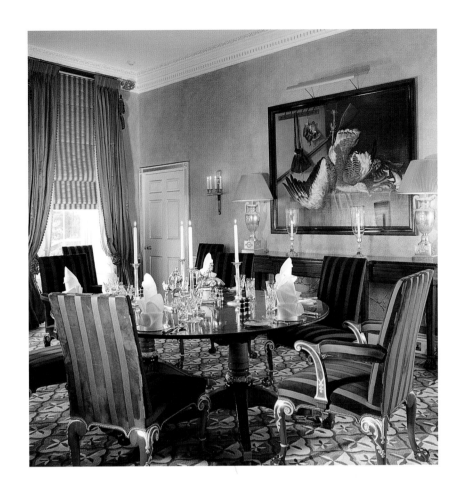

THE DINING ROOM (*left and above*) appeared somewhat dingy and it was decided to paint it in myriad blues. The alcove (*left*) now contains a plain, handsome sideboard – the pine doric columns and pilasters were gilded and painted to simulate lapis lazuli. The blue, yellow and black rug was made for the room to a design inspired by Emilio Terry.

The parcel-gilt chairs, also made for the room, are covered with a wide satin stripe in saxon blue. The intense blue silk curtains hang on poles with neo-classical finials. Beneath them are folding Roman blinds of yellow and blue horsehair. The cornflower blue walls are stippled and below the dado rail are marbled pale blue panels framed in cobalt.

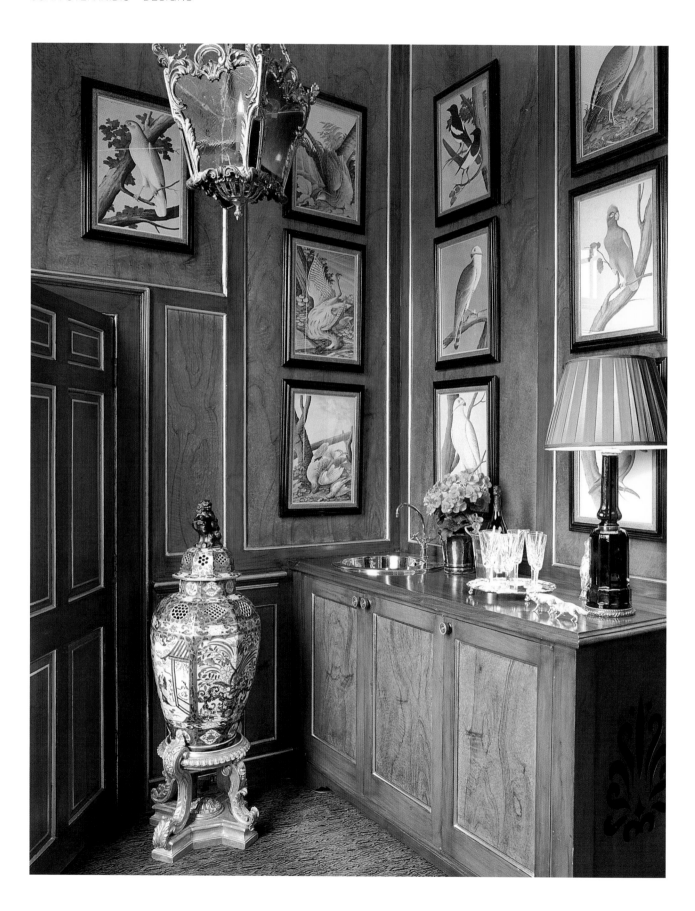

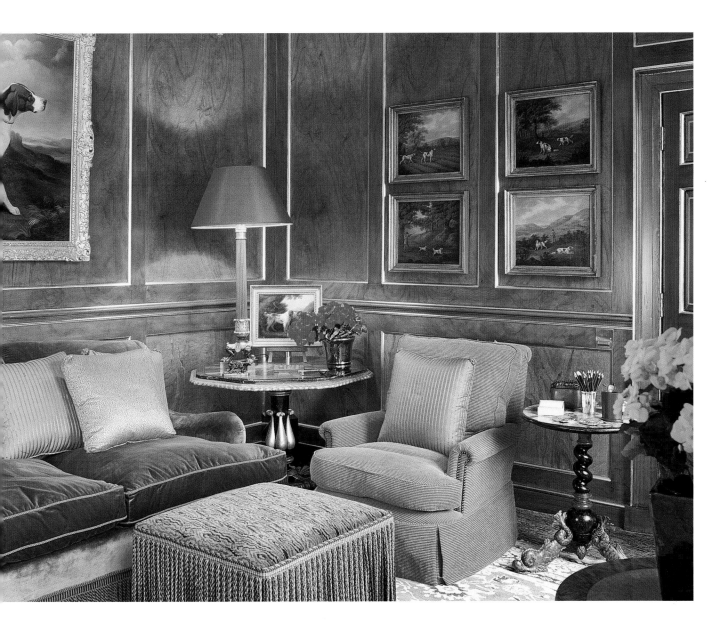

AN ANTEROOM is painted to imitate walnut wood and gilded (*left*). The sideboard serves as a bar; hanging above is a collection of 17th-century German watercolours of birds. An Imari 18th-century vase sits on a wooden gilt stand. The fitted carpet has a green and black wood pattern. This room, continuing the decorative scheme of the cigar room (*above*), leads to a back staircase.

SMALL AND INTIMATE, this room is mainly for talking and smoking cigars (*above*). There are two windows overlooking the front of the house. The hard top of the fringed ottoman is covered in the same carpet as lies under the 19th-century Ziegler rug. The table with dolphin feet to the right is Italian Regency. Sporting pictures hang on the walls.

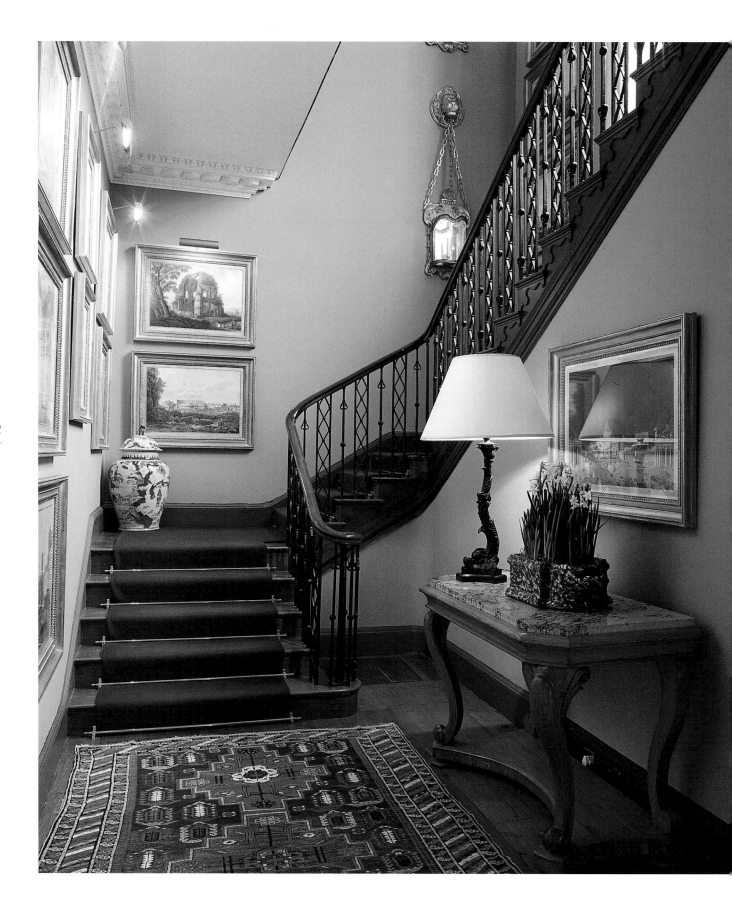

THE STAIRCASE HALL and stairwell is painted bright Adriatic blue (*left*). The staircase, of a sober Regency design, climbs to the first floor past a Palladian window. The runner is bright blue thick felt held in place by brass stair rods. A series of 19th-century views of Italy hang on the walls.

NEO-CLASSICAL prints taken from vases from the collection of Sir William Hamilton – husband of Emma. They hang floor to ceiling on the landing and along the first floor bedroom passage (*above and left*). All are mounted in strong black and gold frames.

MORE ITALIAN landscapes and a wall light inspired by a William Kent design (*below*).

93

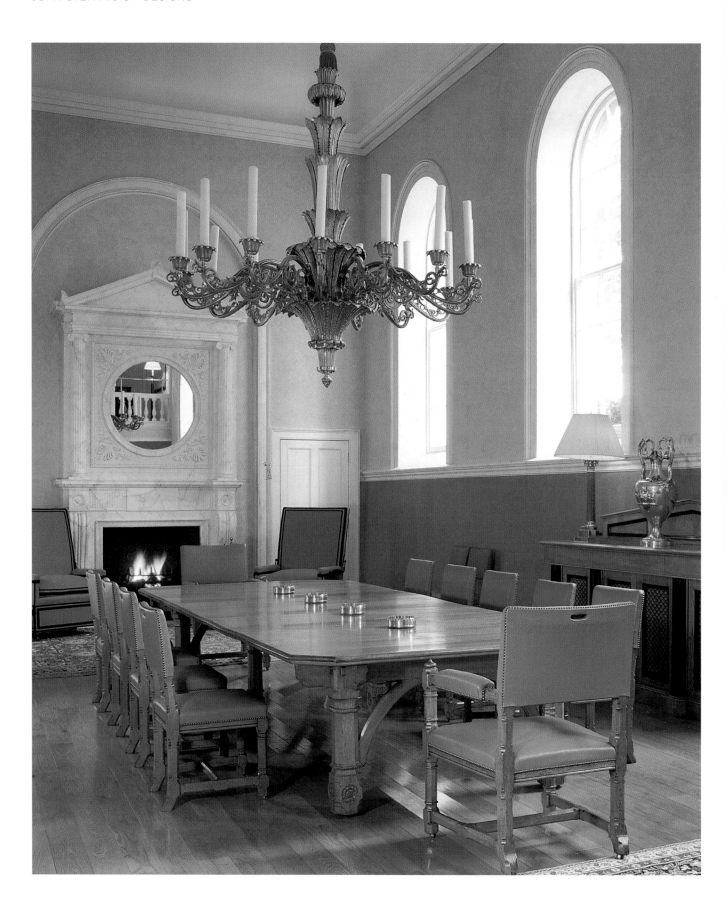

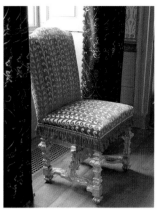

A GILT-WOOD CHAIR dating from the early 18th century stands under a window in the hall (*above*). The chair is covered in raised velvet in two different reds.

ON THE ATTIC FLOOR, a corner of the Michelangelo bedroom (*below*) – so called because of its steps and balustrade, a tongue-in-cheek reference to the Laurentian library in Florence. The platform, as in other rooms, gives you the pleasure of a view from the high windows and leads to a commodious bathroom with a decorative Mannerist nudge.

IN A SEPARATE BUILDING, the shooting dining room (*left*) has access to the stable yard and its own kitchen and pantry. This building is connected by a gallery and a new, most generous circular staircase to the main house. Once the chapel built by the original Catholic owners, there is no trace of its ecclesiastical past. In place of the altar, it now has a dignified chimney painted to simulate veined white marble. The chairs flanking the fireplace are re-upholstered in beige with black trimmings designed for the Château de Groussay – by Emilio Terry no doubt.

THE LARGE KITCHEN now has a roof light (*above*). The table and chairs are by JS and can seat up to twelve people for breakfast.

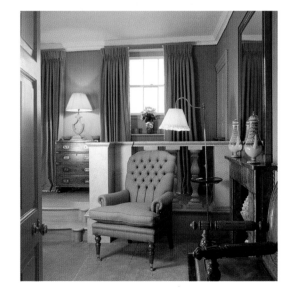

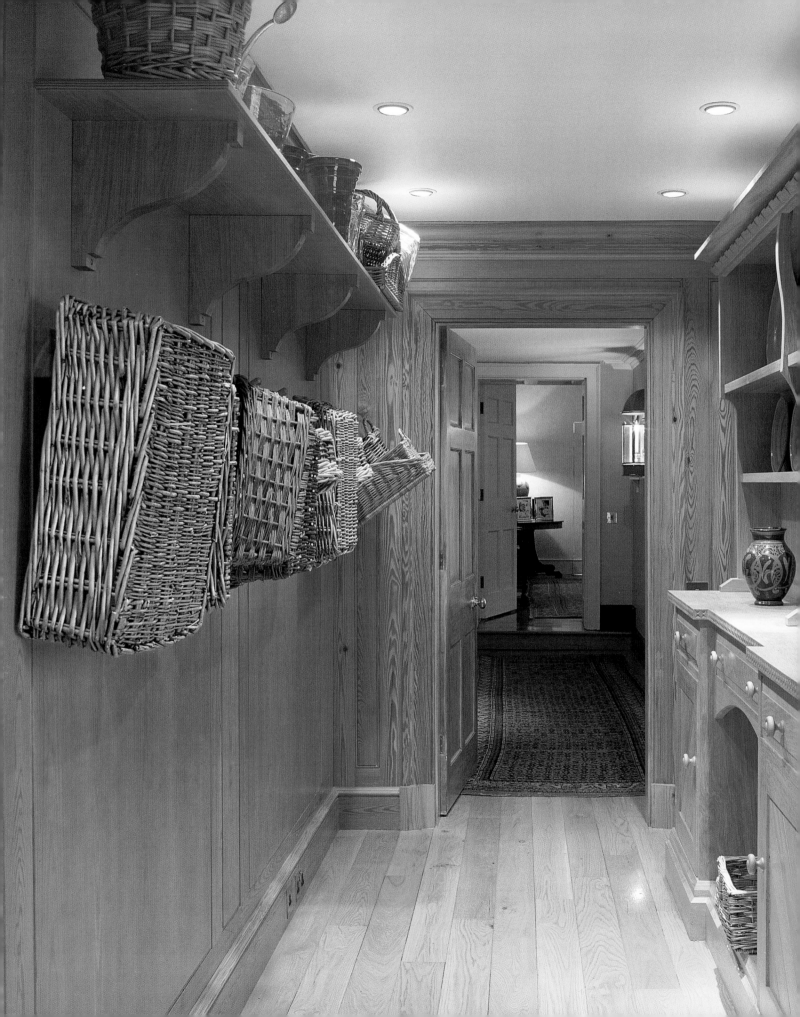

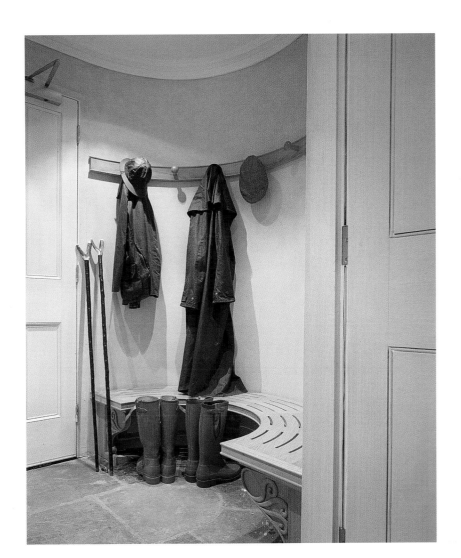

A SHORT PASSAGE from the
kitchen (see page 95) contains
a generous Welsh dresser (*left*).
There is a plentiful supply of
round baskets for use as cachepots
and for gathering produce from
the abundant walled garden.

THIS CIRCULAR ROOM with its
oak bench (*above*) is a place for
sportsmen to take off their boots
before going into a shooting lunch.

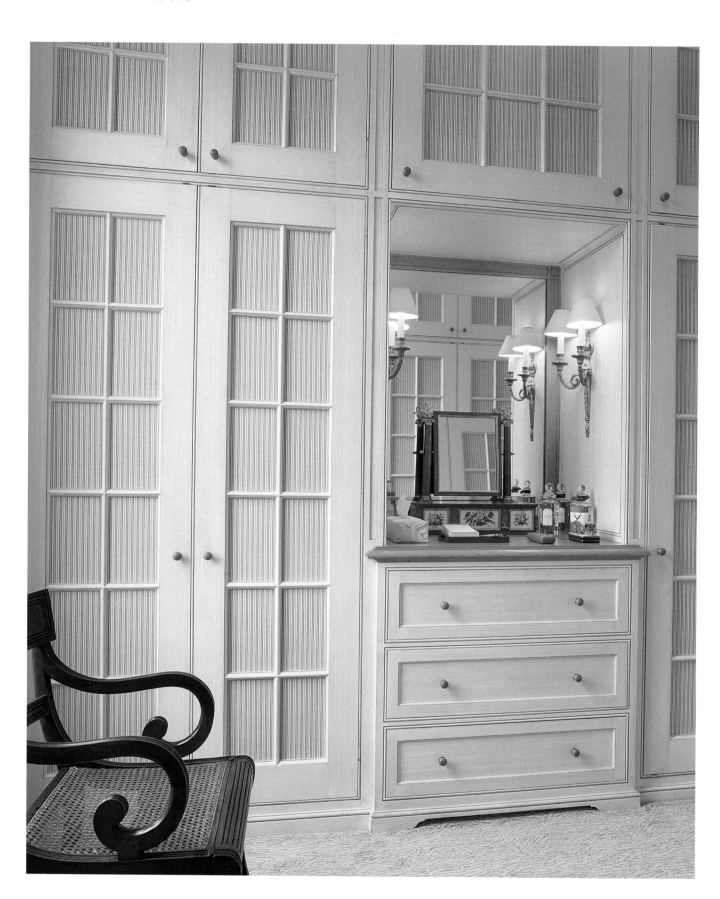

THE DRESSING ROOM off the master bedroom has cupboard fronts lined with striped fabric (*left*). A chest of drawers is incorporated into the storage system – ample space for everything.

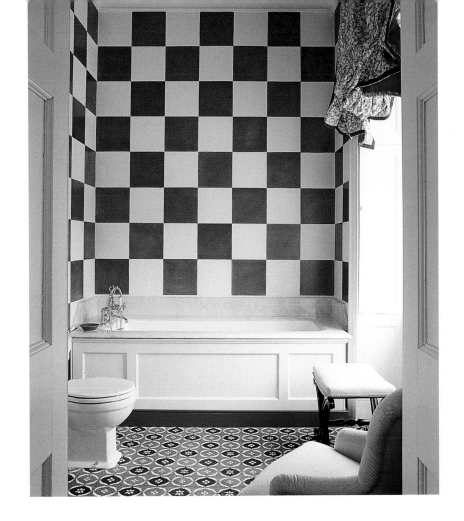

THE BLUE BEDROOM has Japanese-inspired JS fabrics on the walls and for the curtains (*right*). The bed has a shaped tester on buckram with closely gathered JS fabric behind.

A BATHROOM off the blue bedroom has painted squares of blue and white, also Japanese in influence (*above right*).

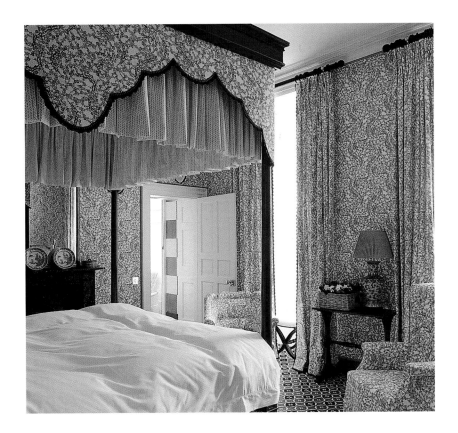

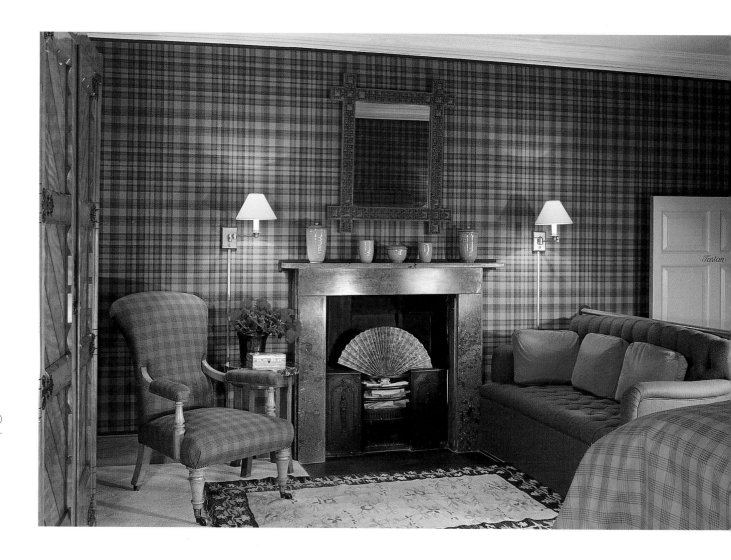

THIS ATTIC ROOM has a raised floor – note the balustrade behind the small sofa – to allow you to see out of the windows (*above*). The furniture is oak; the sofa is covered in baize and the armchair in a blue and grey check. On the walls is a subdued tartan. The rug is 19th-century Bessarabian. The sober grey stone fireplace is original to the room.

ANOTHER ATTIC ROOM has a JS cupboard with blue panels framed in faux burr wood (*left*). The walls are hung in a deep blue check wool. The oak armchairs are 19th-century Gothic.

THE FOUR-POSTER in the master bedroom was specially made tall and wide (*right*). Three different rose patterns are used in the room. The rug is Pontremoli needlework.

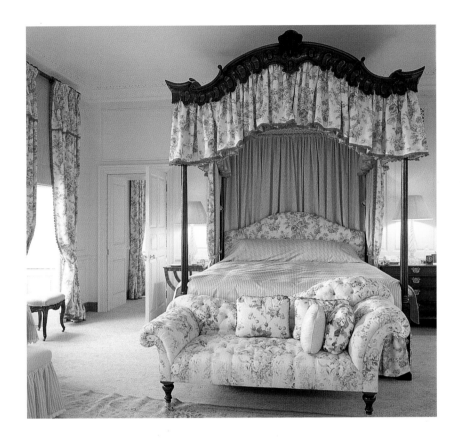

THE COUNTRY ROOM – each of the attic rooms has its name painted on the door – is somewhat sophisticated in its simplicity (*right*). The balustrade in the foreground is dragged white and cream, as is a cupboard (not visible). The walls are dragged white or bright candy pink. The curtains are white embroidered voile on pink chintz. The bed hangings are made of white organza trimmed with fan edging. Pink chintz erupts in flounces on the curtains at the back. The dressing table is covered in a green and white checked acetate fabric. The carpet is acid green, bright madder and rose pink with a lily-of-the-valley trellis – the design taken from a Regency archive.

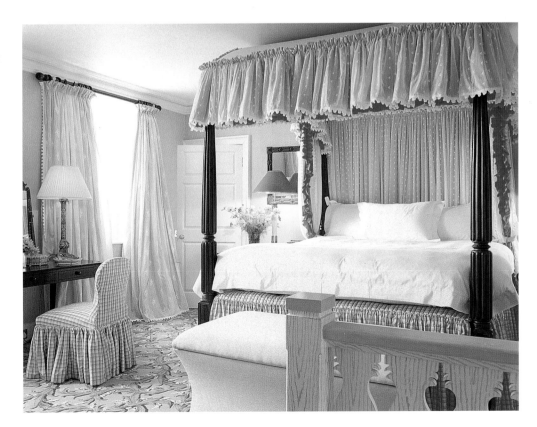

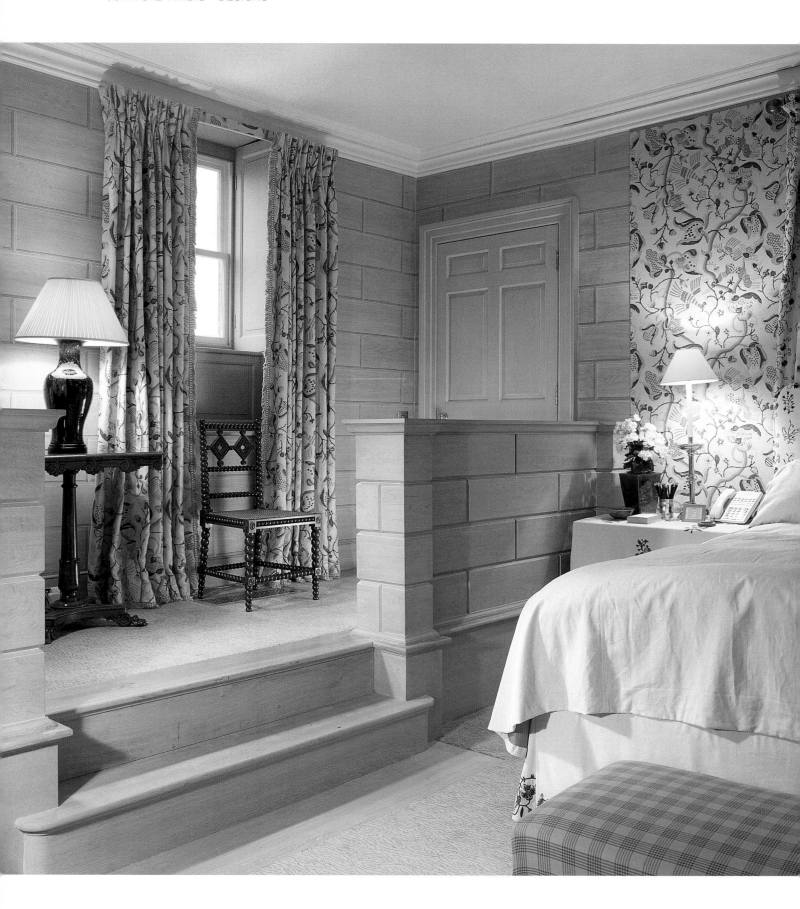

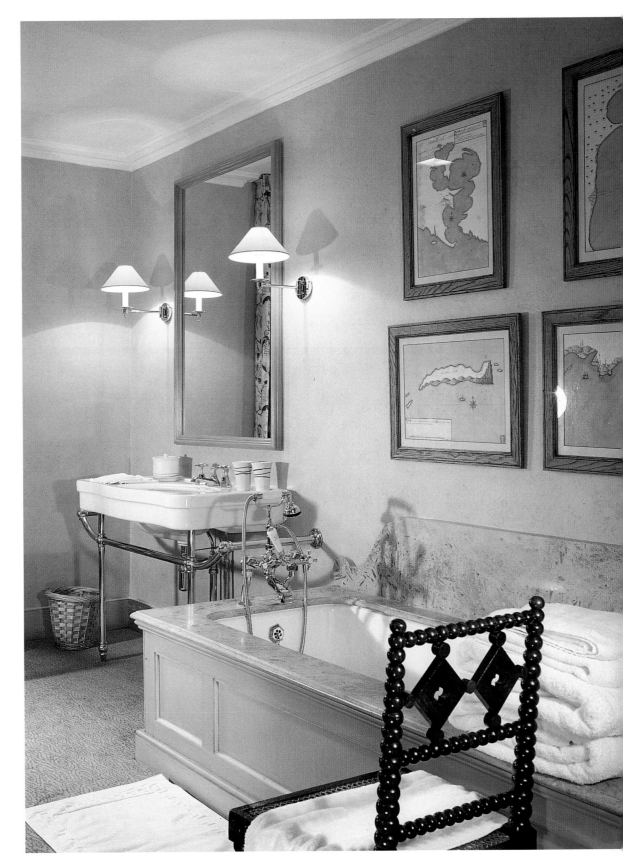

A BEDROOM known as the Elizabethan room because of its crewel-work curtains and fabric in a design of the same period (*left*). The room has rusticated walls, and oak steps which lead to a platform where you can see out of the windows en route to the bathroom (*right*).

BATHROOMS throughout the house have been kept simple: free-standing basins, hand-showers in the baths and no separate shower areas (*right*). There are cupboards and sometimes armchairs. Pictures on the wall are relevant to the theme of the room – in this particular room, 17th-century maps.

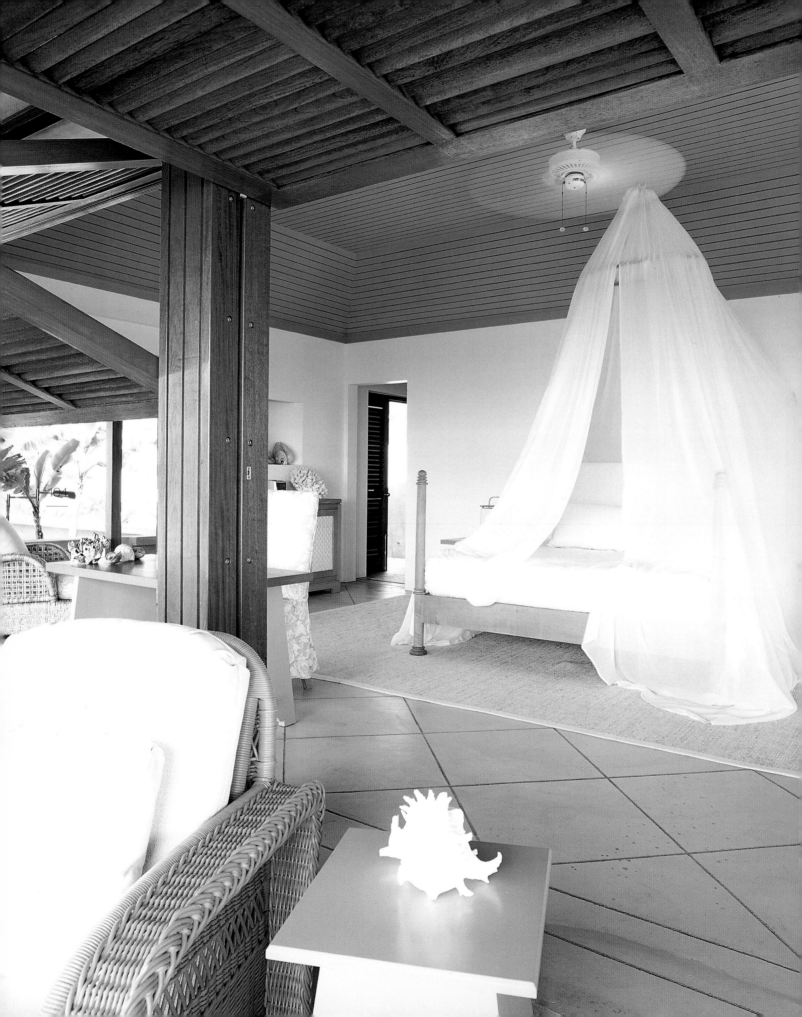

MUSTIQUE
a house in the Caribbean

THE SCORED PLASTER floors in this room (*left*) were introduced on the island by Oliver Messel. In the foreground is a JS cane chair with seat cushions in waterproof fabric and frogging with toggle fasteners – a feature of cushions in this house. The Patmos table next to the chair is painted Mediterranean blue. The shutters above are counter-balanced – they slide vertically and effortlessly. The bed, chest of drawers and table are all JS. The tray ceiling is painted French blue and the walls are chalk white. Beige matting on the floor is from Cogolin in the South of France. The house overlooks Macaroni Beach (*above*).

FOR OVER TWO DECADES, thanks to the West Indies' very own Prospero, I have been a visitor to Mustique, one of the Caribbean's most beguiling of islands, for sun-drenched holidays and parties that lasted several days, rivalling those given by Prince Grigori Potemkin in St Petersburg at the court of Catherine II. The memory of the excitement and wonder engendered by our host – the island's owner – makes the heart beat faster even now. I was also called in to advise on the first Great House, but conscientiously refused since the design was by the charming and talented Oliver Messel, who gave the island its first architectural vernacular. With his demise, the house was left unfinished. Inspired by Eugène Delacroix watercolours, the owner and I, with moguls breathing down our backs, improvised on site with the builders. We had a lot of fun.

Years later there was talk of a house on Mustique overlooking the glamorous Macaroni Bay on the island's windward side. The client chose the Toronto architectural firm of A J Diamond, Donald Schmitt & Co. The senior partner, Jack Diamond, an Oxford friend, and I had talked about cooperating on a project for years; somehow this only happened in

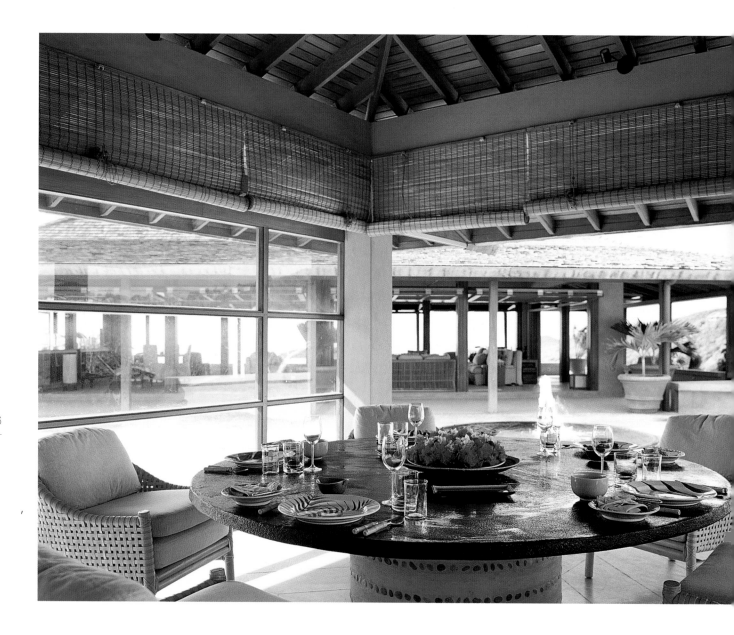

106

1998 when I was asked to design furniture and to be responsible for all the interior fittings to accommodate comfortably an extended family, friends and children.

The house was to have five bedrooms: two master bedrooms, a guest room, a room with twin beds and another room filled with bunks. The design would also include a living room, dining pavilion and a games room – plus a guest pavilion for senior members. (In India it would have been for their senior highnesses.) The result is this

A GLASS SLIDING DOOR disappears entirely into a wall when not needed to protect the pavilion from the prevailing wind (*above*). The pinoleum blinds can be lowered as a *brise soleil*. The table top is made of cement hammered to look like jet black slate. Its base is a cement drum circled with bracelets of pebbles. The cane dining chairs are braided rawhide.

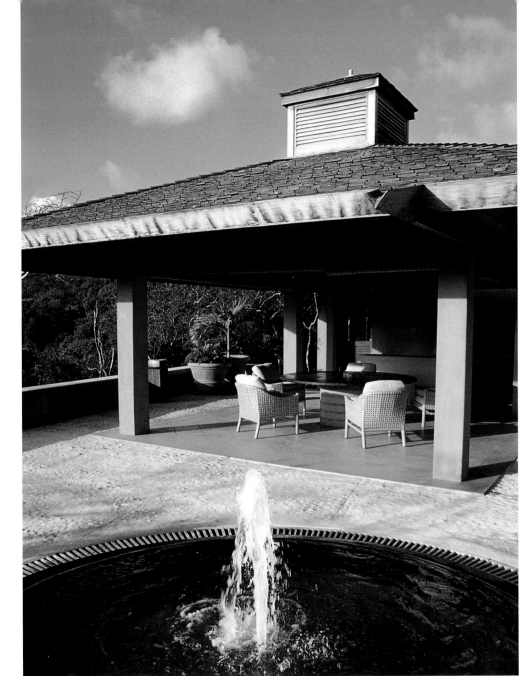

THE DINING PAVILION with its shingle roof (*right*). Beyond are the kitchen and staff quarters. You arrive down a flight of steps (see page 111) into this open courtyard with the dining pavilion at an angle to the living room pavilion. A fountain makes a visual break among the angular buildings.

contemporary house to which you leisurely descend by curved steps from a road. The cedar tile roofs below are not unlike a cluster of pavilions in the East. Nostalgia ends there. The house was designed for the Caribbean climate. The pavilions, felicitously distributed along the contours of the land, are supported by stone walls battered to ground the buildings to the steep landscape.

The living room pavilion is designed and carefully sited to catch the breeze – not the trade winds. It has a steep niched roof with a softer

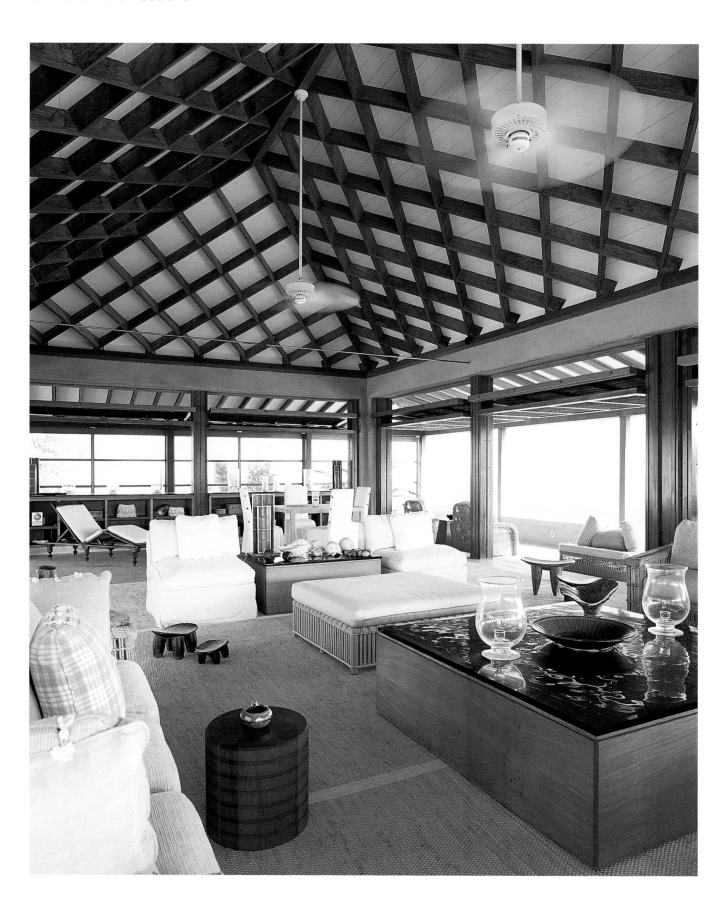

THE LIVING ROOM PAVILION. Glass on the far wall is protection against the wind – the room is otherwise open to the breeze (*left*). The counter-balanced shutters can be raised or lowered at a touch (*right*). The table tops and the shelf stretching across the top of the compartmented open shelving are made of thick emerald-coloured glass. The sofas and armchairs are in cool whites and greys accentuated by pale blue cushions in thick linen – some plain, some check (*above and below*). The stools are African; the low JS tables are teak. The verandah on three sides faces the incomparable Macaroni beach.

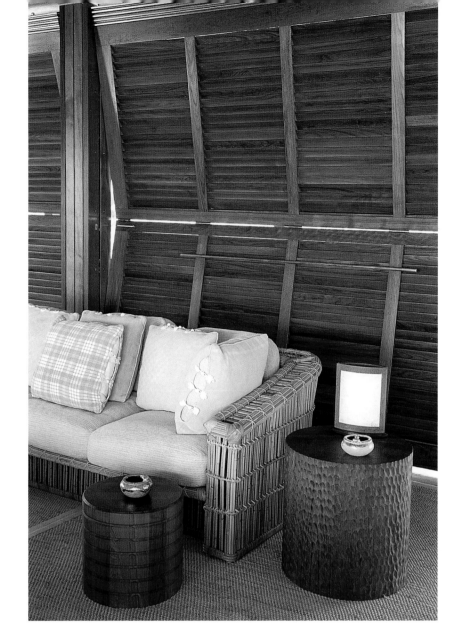

gradient over the verandahs that surround it on all sides – this raises the verandah eaves and breaks the fall of the rain.

The bedrooms all have traditional Caribbean tray ceilings, but thanks to the architect they are ventilated to create natural cooling. The heat escapes through lowered gables.

It is impossible to imagine a more appropriate and distinguished design for such brilliant scenery. The house is beautifully positioned, not too high or too low in the steep terrain of the site. From a distance the building merges into the hillside behind, which is otherwise covered with wild vegetation.

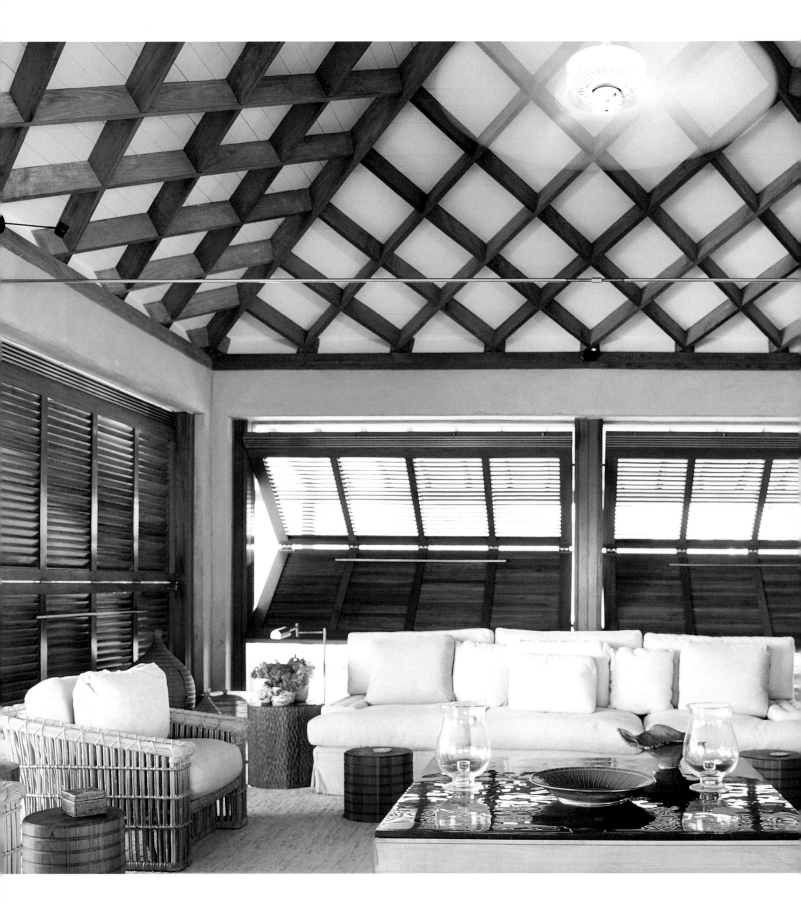

THE CEILING is constructed of intersecting diagonal rafters which create a decorative coffer and give structural strength (*left*). The thick emerald-green glass table top sits on an oak base.

FACING THE BEACH, the verandah (*right*) has plenty of comfortable cane chairs for gazing at the sapphire, aquamarine and turquoise sea with its foaming white horses thundering on white sand.

A MOST SATISFACTORY architectural feature – these walls flank the steps descending from the entrance above as well as a flight of steps to a bedroom verandah (*below*).

111

A BEDROOM in the guest pavilion (*above*) has a window looking onto a grove of banana trees and another looking onto the sea. The cane furniture is deliberately hard edged and simple. The four-poster bed has muslin hangings held with ribbons of the same fabric. The curtains can be let down to act as a mosquito net. The matting is straw.

THE LOBBY of this guest room (*right*) has scored cement floors as elsewhere in the house. The chairs are JS Malcontenta, with tables to match. African gourds sit on shelves on the wall. A rope allows the JS-designed lantern to be raised or lowered. All the furniture is painted terracotta. The tray ceilings are a cool geranium leaf green and the walls white.

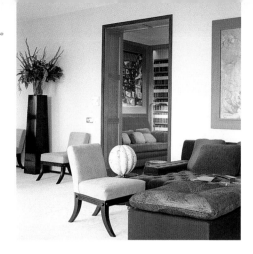

WESTMINSTER
a penthouse in SW1

THE VIEW from the terrace of the Houses of Parliament, Big Ben and the Millennium Wheel (*left*).

IN THE DRAWING ROOM (*above*) is a JS pull-up chair, a velvet sofa and a ceramic gourd. The library can be seen beyond.

THIS APARTMENT IS SO CLOSE to the Houses of Parliament, you might be forgiven for assuming you might sit on the woolsack at the House of Lords one afternoon or submit to the strictures of the Speaker in the House of Commons. At the time these photographs were taken, the House was not sitting, which is why there is no flag flying.

There is an air of tranquillity – you are far above the noise of traffic. Lateral space is a luxury in London, a city of mostly terraced houses and steep staircases. This, however, is not an apartment in the sky – its views are not telescopic but urbane and vital.

The apartment contains three glorious-sized bedrooms; huge walk-in closets as well as cupboards; sybaritic bathrooms lined in marble from which to emerge clean and glistening; a most convenient and streamlined kitchen; a room that can become a dining room with hydraulically controlled tables; a terrace from which to gasp at the River Thames and the views of the metropolis; and plenty of room to entertain your friends or hold official receptions. A sleek, faintly un-English apartment which was a joy to design.

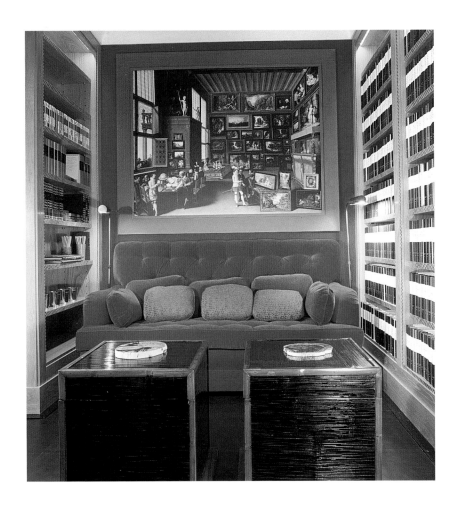

THE LIBRARY off the drawing
room and hall has a sofa covered
in a soft red velvet (*above*). Two
Chinese lacquer boxes are used
as tables. Behind the sofa is a
projected poster image.

A STUDY lined in wenge wood
contains a JS-designed oval desk
with an upholstered pigskin top
and a Taps desk lamp (*right*). By
the desk are two pigskin Charles
Eames swivel chairs. The carpet
is ribbed wool.

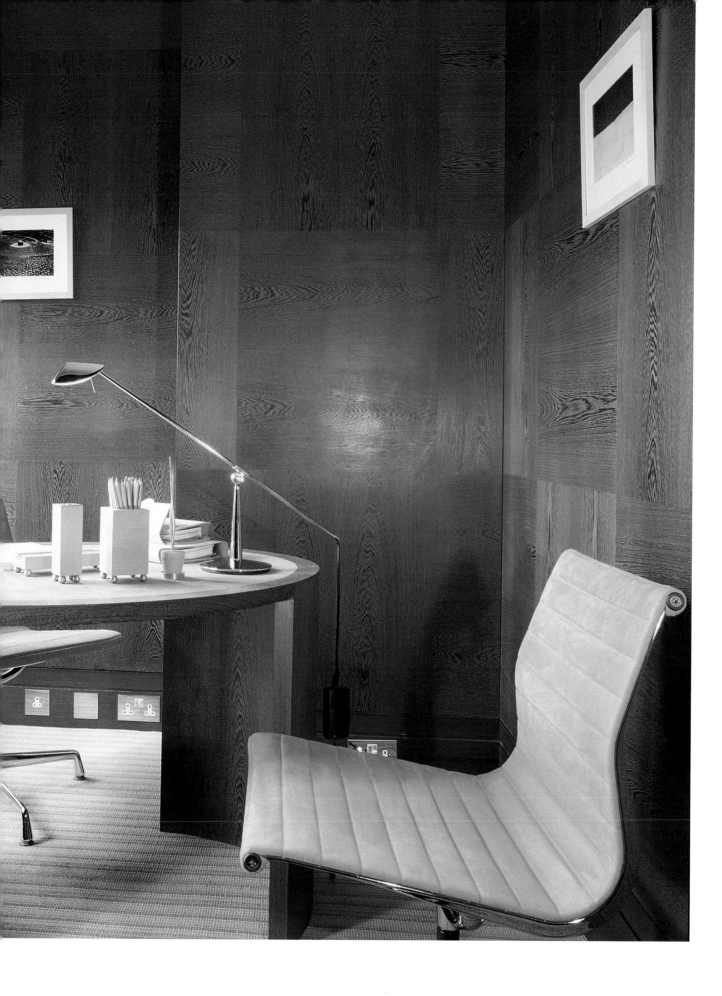

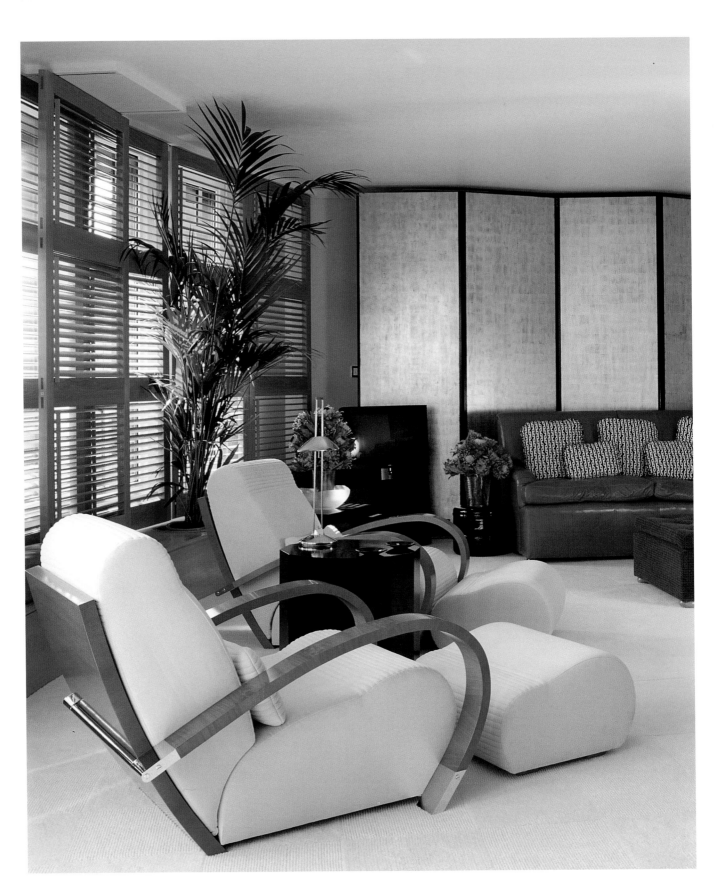

IN THE DRAWING ROOM are two Jaime Tressera armchairs; between them a JS faceted black lacquer table (*left*). Sliding shutters make curtains unnecessary and regulate light from the terrace with its spectacular London views. A full-height gold-leaf screen takes up the end wall of this lozenge-shaped room. A vast sofa is positioned in front of the screen.

THE ENTRANCE HALL features a long shelf protruding from a wall of mirror (*below*). A rectangular wooden umbrella stand is reflected in the mirror and a Venini beaten glass vase sits on the shelf. The floor is made of oak, stained black.

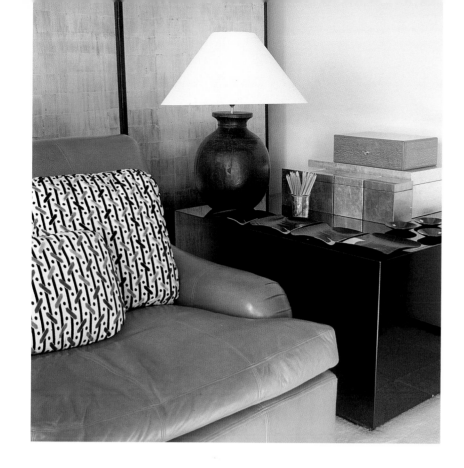

THE SOFA is covered in tan leather (*above*). The cushions are in a 1950s pattern. A black ceramic light with a coolie shade sits on a black lacquer box table.

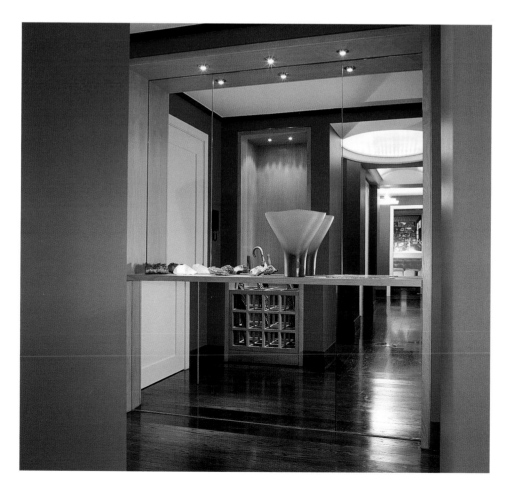

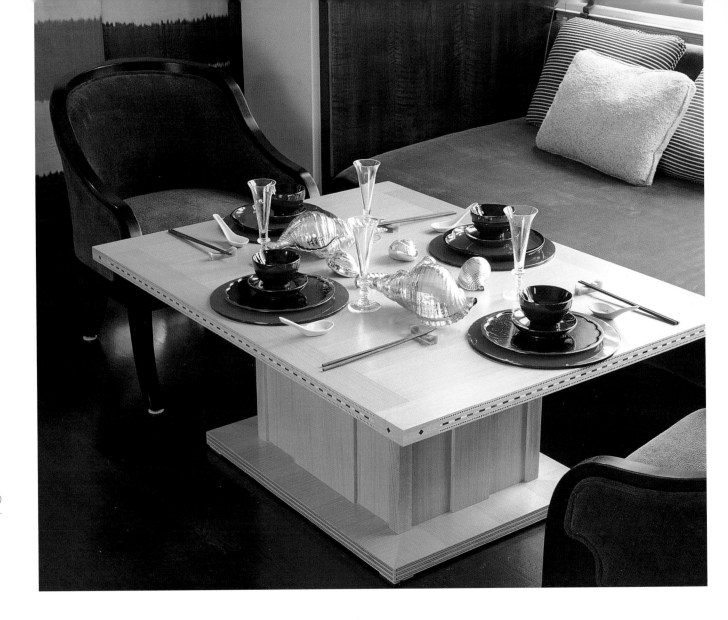

AFRICAN FABRIC of ochre, terracotta and indigo blue is used for wall panels either side of the kitchen door (*right*). The banquette stretches across and fills the alcove.

A DUAL PURPOSE AREA is separated from the drawing room by vast sliding doors (*above*). Although this does not look like a dining room, two low tables are hydraulically controlled so that they can be raised to normal table height for eating. Here the table is set with chopsticks for a Japanese meal. Designed by JS, the oak table has geometrical veneer patterns. The chairs are low enough to lounge in or for sitting at the table when it is adjusted.

A CHROME-BASED TABLE
on wheels with sky blue stools that
can be adjusted up and down sits
close to a window in this simple
but fully equipped kitchen (*left*).
The floor of the kitchen, as in the
hall and dining room, is made of
large squares of plywood, stained
Carmelite brown.

121

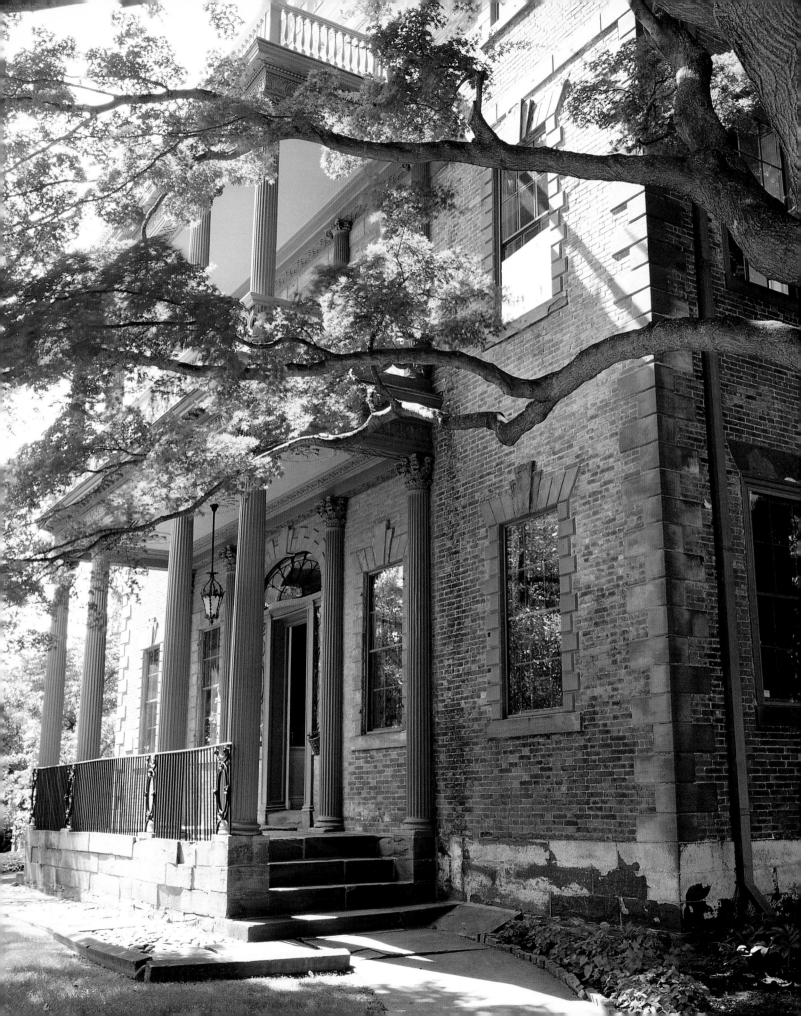

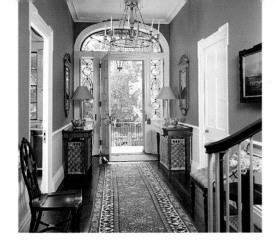

PROVIDENCE

a Federal house in Rhode Island

WITH ITS DARK RED and umber brickwork, the house looks severe at first sight. Closer inspection reveals handsome, rusticated windows and a double-deck porch supported by slender Corinthian columns, all in a deep red sandstone (*left*).

THE ENTRANCE HALL looking towards the front porch (*above*).

IN THE TOWN OF PROVIDENCE, famous for its role in the history of New England and for its trading and whaling industries, are Brown University, the Rhode Island School of Design and street after street of unspoiled and immaculate 19th-century houses. These are from the days of the clipper ships with their cargoes of blue and white china, bolts of nankeen, white, indigo, blue and black silk and cotton – brought from China.

Upon taking this commission, we found to our amazement that no planning permission was needed for this historic house. All was to be done at our discretion – a very New World nuance which meant we had to impose our own historical discipline.

Federal is a chronological rather than stylistic term which stretches from 1789 to 1830. It is the equivalent of English Regency but, inevitably, has an American character. Carrington House was built by a ship's captain of that name in 1811. This handsome, sober and dignified dwelling has views of its garden from windows that are of the same period as the house.

The window frames are rusticated red sandstone; the double-deck porch is made of the same stone supported by Corinthian columns with

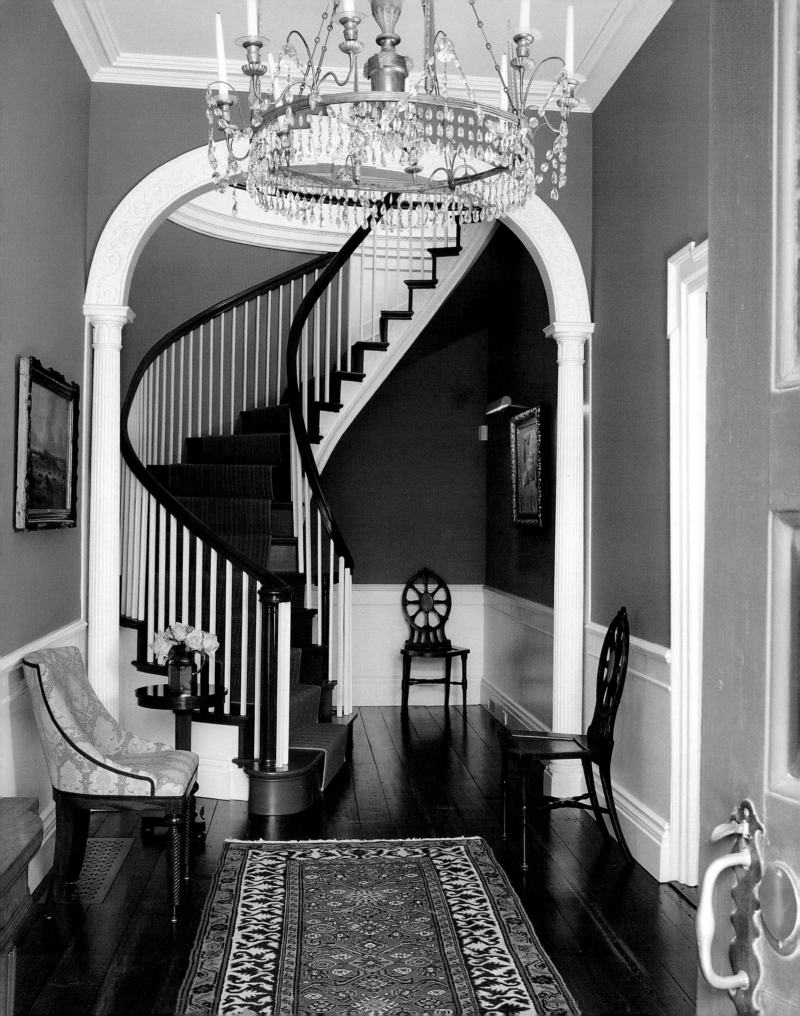

IN THE ENTRANCE HALL, glass in the higher part of the arch blocked the curve of the stairs. We ripped it out, knowing that our vandalism could be forgiven due to the care and trouble we took preserving other architectural details. We also chose a palette of colours that even a museum curator might be convinced was original (*left*).

THE LIBRARY off the entrance hall has russet walls and bookcases constructed from floor-to-ceiling with the cornice wrapped around the top (*right*). Edwardian upholstery in JS Confalonière fabric provides comfort without clashing with the traditional period furniture.

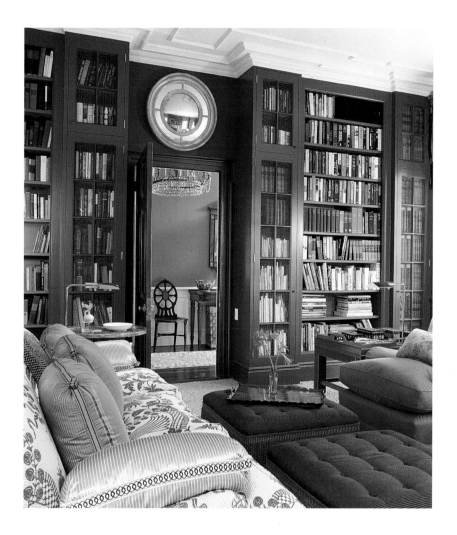

neo-classical friezes and pierced railings. The house has a cobbled yard and stables at the back. Although the house had kept a remarkable number of its original features, renovations needed to be extensive: an elevator was installed – invisibly – which meant building a new curving staircase which was less steep and, I feel, more graceful than the original in the front hall (see page 124). You don't sneak in the back door; you arrive from your car to a stair hall and mudroom of double height which leads to the kitchen. The second floor is connected by a staircase with a new landing that stretches from the house across to a sauna and exercise room and the large attic above the stable wing.

126

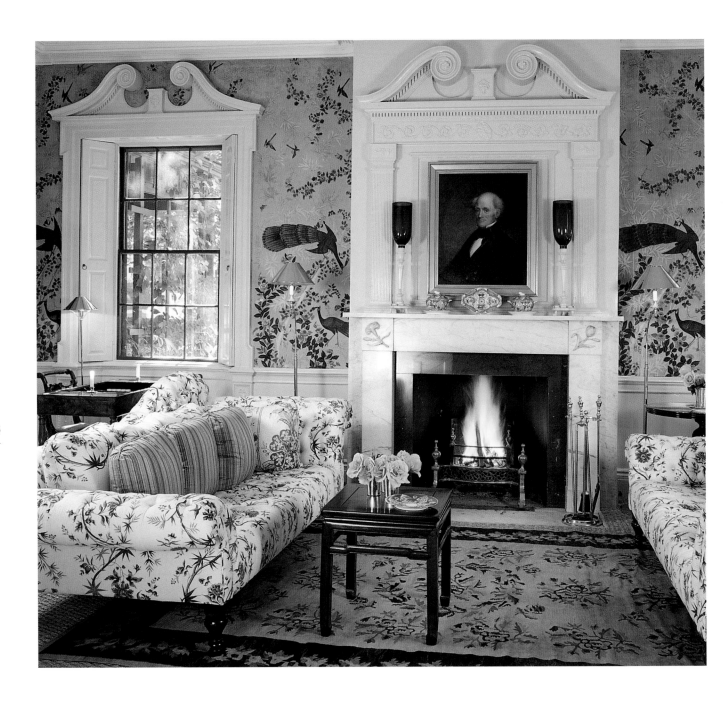

The second floor (first floor is the English term) has two master

bedrooms, dressing rooms and bathrooms with a sitting room over the

front porch. The bathrooms were kept very simple to conform to the

necessities of a consumer society, but new closets, drawers and storage

were provided everywhere. I like to create an enfilade whenever possible

– it is a way to entice and guide the eye, however humbly interpreted.

IN THE DRAWING ROOM a pair
of chintz-covered camel-back
sofas flank the fireplace. No
curtains obscure the sculpted
millwork of the window casements
– the broken pediment design is
repeated over the fireplace, which
also has a Greek fretwork motif.
The Chinese wallpaper is original
to the house. Bessarabian carpets
partly cover the floor matting.

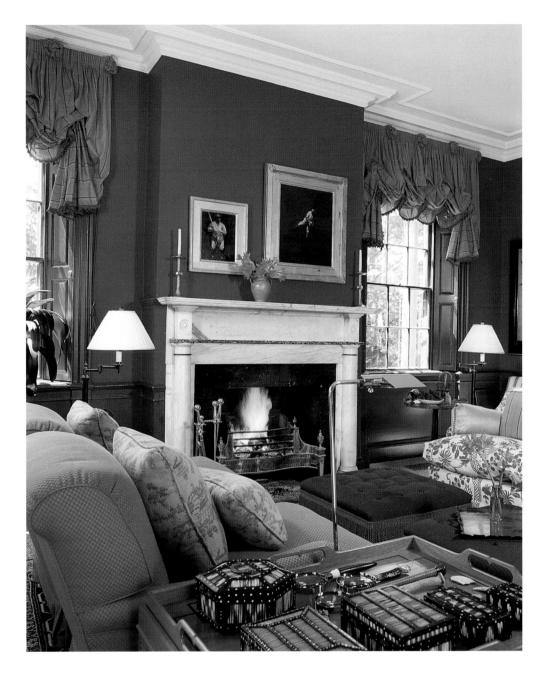

DOUBLE DOORS from the drawing room lead to this comfortable sitting room. It opens onto a porch with rocking chairs overlooking the very large garden. As elsewhere in the house, flat paint and period colours were used – no stencilling, stippling, ragging or other special effects.

This typical feature of grand French houses and palaces always works and gives you vistas of space and light.

Elegant and restrained, the architecture is, after the Indian tepee and log cabin, a fine example of the New World's exuberance and pragmatism. This early 19th-century house, imperceptibly adapted to contemporary needs, is a gratifying house in which to live.

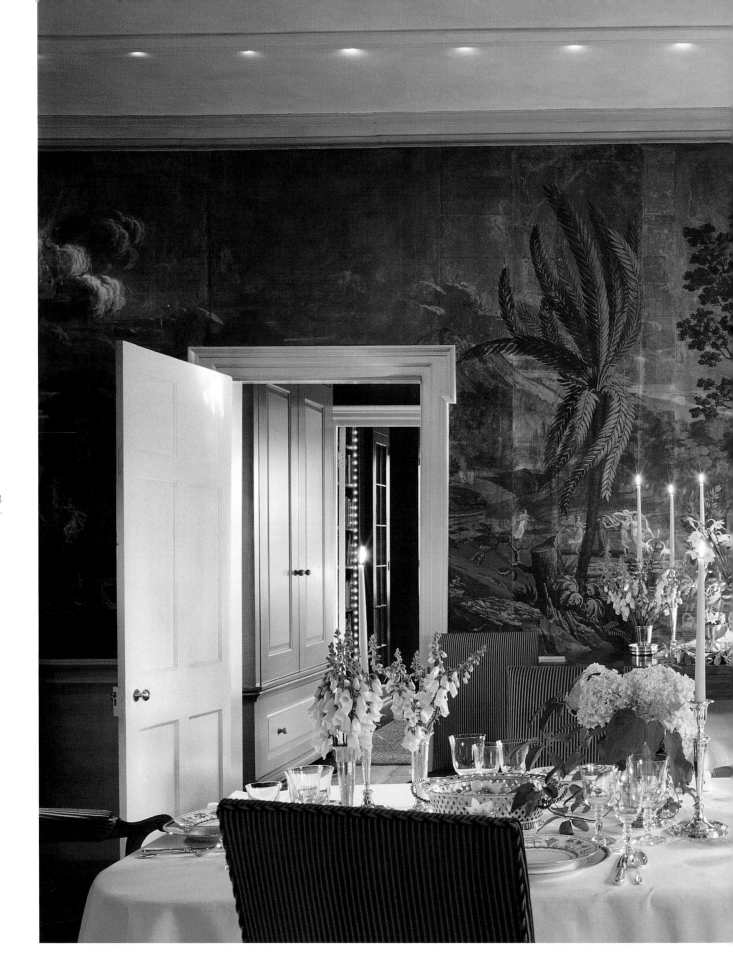

IN THE DINING ROOM the
original 19th-century Dufour
wallpaper depicts Telemachus on
the island of Calypso. Fibre-optic
lighting illuminates the walls so
the room is no longer as dark as
it once was. The pull-up blinds
are unlined eau-de-nil silk taffeta,
with knife-pleated frills. The table
is laid with English silver and
china. The chairs are covered in a
raised velvet stripe.

129

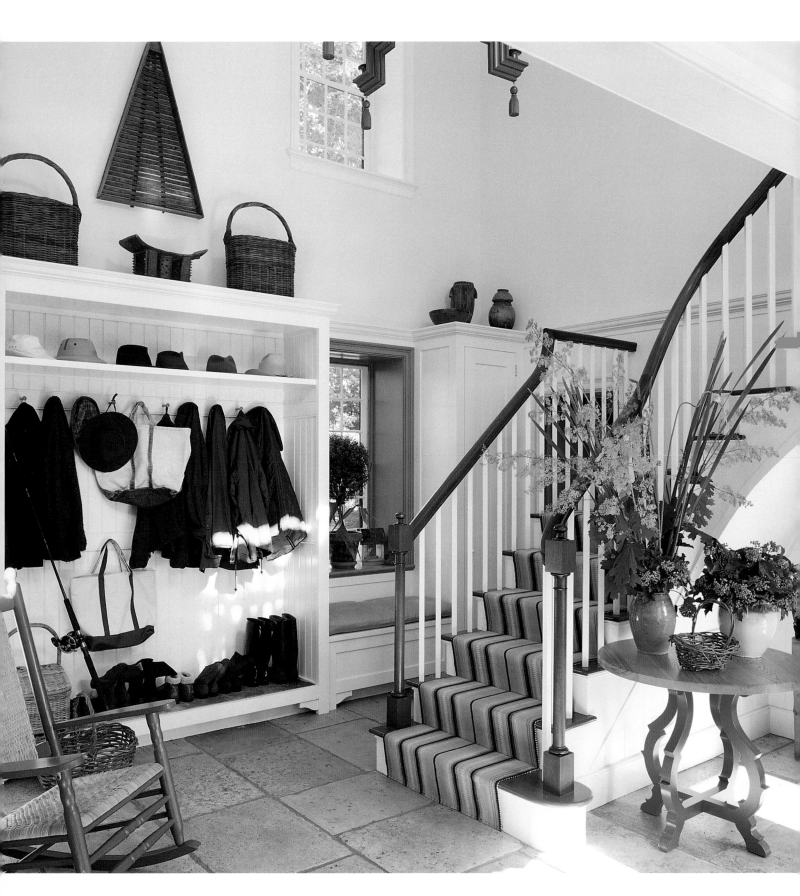

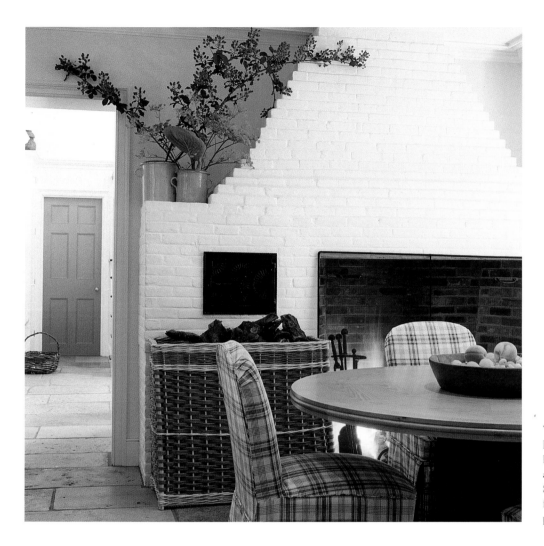

THE SAME STONE as on the hall floor extends to the large kitchen and pantry (*left*). This area was designed with almost Shaker simplicity to have the fresh scrubbed character of places close to the sea.

THE DOUBLE-HEIGHT HALL (*left*) has a stone floor and was created as a practical entrance to the house through the stable yard. A remarkable attribute for a town house, this hall permits you to get from the yard into the kitchen area or upstairs. It is the core of the house and, moreover, the most comfortable of mudrooms. To the right of the stairs is a JS cut-out table and on the stairs themselves is a striped wool runner. The millwork is painted white.

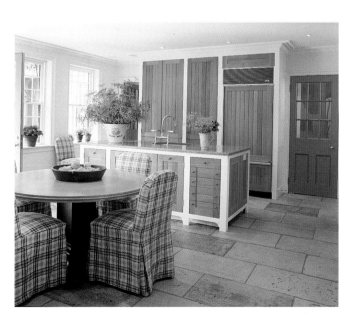

THE JS-DESIGNED kitchen has oak panels edged in white-painted wood to prevent monotony (*left*). The chairs have checked loose covers that reach to the floor

INTERIOR DOORS provide an
unbroken vista – an enfilade and
a favourite trick (*right*). The four-
poster bed is sumptuously hung
with a JS Emma print in oranges,
green and white. The fulsome
pull-up blinds are in a blue and
white JS Rice check. The view
from the bedroom looks through
the simple bathroom to a large
cream-painted dressing room
with cupboards lined in JS Rice
fabric (*below*).

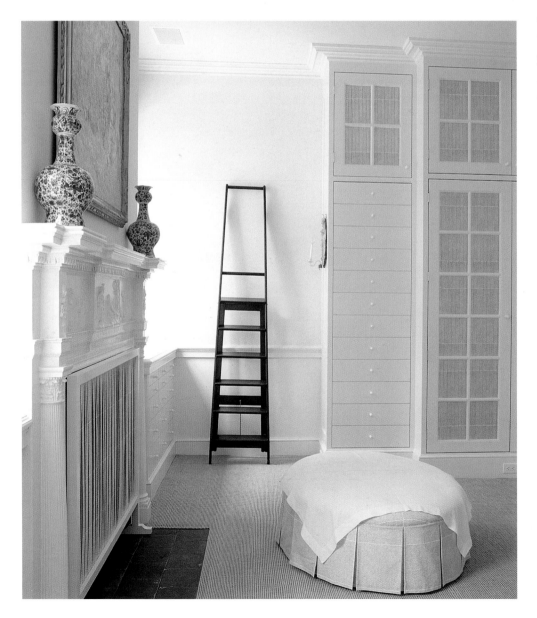

THE LANDING viewed from
the dressing room, revealing a
gracefully curved staircase (*right*).
This was rebuilt to a new design
to accommodate the hidden
elevator that, needless to say,
did not exist before. The oval
above the dressing room door is
a repetition of the ovals on the
main staircase landing which
are original to the house. These
small openings give a surprising
feeling of space.

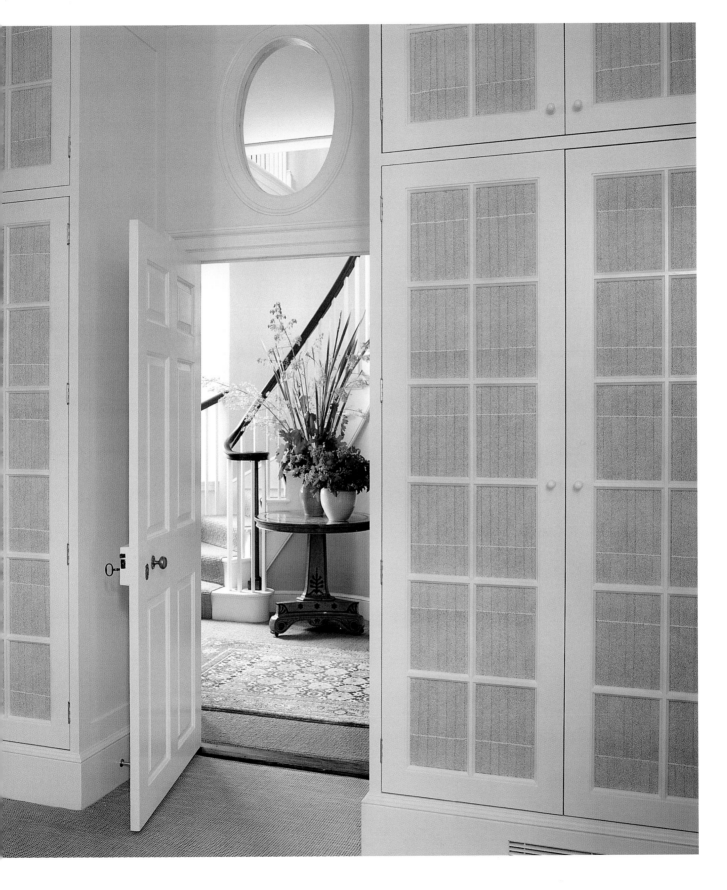

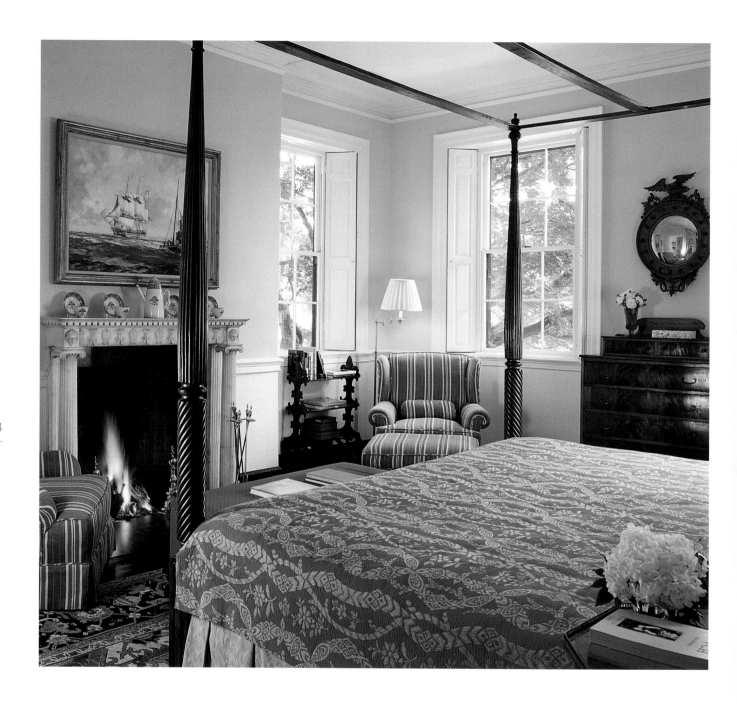

134

WITH ITS UNADORNED four-
poster bed, this is a New England
gentleman's bedroom (*above*).
A corner room, it has four
windows with working shutters
and a finely carved fireplace.

A DETAIL OF THE MANTEL
with Compagnie des Indes
cups, saucers and a coffee
pot – captain's booty of the
1800s. Above the mantel is
a marine painting, not an
unexpected feature in this most
Yankee of Atlantic ports.

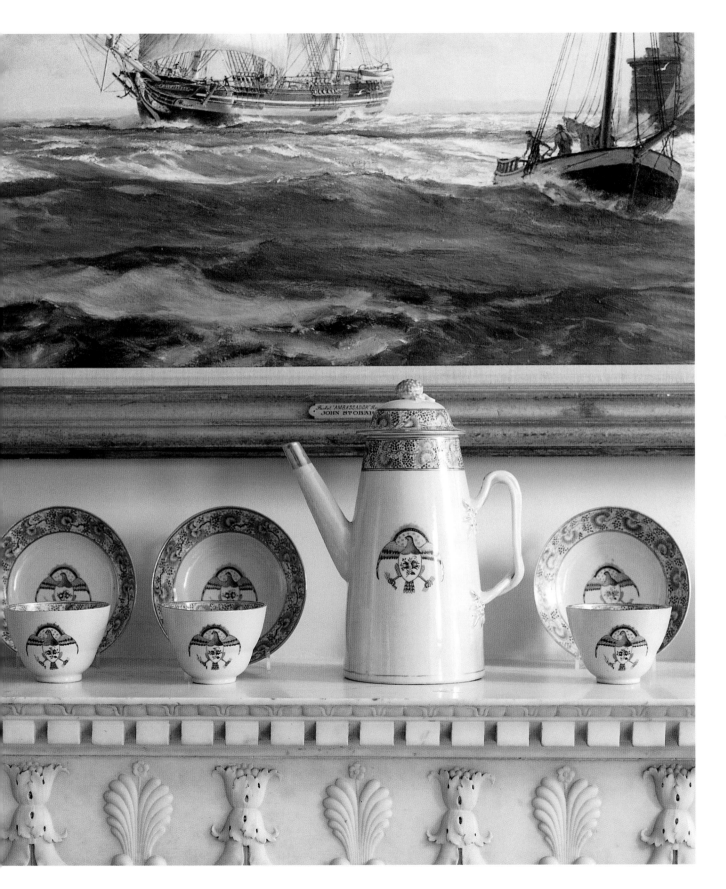

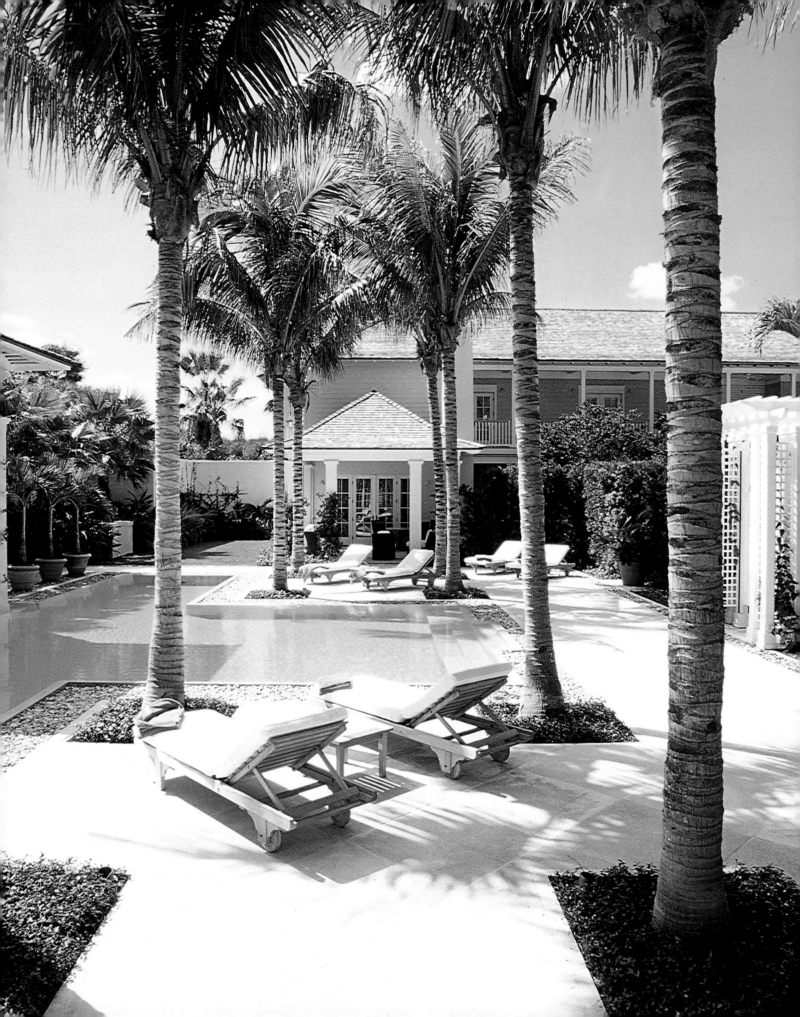

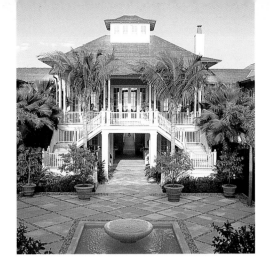

WINDSOR

a house on the beach in Florida

THE TOWN OF WINDSOR IS SET AMONG the waterways and grapefruit groves of the Sunshine State, between the Indian River and the Atlantic Ocean. First there was only a polo-sized field, a golf course and a solitary house called Side Yard – meticulously designed by architect Scott Merrill – which we were asked to furnish and kit out.

It was the beginning of a grand plan based on the colonial architecture of the Western hemisphere. An urban design with small city blocks and varied streets evolved, with a strict architectural code in Anglo-Caribbean style devised by Andres Duane and his wife Elisabeth. Windsor has set a high standard for building and design.

The village has become a town. There are now some one hundred and fifty buildings (to reach a maximum of three hundred and fifty), designed among others by Hugh Jacobsen and Jaquelin Robertson. There is also a town centre, a tennis club with a witty neo-classical building, a beach club, and a meeting house designed by Leon Krier. The golf club building is near completion. Manicured lawns, avenues of palm trees, and streets of well-designed houses make this the most handsome of all Florida towns.

A TRANQUIL SWIMMING POOL – water ebbs onto the surround of loose stones (*left*) and the space is defined by tall, elegant palm trees. This part of the garden connects the main house to a wing for guests and children.

A VIEW OF THE COURTYARD, paved with large criss-cross squares of stone with pebbles in between (*above*). At its centre is a round Mexican shellstone fountain. A double-sided staircase leads to the white and blue verandah. From the courtyard you can see through the house to the ocean.

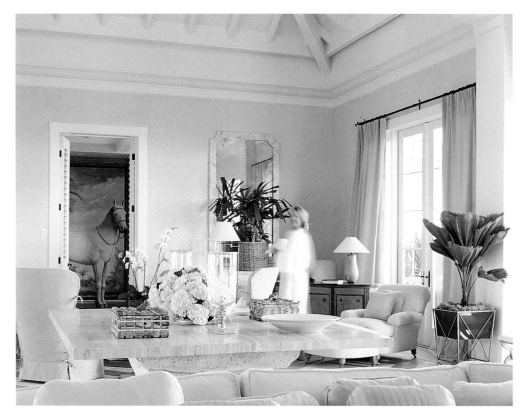

THE SPIRIT OF THE HOUSE walks as a ghost through this luminous living room which opens on to verandahs facing the courtyard and ocean (*left*). The horse is the owner's favourite polo pony (*below*). Life-size, it has a beady eye like the horse in the Palazzo Tè in Mantova.

THE WOOD FLOOR is juxtaposed with limed grey boards in large squares. In the foreground is a Ruhlman oak coffee table with smaller cousins for the Stefanidis Rothschild armchair. In the centre is a large table on a cut-stone base and beyond is a stone fireplace. The king-post roof has white painted rafters culminating in a huge skylight at the apex (*right*).

The style of Side Yard was hot-climate-colonial with Indian furniture – four-poster beds, planters' chairs on the verandah; all comfortable and understated. This became the basis for the style of many of the new houses and club premises. When I was commissioned to work on the house on the beach portrayed in these pages, it was time for a change – for a more spirited and idiosyncratic approach and invention. The antiques were to be predominately of the 1940s, but there were not to be too many of them. The standard of hospitality was well-established, and this was to be taken into account.

The house, designed by Clem Schaub, was on a fast-track schedule. The house was to be inhabited by family and friends in time for Christmas and the new millennium – an ubiquitous deadline. On that note the project started. Perfectly managed by conscientious constructors, the site was spotless, in true US fashion.

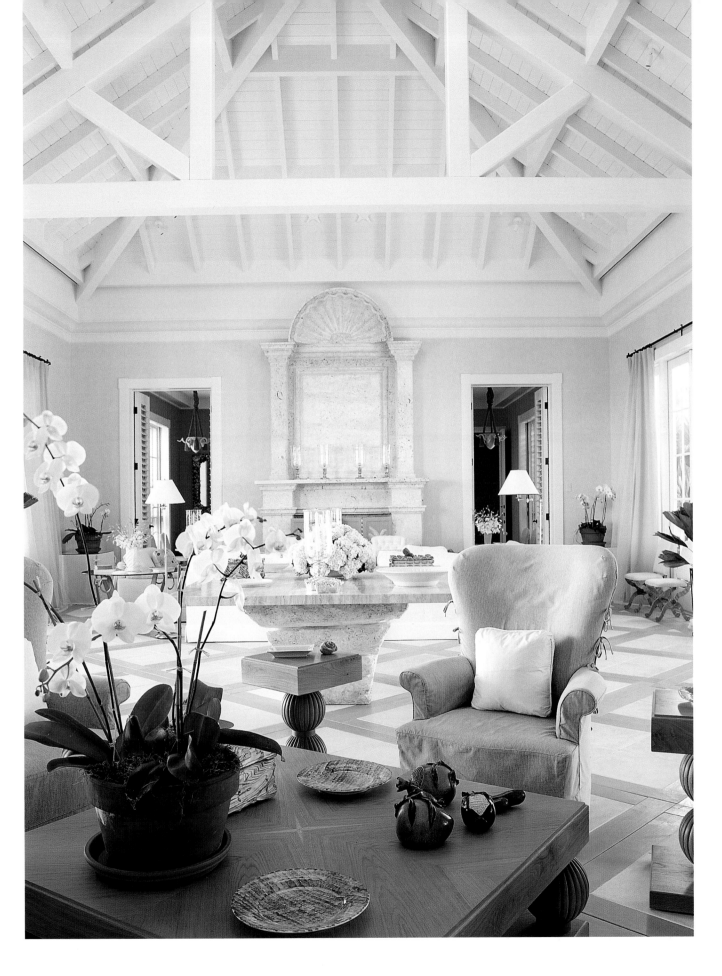

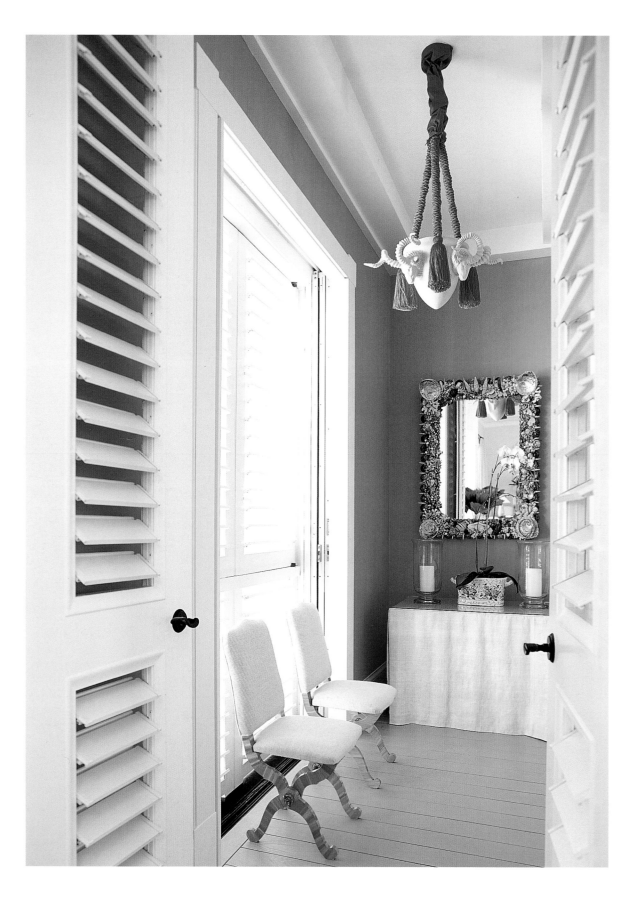

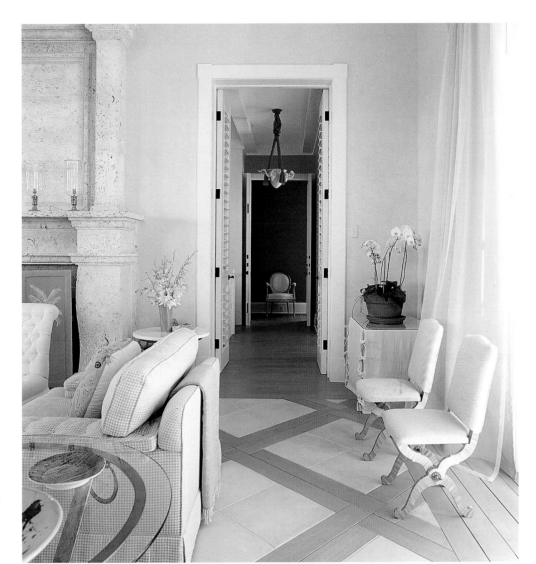

THE LOBBY WALLS are painted the brightest peony pink, then thinly dragged in white (*left*). The two Jansen chairs are marbled, one in pink and the other in grey. A third colour on these chairs is pistachio – the chairs are used for dining all over the house, including at the central stone table. The tablecloth is the crispest of white linen; the shell mirror dates from the 1960s. Oversize tassels complement an Oriel Harwood ram light, paired on the opposite landing of the fretwork staircase .

AN ENFILADE to the heliotrope-coloured passage of the master suite (*right*). The curtains are pistachio cotton duck with loose netting attached at the top only; they float like ball gowns.

Since this was the fifth house we were embarking on as client and designer, there was an empathy and understanding. Teamwork and no politics did the rest – from laying the foundations to living in the house took eleven months. The result is a house with its own distinct character – white-shuttered French windows everywhere, limed paolope wood floors changing to sand-coloured cast-stone pavers.

The site and climate is a lotus-eater's dream-come-true, requiring comforts which this graceful house provides most generously without taking itself too seriously. On the one-acre plot is a courtyard with tall

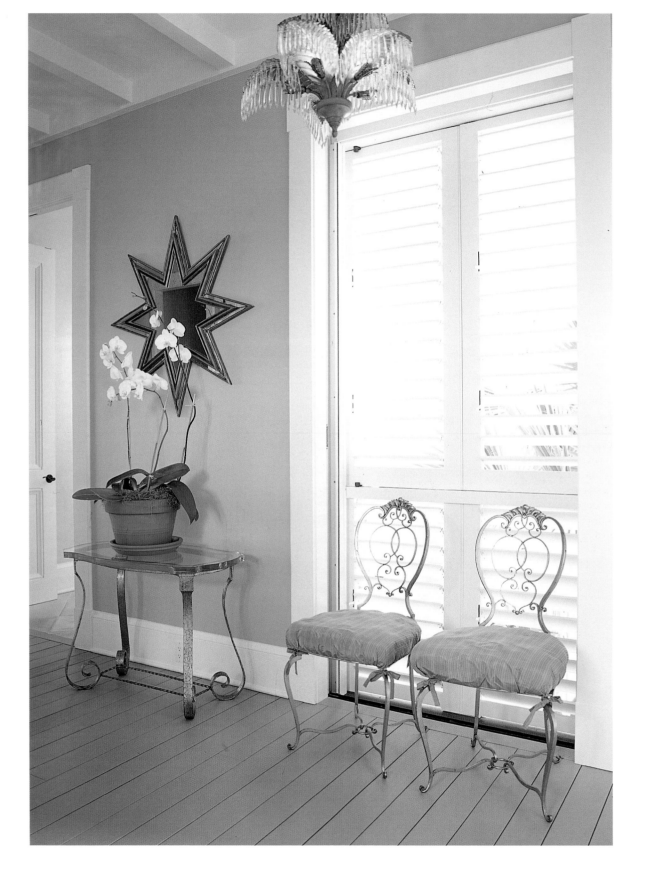

IN THE ACID-GREEN LOBBY which leads to a wing of the house are a pair of Regency emerald and glass hung chandeliers (*left*). A red and gold framed 1940s mirror hangs above a French gilt-metal and glass table of the same period. Gilt-metal 1940s chairs stand in front of the window.

THE BAR, with its rough plaster walls, is a sophisticated stable for the horse (see page 138). Refrigerators, their doors covered in woven straw, are tucked beneath a shelf of cast-stone – a euphemism for cement. Woven straw also covers the over-sized fern-filled jardinières. The Venetian wall lights were made for the room and have the same 1940s spirit as so much of the furniture.

palms and luxuriant plants, a plain circular stone fountain at its centre. It hides a swimming pool sited to suit the climate on the south side.

The rooms are airy; bathrooms large with shallow, scooped basins of stone, big baths and vast showers. Guests are pampered: the napery is crisp, the food delicious. Clothes are whisked away, washed and ironed and hung in your cupboards in what seems like minutes. Fine embroidered sheets and pillow cases are ironed to perfection. No place is more immaculate or inviting.

THE PIZZA ROOM – named after its oven which is not visible here – has deep emerald-green walls and a chalk-white ceiling (*left*). Metal lights hang over a zinc-topped table at which as many as 24 people can sit on long benches made comfortable with cotton gingham squab cushions. Two 1940s red metal cabinets with gold decoration face one another and serve as storage for china, interspersed with Jean Cocteau plates.

THE LIBRARY fireplace has a large shell over the grate and two more shells on the mantel (*above*) carved from Mexican shell-stone. The ocean motif is repeated in the waves on the classical frieze and there are more shells on the sides of the window seats.

THE DESK, LAMPS, chairs and games table all date from the 1940s (*right*).

146

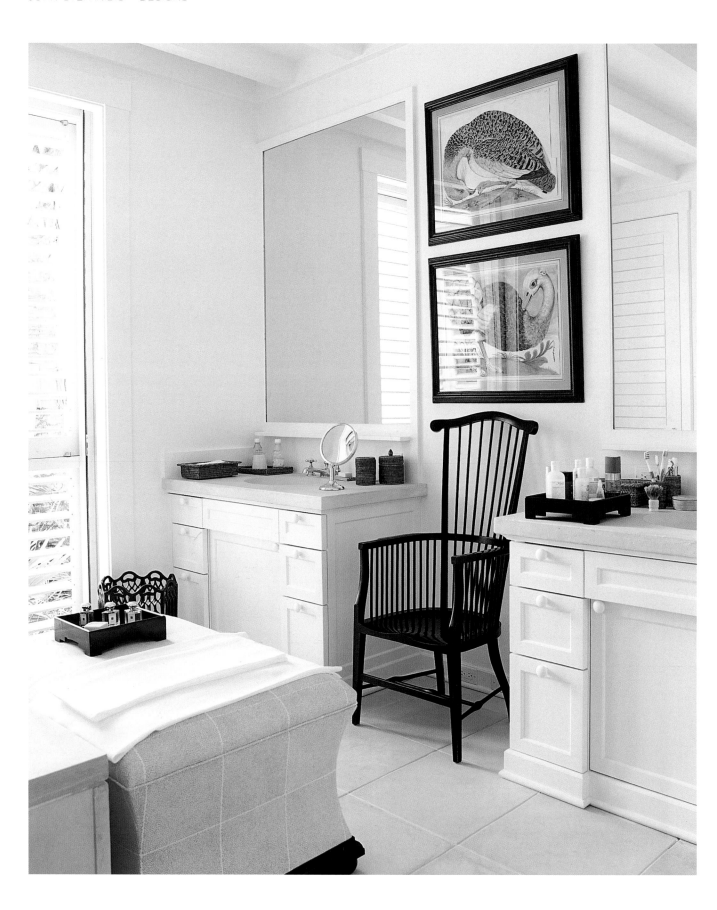

THE PALAZZO BATHROOM has white-shuttered French windows (*left*). A strict Quaker Windsor chair in black stands between the twin basins; above the chair hang French 19th-century bird prints in black frames. At the end of the bath is a large ottoman covered in a JS pink Rice fabric.

STRAW MATTING was woven in different colours to match the bedroom colour schemes – in this case, blue (*right*). A tall bedhead, seen here reflected in the mirror, is covered in thick blue and white woven linen – the weave and pattern date to the Renaissance. On the ebony table is a turquoise blue Venetian lamp with a clean white card shade. On either side of the French 19th-century painted and gilt mirror are two black and gilt chairs which are covered in a pink and blue JS stripe. The walls are sponged a deep tobacco colour.

THE BLUE AND WHITE verandah overlooks the courtyard and is surrounded by ebullient palm trees (*left*). On the JS-designed wicker furniture are cushions covered in a JS Puccini fabric in blue with cyclamen on white. Between the chairs are JS Turkish tables painted in French blue. The eaves all around the house are painted a cooling pale aquamarine.

A CORNER of the blue and white terrace (*right*). The JS table and chairs – homage to Mallet Stevens – are white with blue cross-bars in the centre.

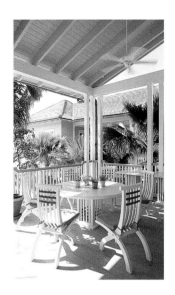

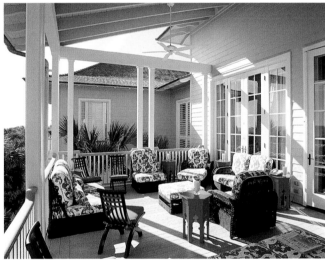

THE BLACK AND RED terrace (*above and right*) faces the ocean and is almost a replica of the courtyard verandah. The same Puccini fabric is used as on the other terrace but in green, accentuated with the same cyclamen on white. The Turkish tables are a deep cadmium red. There is also a larger dining table painted black and chairs in black with red cross-bars.

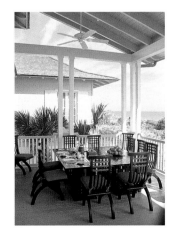

THE WALLS of the master bedroom are painted to look like lace to dado height against a background of dark Havana-brown walls (*above*). The Italian Empire parcel-gilt chairs are covered in white cotton.

THE MASTER BEDROOM overlooks the ocean so that the sound of the waves lulls you to sleep (*right*). The four-poster bed is hung in muslin with glass bead trimmings. The beams and ceiling boards are painted white, and on the floor is straw matting woven with white cotton. The two French 19th-century armchairs are also covered in white. The light on the round covered table is a milky-white opaline.

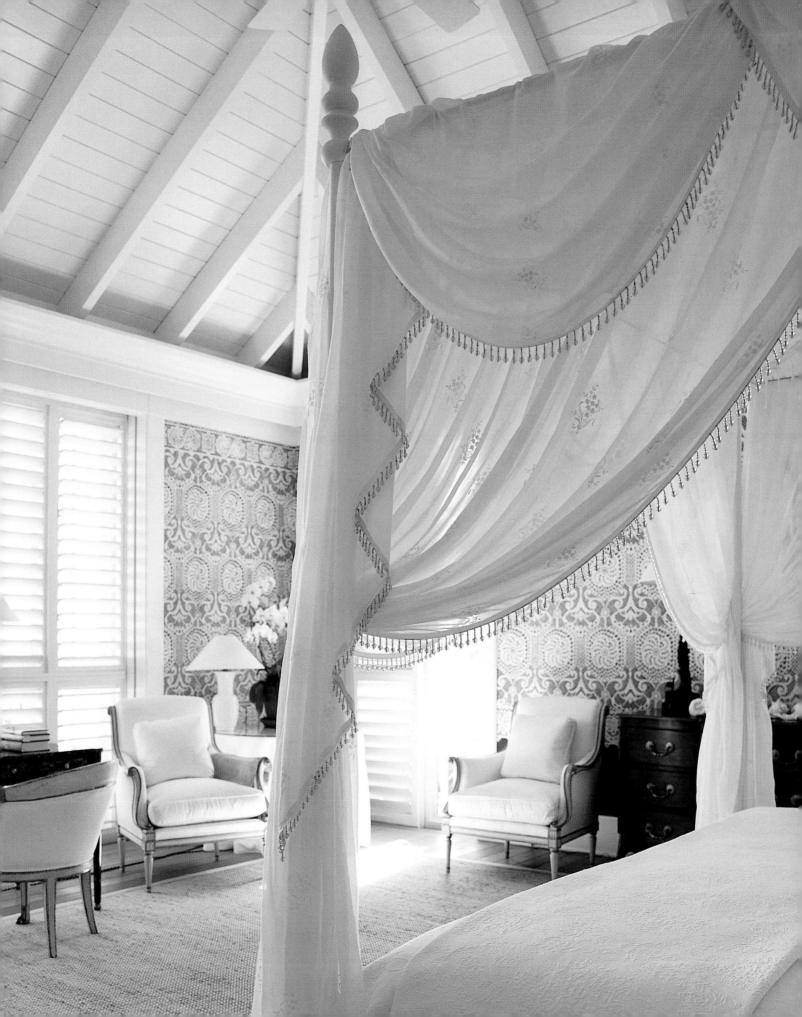

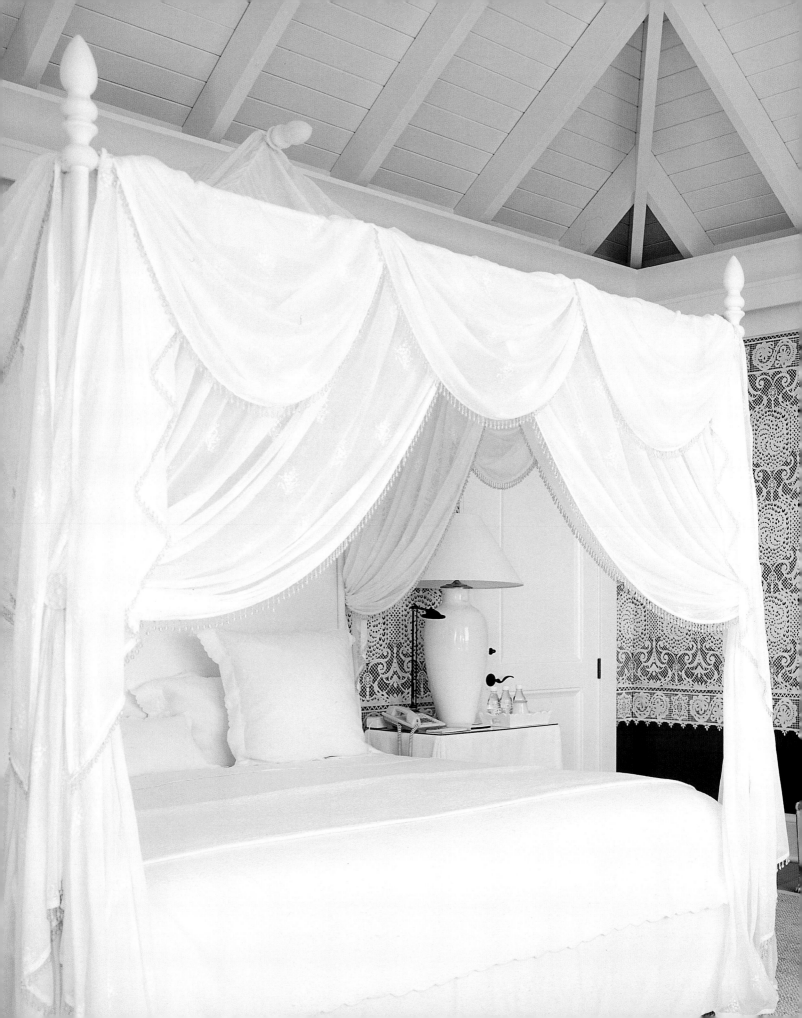

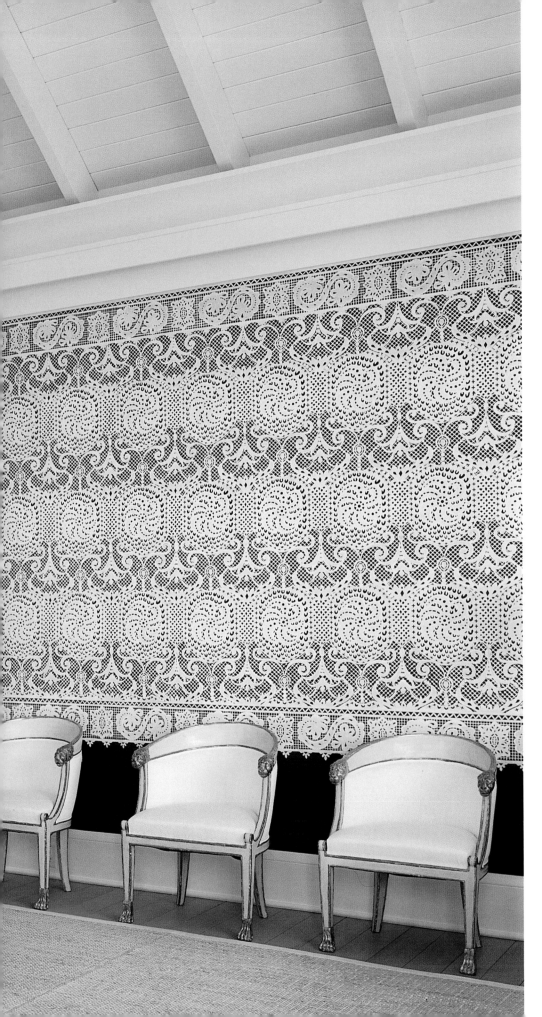

A SOLDIERLY ROW of chairs
is arranged against the lace-
painted wall of the master
bedroom. The specialist
painters are masters of their art:
sometimes two, sometimes ten,
they congregate from different
countries to gild, paint and
embellish my ideas. The bedside
lights are white opaline with
simple card shades.

153

FRENCH WINDOWS open onto a balcony off this dressing room (*right*). A black ebony table is flanked by two large chairs covered in linen and there is a blue and white dhurrie on the floor. The frieze is a cut-out of all the Windsor buildings, which, despite their variety, all adhere to a strict architectural code.

THE MASTER BATHROOM has a free-standing bathtub placed in the centre of the window on the limed wooden floor (*below*). A coral mirror matches the chandelier (just visible at the top right of the picture). A large oval dressing table is covered in organza with matching bows atop a dark rose chintz underskirt. The parcel-gilt chair, one of a pair, is a 1940s hybrid covered in white fabric.

154

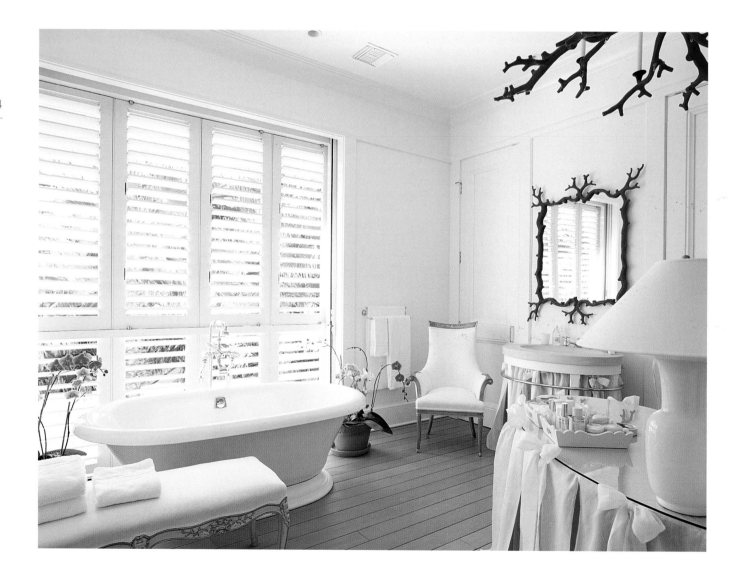

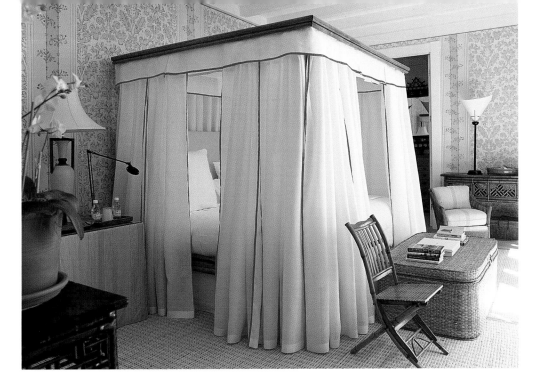

THE BAMBOO GUEST ROOM
has a bed with hangings of
the finest, most delicate ivory-
coloured linen, edged in geranium
satin ribbon. The side tables are
Chinese bamboo. The matting on
the floor of this room is woven
with green cotton and the walls
are stencilled with panels of an
orange and green motif on an
ochre background. The same
pattern is repeated on the
upholstery in the bamboo sitting
room (*below*).

155

LARGE BAMBOO POLES,
arranged vertically, cover the
walls of a bamboo sitting room
(*above and left*). Japanese
umbrellas in red, indigo blue and
green hang from the walls.
Orchids – white like almost all
of the flowers in the house – are

mounted on outsize bamboo poles.
The electric fan is made from
pleated palm fronds to follow the
tropical theme of the room.
Bamboo shutters (*left*) lead to a
garden enclosed by lush tropical
plants. The azure blue furniture is
painted to simulate bamboo.

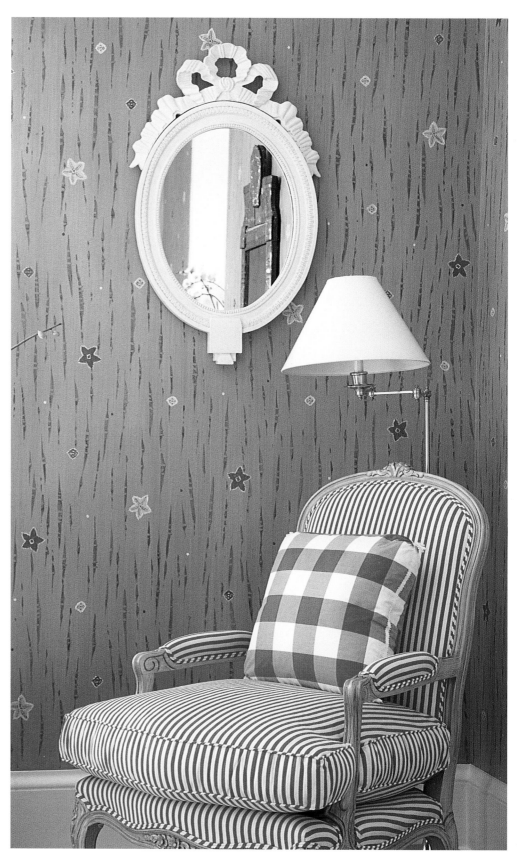

THE SWEDISH BEDROOM
opens onto a terrace (*above*). The
JS Turkish chair in the foreground
is one of many used on the
terraces and in the gardens.

THE DEEP ROSE MADDER
walls are streaked in white with a
pattern of scattered sea anemones
(*right*). A painted white Swedish
mirror hangs above a painted
Louis XV armchair. A large red
and white check cushion sits on
the chair.

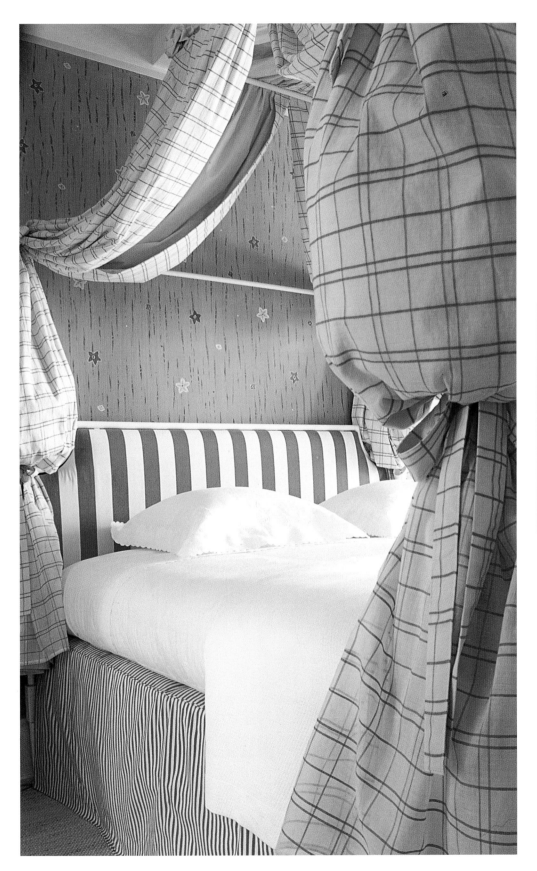

THE SAME RED as used for the
check cushion on the Louis XV
armchair (see page 156) is used
on the large striped bedhead (*left*)
and the sofa (*above*). The bed is
hung with a simple red check
fabric and the bouffant curtains
are held back by long ties of the
same fabric.

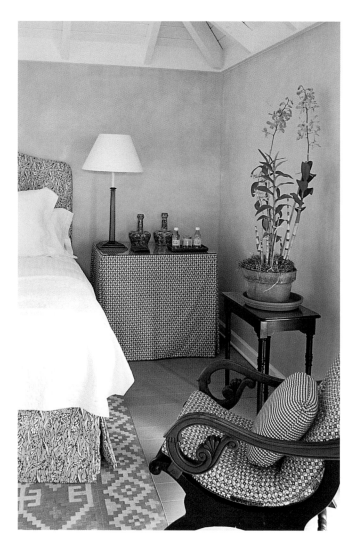

IN THIS CORNER of the Indian room is an Anglo-Indian seat of carved ebony with a seat cover in a saffron yellow hand-blocked Indian fabric of Rajput design (*right*). The table is also ebony. The walls are sponged a rich ochre.

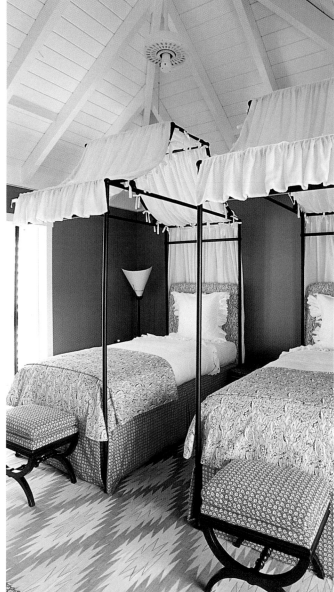

THE BEDROOMS shown on these pages are across the courtyard in a balconied wing which faces the house across the courtyard. Below this room is the large but friendly entrance to the house.

THE BLUE BEDROOM has plain painted grey blue walls and a pink and white cotton dhurrie (*above*). The JS fabrics are blue and white Japanese-inspired designs.

IN THE COLONIAL ROOM the metal beds have light butter muslin canopies (*right*). The bedcovers, valances and matching stools are all in a red Japanese-inspired JS fabric. The Japanese lights have inverted cone paper shades. On the floor is a dhurrie in three blues and faded pink.

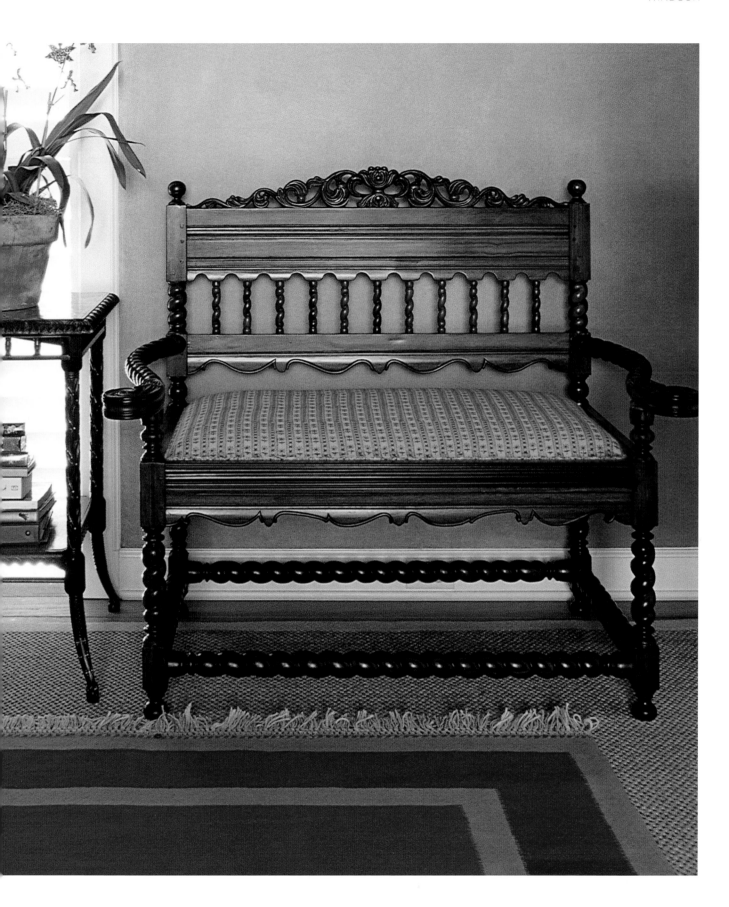

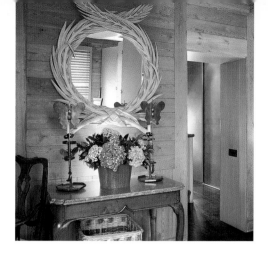

NOTTING HILL W11
a house and city garden

THE ENTRANCE HALL has walls covered with vertical wainscotting and horizontal boards in honey-coloured pine (*left*). The large gouache is by Millington-Drake. Either side of the stool with its shell motif – a modern adaptation of a William Kent design – are Chinese play pens in sealing-wax red – one contains walking sticks, the other umbrellas. The floor is plyboard, stained black .

A PLAIN, 18TH-CENTURY oak side table has a grey fossil stone top (*above*). On it is a pair of Korean butterfly candlesticks. Above the table is a round JS mirror inspired by Borromini and painted café-au-lait with a gilt ribbon.

THIS COMMISSION FOR A GENTLEMAN in his declining years might have had as a leitmotif T.S. Eliot's lines from *The Love Song of J. Alfred Prufrock*:

> *Then how should I begin*
> *To spit out all the butt-ends of my days and ways?*
> *And how should I presume?*

Having abandoned a very large house on the River Thames and a country retreat of distinction and invention, the owner had to rationalize their contents to fit a new house. This was to be a pied-à-terre, enabling him to enjoy his freedom from the strains of owning two houses in England.

Priority was given to shelves to incorporate literary and history books from the country house; books on architecture and design from his house in the city. A view-through had to be made from the front of the house across the courtyard to the garden. A large basement was to be made, with a door and window opening on to the street. The furniture was from the previous houses – sentiment might well govern its choice but what did not fit was ruthlessly discarded.

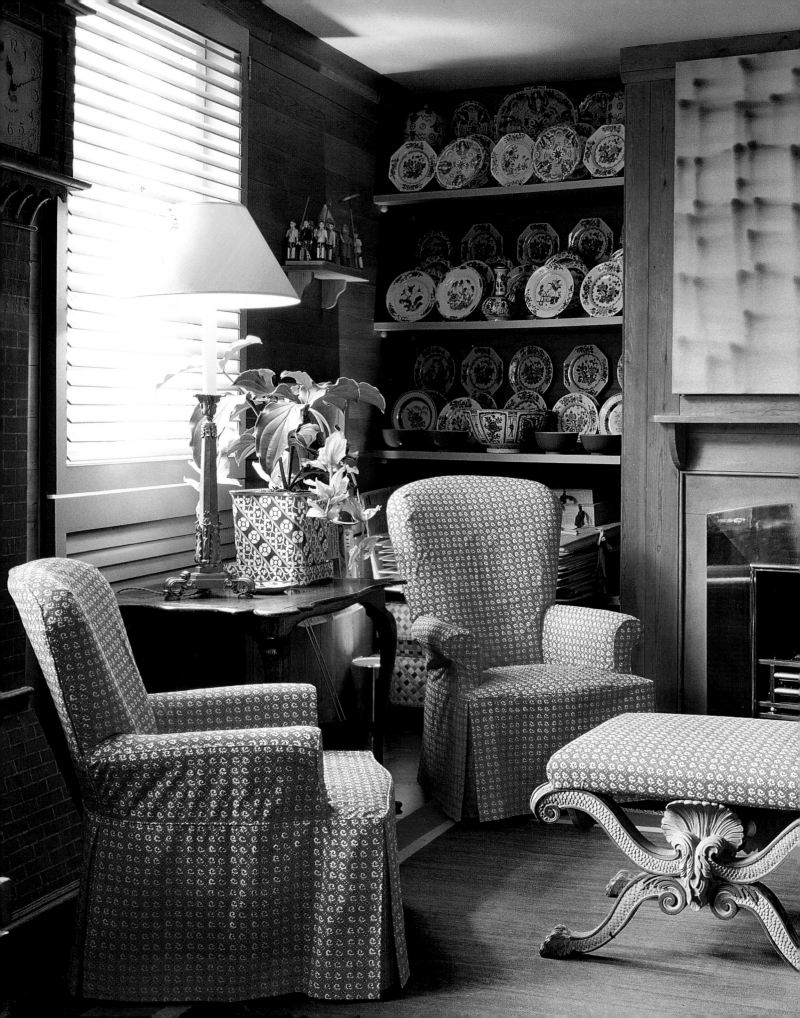

THE SITTING ROOM chairs are covered in deep aqua green on the outside with a woven cotton toile fabric inside (*above*). On the floor is a flat dhurrie with a red border. A grandfather nursery clock is painted to simulate brick. Wide-slatted apple green shutters filter or block light depending on the time of day.

THE SAME ROOM but the chairs and stool have loose summer covers in a JS Japanese Collection fabric (*left*). A Mark Francis painting hangs above the fireplace. The walls are pine – with horizontal and vertical boards. To the left, shelves painted apple green hold a collection of blue and white Spode china. On the right are ceramics by Picasso among others, and photo albums with dates embroidered on ribbons. An 18th-century table holds a cachepot by William Morris. An Indonesian temple procession bearing a mountain of rice sits on its own shelf.

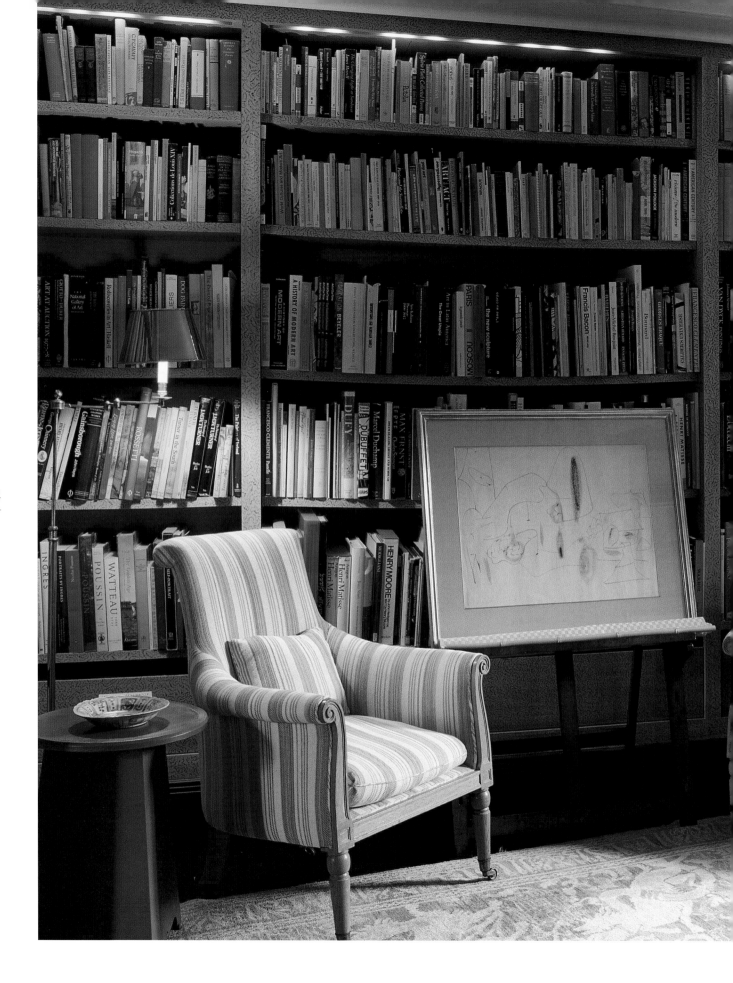

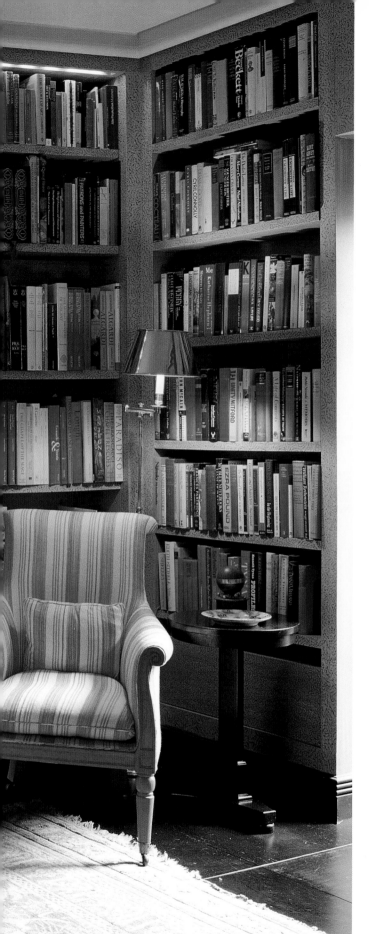

THE SMALL LIBRARY has a
pink Spanish rug with an Islamic
design of lions and a scroll motif
(*left*). The JS oak library chairs
are covered in *spinato* – a pink
woven stripe; the fabric a dry and
rough mixture of flax and cotton.
The drawing on the easel is by
Arshile Gorky. The light comes
from French windows which open
onto an inner courtyard.

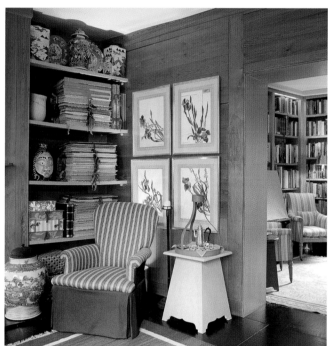

165

IN THIS CORNER of the drawing
room, with a view into the small
library, is a JS Rothschild chair
and a JS Patmos table painted
face powder pink (*above*). On
the wall above the table is a set
of Millington-Drake watercolours
of irises.

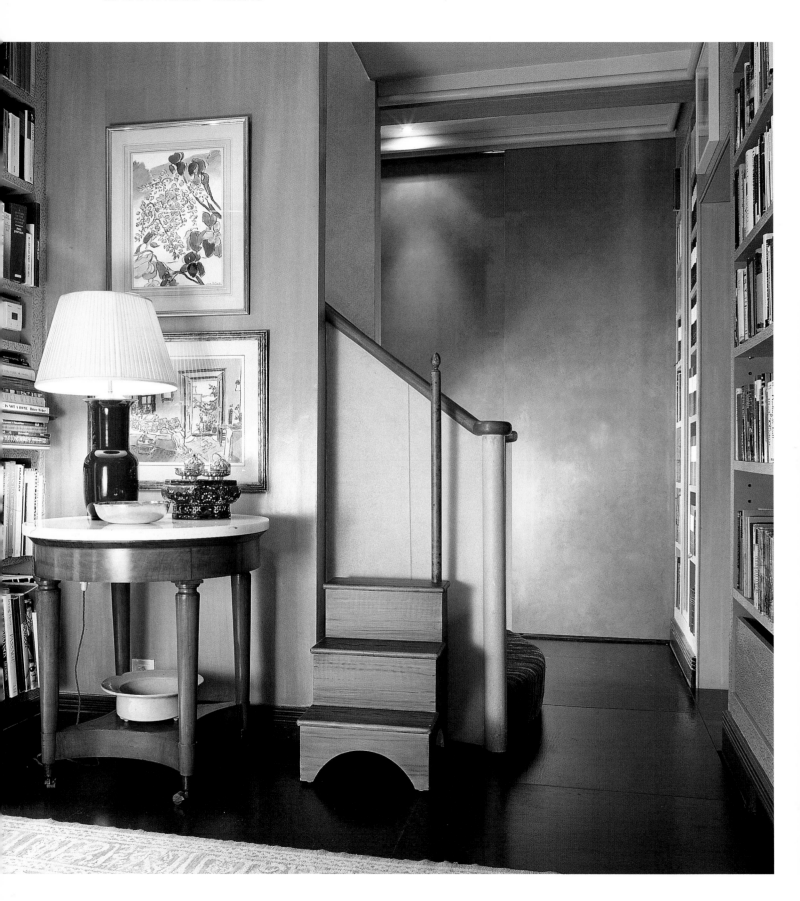

THE SMALL LIBRARY is between the hall and courtyard, with the staircase opposite one of the openings (*left*). Beyond are heavy sliding doors lacquered parakeet green. The walls and shelves are painted with fanciful white squiggles on cerulean blue. The round table is French *Directoire*. On it stands a light with a royal blue glass base and a lacquered box with repoussé bowls – this started life in an Indonesian temple.

SLIDING DOORS hide space for coats and for the storage of linen and china. All the pictures here are watercolours by Teddy Millington-Drake of Tuscany, Greece and India (*left*).

A MOVEABLE FEAST on a folding table – an alternative to the dining room – ready for dinner on an English summer evening (*left*). The JS chair is covered in a striped pink. The old folding chairs, made for Jansen in Paris, are covered in leopard with a brown velvet edge. The courtyard and garden are visible beyond.

167

THE KITCHEN TABLE set for lunch with blue and yellow plates by Millington-Drake (*below*), heavy linen place mats and glasses in a deep rich blue. A simple recessed window, left uncovered, makes a perfect setting for an elegant urn.

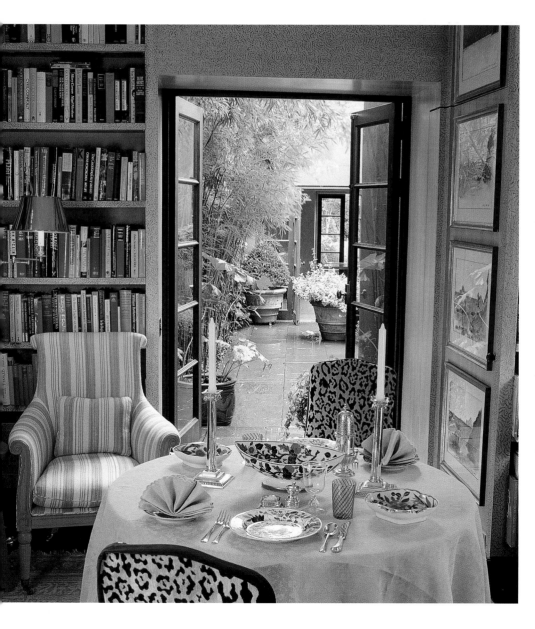

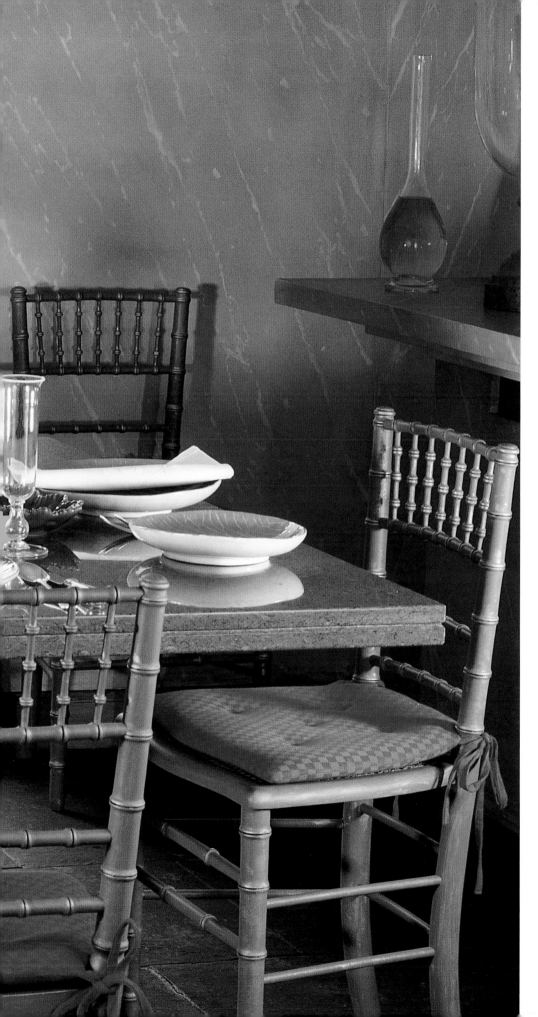

THE DINING ROOM has a slate
floor – a continuation of the stone
in the courtyard and garden
terrace beyond. The table has a
top made of polished Purbeck
stone supported on a rusticated
and pebbled cement base. The
china lettuce-leaf centrepiece with
matching plates, purchased in
Florida, continues an 18th-
century tradition. On the table is
a woven Mexican bread basket in
silver, tall Venini champagne
glasses and white spiral water
glasses. The party chairs, with red
cotton squab cushions, are painted
grey with the bamboo knuckles
gilded. The walls are an invented
marble in tones of grey and lilac.
French windows open wide on one
side to the courtyard and on the
other side to the garden.

169

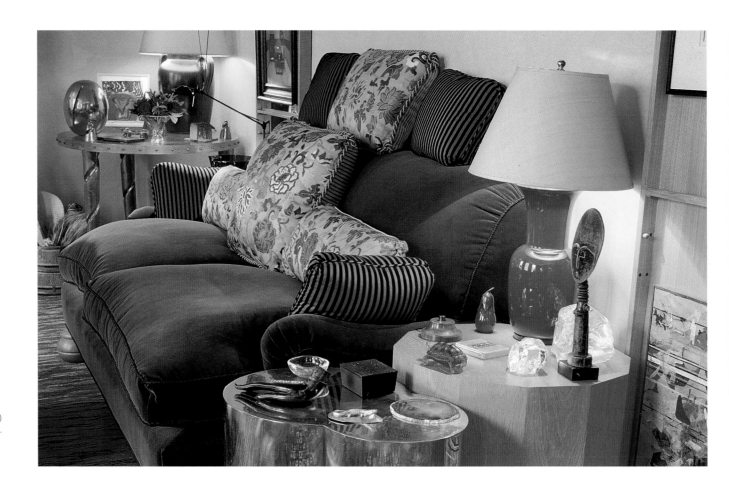

170

IN THE DRAWING ROOM is a
high-backed velvet sofa on turned
oak legs; the cushions are of raised
striped brown velvet and brocade
from Ladakh (*above*). Next to the
sofa is a JS 12-sided drum table in
oak; on it a collection of objects
including chunks of lead crystal
and an African figurine. In front of
the drum-table is a JS cloud table
in brass. At the other end of the
sofa is a Garouste and Bonetti
table with red top and brass legs;
on it an Art Deco bronze lamp, a
Fontana sculpture and a Francesco
Clemente watercolour.

THE BRASS REGISTER grate,
original to the house, has a
bolection moulding painted to
simulate stone (*right*). The
sculpture is by Vittorio Amato,
commissioned for the room.

A VIEW from the drawing room
of the staircase to the next floor
(*right*). Oak book and display
cases with wooden knobs – books
face the landing and the backs
have panels divided by adjustable
horizontal struts that serve to
hang drawings or paintings –
shown is a Nikos Ghika gouache
and a drawing by David Hockney.
On the opposite side, storage
boxes face the drawing room.
To the left is a small red library
and on the right is the bar. The
carpet is a JS Woodgrain in black,
red and beige.

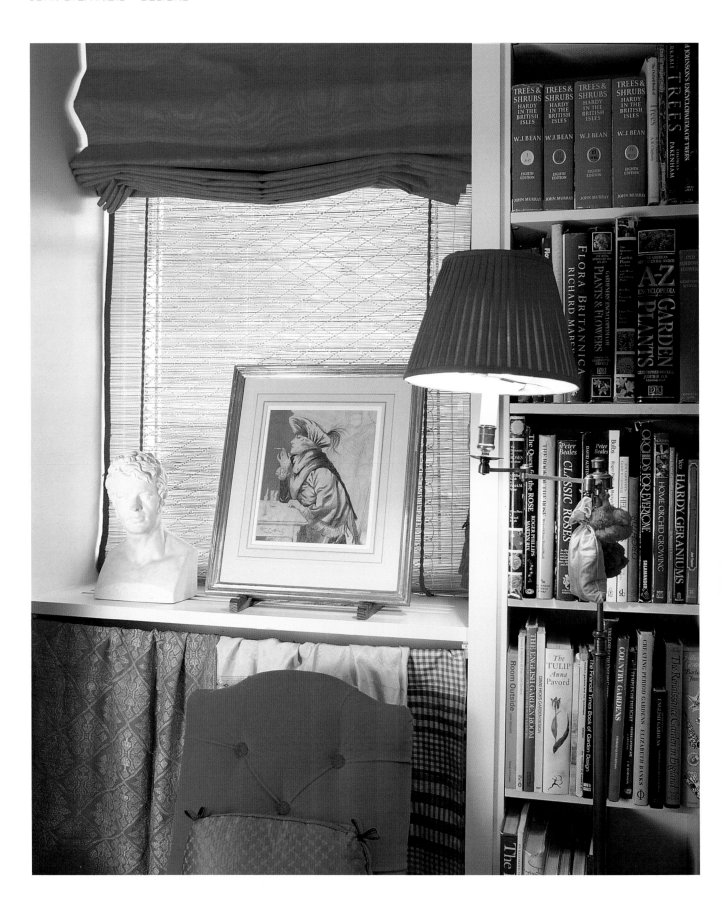

IN THE SMALL RED LIBRARY
a red moiré blind hangs in front of
an Indian cane blind with a
diagonal pattern and red binding
at the edges (*left*). On the
windowsill is a bust by Schinkel
and a drawing by Fernand
Gottlob of a demimondaine family
smoking in public. Taffeta silk
shawls and a silk embroidery hang
in front of the radiator.

A SCREEN painted celadon green
stands in the hall (*below*). In front
of it is a lacquered green JS chest
with an Ancaster stone top. On
the easel is a Millington-Drake
watercolour; beside it a bronze
Tibetan gong.

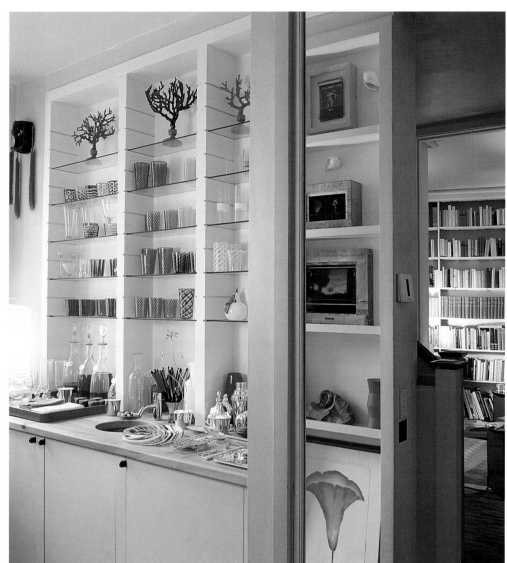

173

SHELVES IN THE BAR on the
first floor hold multi-coloured
Venetian and other glasses as well
as a selection of coral – also made
of glass (*above*). There is a
wooden basin in the cherrywood
top and the doors have leather
pull handles.

OPPOSITE THE BAR is a grid
of shelving for displaying a
collection of small pictures and
memorabilia (*left*).

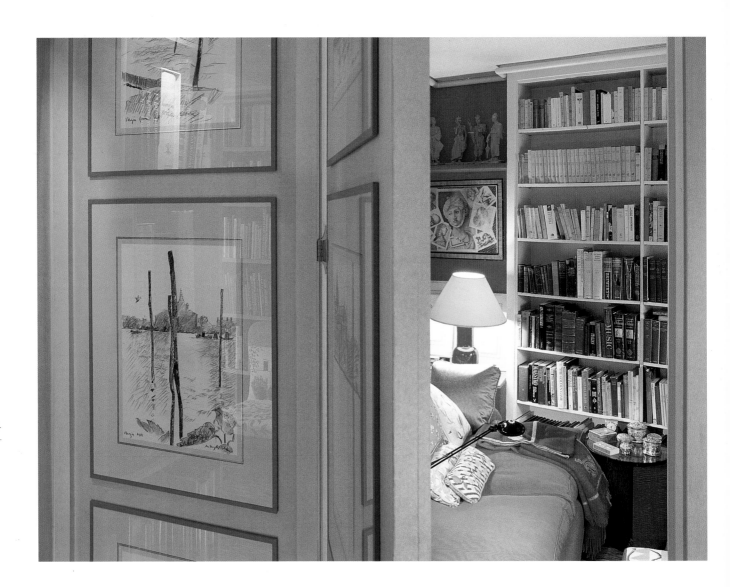

174

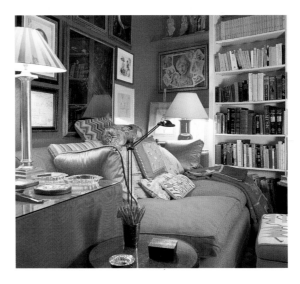

THE SMALL RED LIBRARY
disappears behind secret doors
hung with charcoal sketches of
Venice (*above*). One door, when
opened, has a mirror which
reflects a mirror on the landing
door opposite.

IN THE LIBRARY scarlet hand-
woven Florentine silk moiré is
used on the walls, the sofa and the
covered tables (*left and right*).
The ottoman cover and cushions
in needlepoint made by friends
and relations over the years are
a testament to affection. The
animal pictures are by Derrick
Guild. The JS gilt column has a
shade painted in coloured stripes;
a plaster hand sensually holds a
perfect plaster breast. The walls
are lined with shelving for books,
hi-fi and CDs.

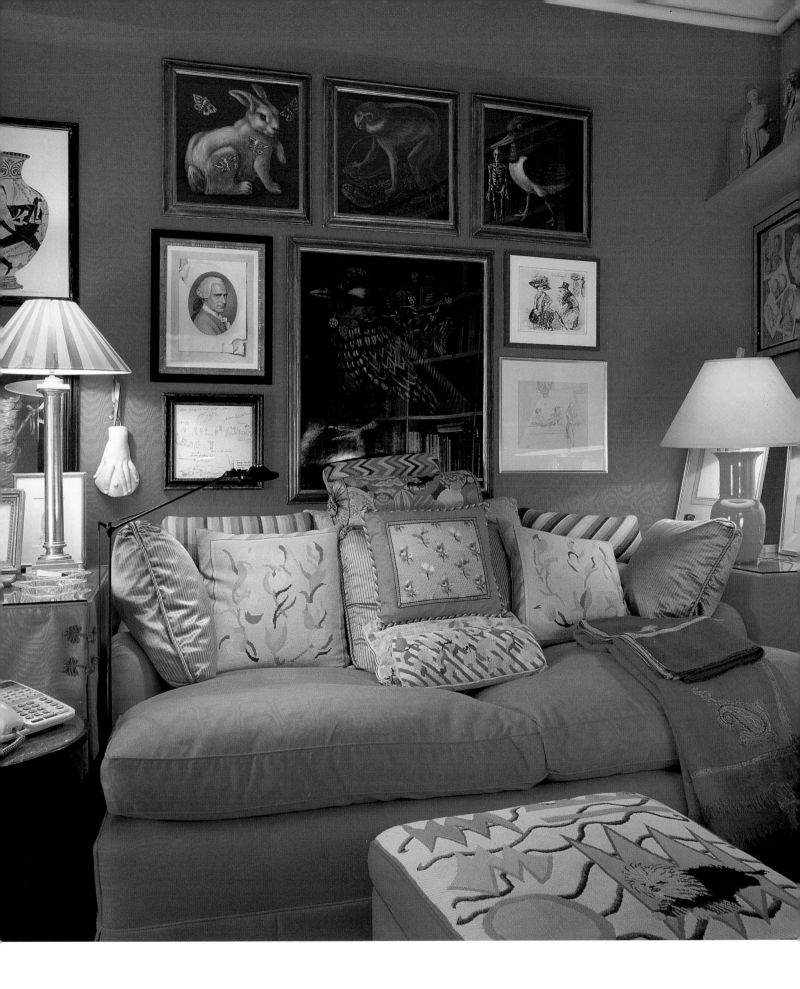

THIS BEDROOM was planned around a collection of Indonesian batiks, which are on chairs, cushions and blinds (*below*). Tibetan rugs and a Bessarabian carpet with a walnut brown border are laid over the tatami matting on the floor. Tatami matting also covers the front of the cupboards of the dressing room. The room is hung with Millington-Drake watercolours of India and Burma.

THE FIREPLACE has a plain wood surround painted lilac grey to match the bedroom lobby walls (*below*). Simple blue and green tiles surround the stainless steel register grate. The metal cupboard is by Garouste and Bonetti. On top is a Pacific shell.

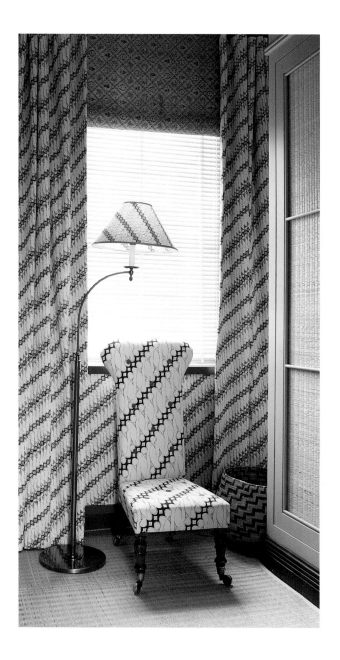

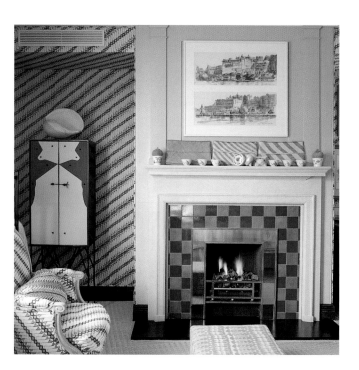

IN THE LOBBY to the bedroom is a 1930s English chest of drawers with ivory handles (*right*). On it stand a Jean Cocteau plate, another Pacific shell and a painted statue of Ganesh – the Indian elephant god. Above the chest is an 18th-century Italian gilt mirror. Left of the chest is a Corbusier chrome chair with a canvas seat and leather armrests – one of a pair in the room.

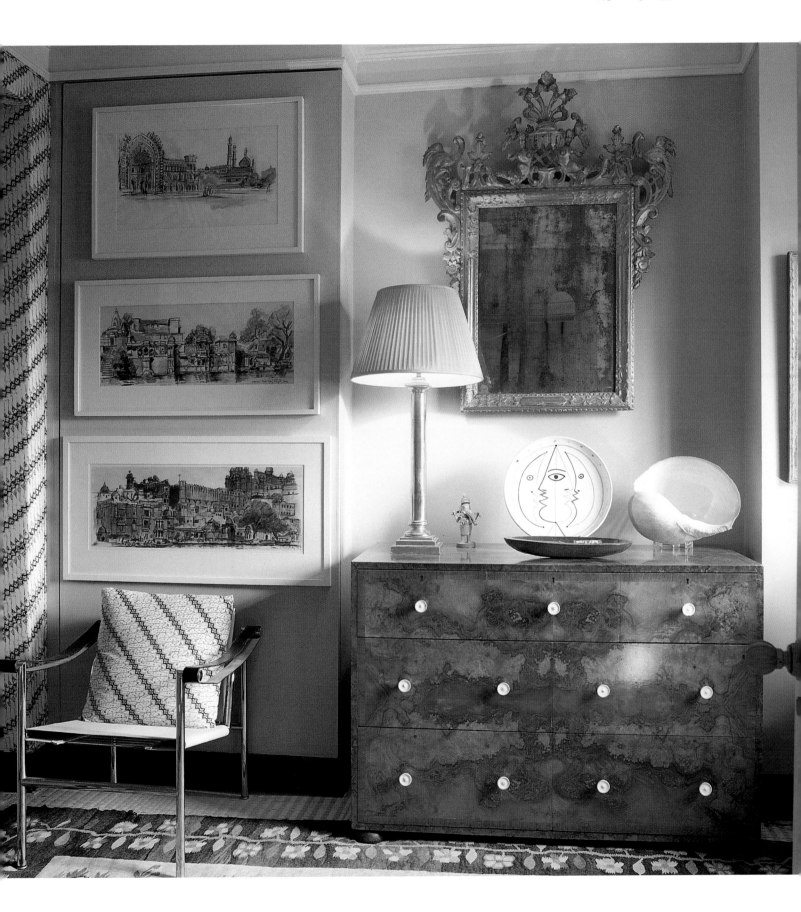

A DETAIL of painted fossils (*left*).

A MIRROR behind the bathroom door and the entrance to a large shower room (*below*). The bathrobe and chair cover are in white waffle cotton fabric.

THE BATHROOM for the bedroom on the previous pages contains a collection of shells and woven palm fibre fans from the Cook Islands (*left*). The niches are painted in *faux marbre* and the walls to simulate fossilised stone.

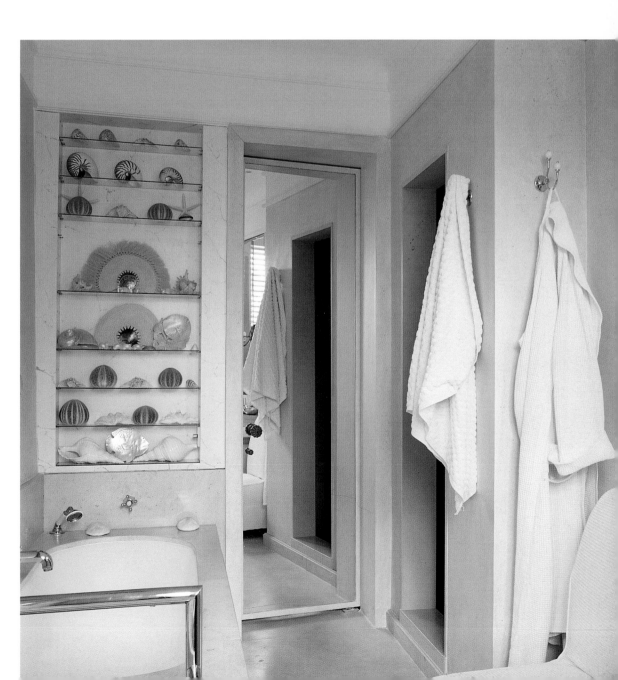

DETAILS: Comfort

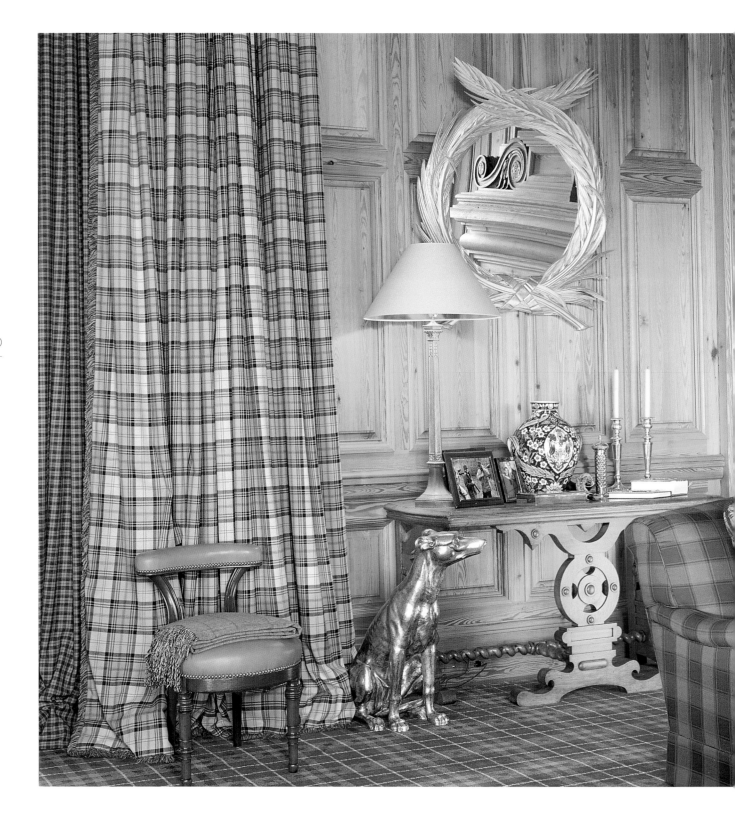

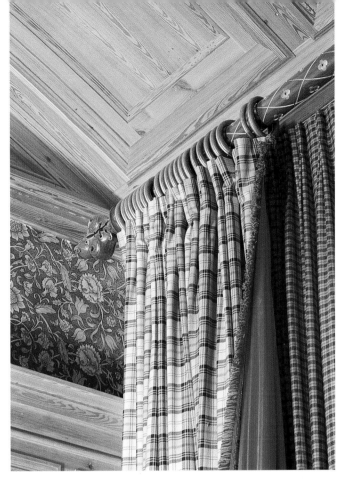

A MIXTURE OF FABRICS is not necessarily inharmonious. In this seasoned pine-panelled country room in an American house there are numerous checks and colours (*left*). Tartan curtains in wool are edged with a multiple fringe; they break generously on a carpet of a different tartan. Inner curtains are in a smaller check, a grey lovat-green and slate black check covers one of two sofas. The cushions are red and cream tartan, but in silk taffeta. On the Scottish baronial table is an Arts and Crafts Iznik pot; a life-size silver greyhound keeps guard. The palm leaves of the gilt JS mirror, inspired by a Borromini over-door, reflect the moulding on the pine fireplace.

THE BARREL CEILING to this room is in the same pine as the panelled walls (*above right*). The hand-painted frieze uses a William Morris motif. There is a torsade incision in gilt on the massive oak curtain rail and finial.

A YOUNG GIRL'S BEDROOM (*right*). Two prim Biedermeier chairs stand either side of a tailored, jade green cotton-covered dressing table; there are bows and kick pleats on both the cover and its stool. A shagreen dressing table mirror has two simple JS candlestick lamps with plain card shades.

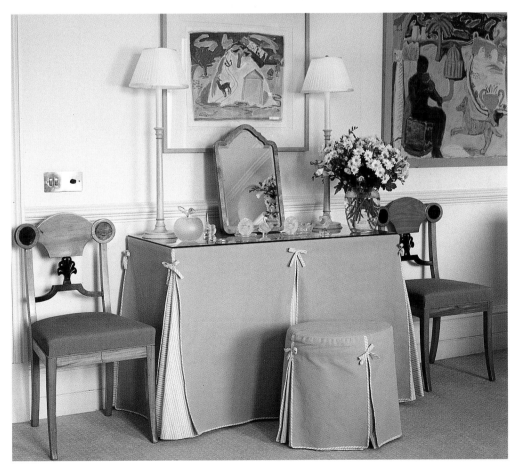

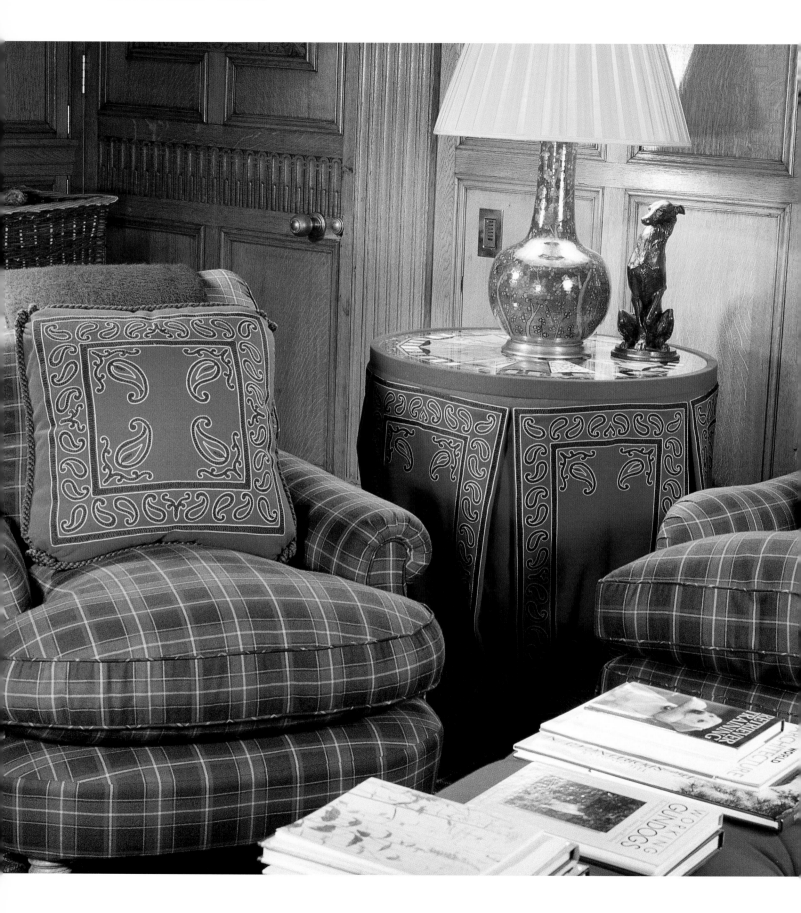

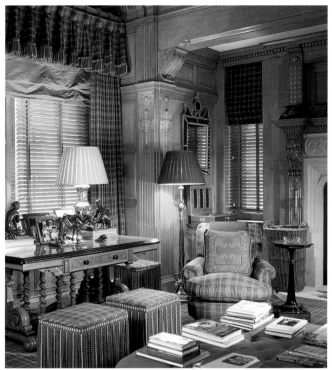

THE CORNER OF A LIBRARY in London. The wood panelling is golden mellow oak (*left*). The armchairs, sofa and stools are covered in the same blue wool tartan, accentuated with red. The tables either side of the sofa have grand multi-coloured marble inlay tops with a red felt surround and wool cloth embroidered panels beneath. An alert bronze greyhound keeps the cloisonné lamp company. The mango motif, a traditional symbol of Kashmir design, is embroidered in Cornely cord woolcloth in guardsman red or royal blue baize cloth.

TWO STOOLS have fringes falling from their tartan-covered tops (*above*). On the 19th-century oak and ebony desk is a display of 19th-century French bronzes. Wooden Venetian blinds hang at the windows. An unstructured blind of blue taffeta is pulled up behind a fulsome pelmet with cords and a fringe.

183

SOFRA IN GREEK, this raised platform typical of the eastern Mediterranean was used originally for sleeping on unrolled bedding (*right*). Surrounding it, a Moroccan wall-hanging in baize with an appliquéd arabesque pattern. The seat cushions are sewn like mattresses – the red and white stripes reminiscent of Eugène Delacroix's North African watercolours. On the left hangs a large accordion Turkish lantern.

THE WINDOW with its iron bars, has red, green and blue glass panels which reflect on the white wall above the hanging (*below*).

184

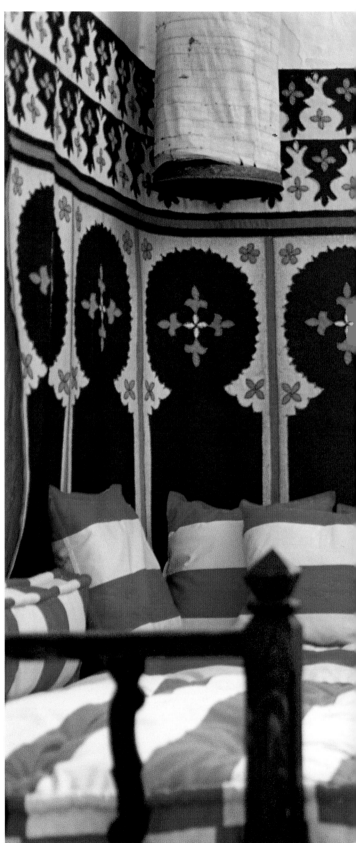

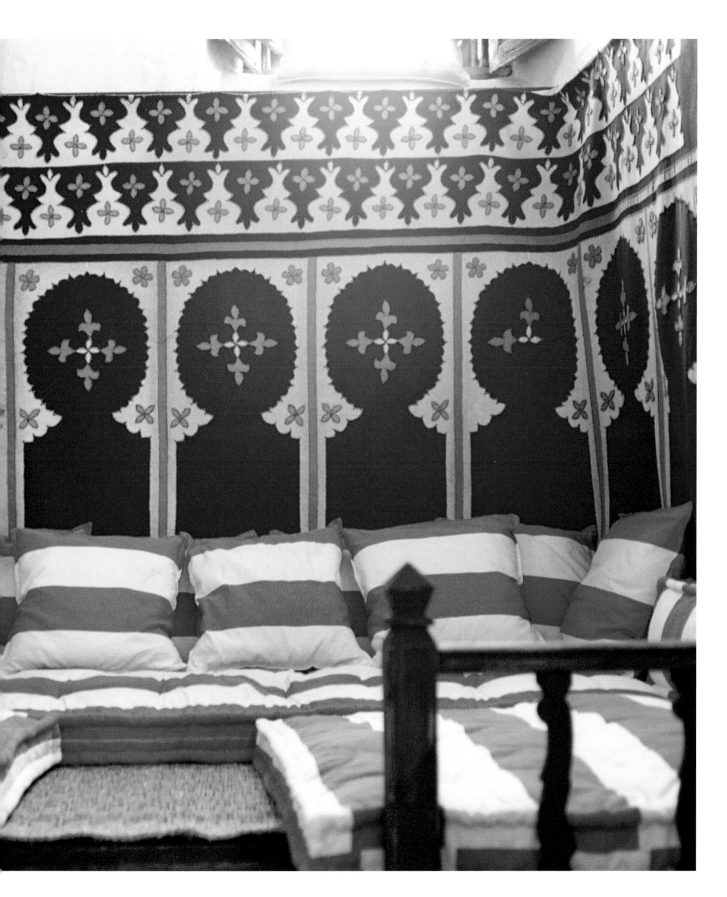

DETAILS: Artifice

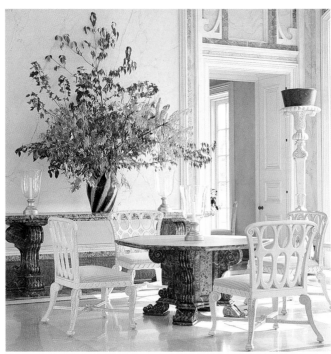

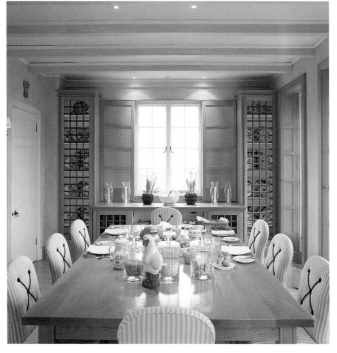

AN EXUBERANT JS side table painted in *faux marbre* to contrast with the real marble inlay of the floor (*top left opposite*). In decoration, as in life, it pays not to take things too seriously.

THE CENTRE TABLE is a close relative with the same paint treatment (*top right opposite*). It is circled by William Kent chairs in parcel-gilt. The walls of this large multi-purpose room are marbled and drenched with light – it is easily transformed for entertaining.

A BREAKFAST ROOM in the English country has an oak table and JS breakfast chairs upholstered in a woven pale green stripe (*bottom left opposite*). China is displayed in the cupboards – Chinese blue and white, as well the Blind Earl pattern.

A DETAIL OF THE CUPBOARDS shows their apple green triangular bars (*bottom right*). The trompe l'oeil on the floor was deemed a success when the family terrier sniffed at the rosemary.

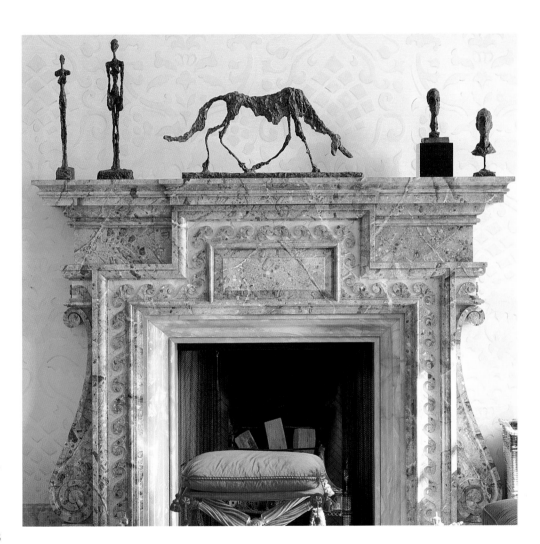

AN 18TH-CENTURY WOOD chimney piece (*above*) made to face its twin across a large drawing room in America is marbled in sienna-coloured stone with a classical Vitruvian scroll on the inner frieze. The traditional *garniture de cheminée* – a set of china vases – would have been banal here. A collection of Alberto Giacometti sculptures is a better alternative.

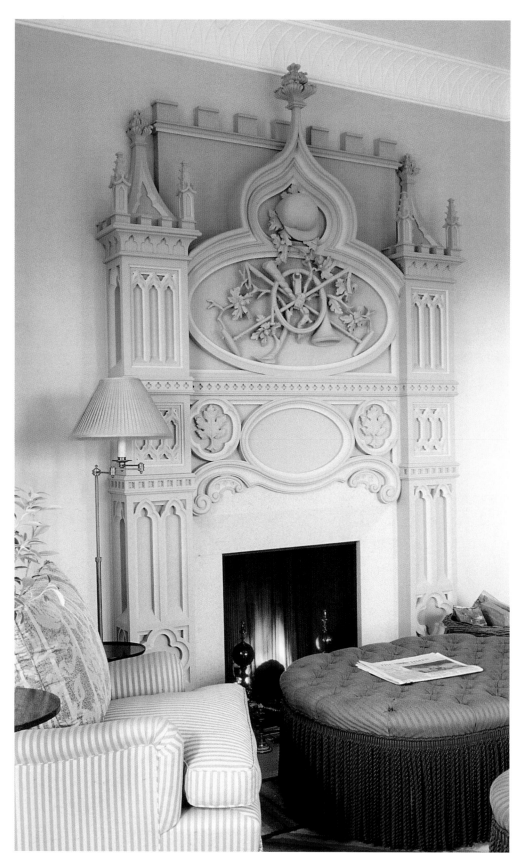

188

THIS SITTING ROOM in a neo-gothic house in England (*left*) adjoins a conservatory that overlooks a formal walled garden. It was deemed appropriate that the fireplace be carved in a hybrid Gothick design to incorporate the family's pursuits. Hence the jockey's cap, the French hunting horn and polo sticks intertwined by maple leaves. Floriated *fleur-de-lys* – not irrelevant to the owners – in the centre of the medallion rise above the castellated top. The fireplace is painted a cool dove grey and picked out in white.

A SLIVER OF A PLAIN but handsome English Regency 1820s fireplace in white marble and jasper can be seen in this corner of a bedroom, also in the English countryside (*right*). Behind the chimney breast the paint is streaked, as might be the sky at twilight. A JS Rothschild chair is covered in leopard, wrapped and skirted in royal blue. The curtains at the window are silk and compliment the painted curtains. The door is secreted behind one of the painted curtains – here you see into an adjoining dressing room painted in neo-classical motifs in burnt sienna, ochre, terracotta and a warm grey.

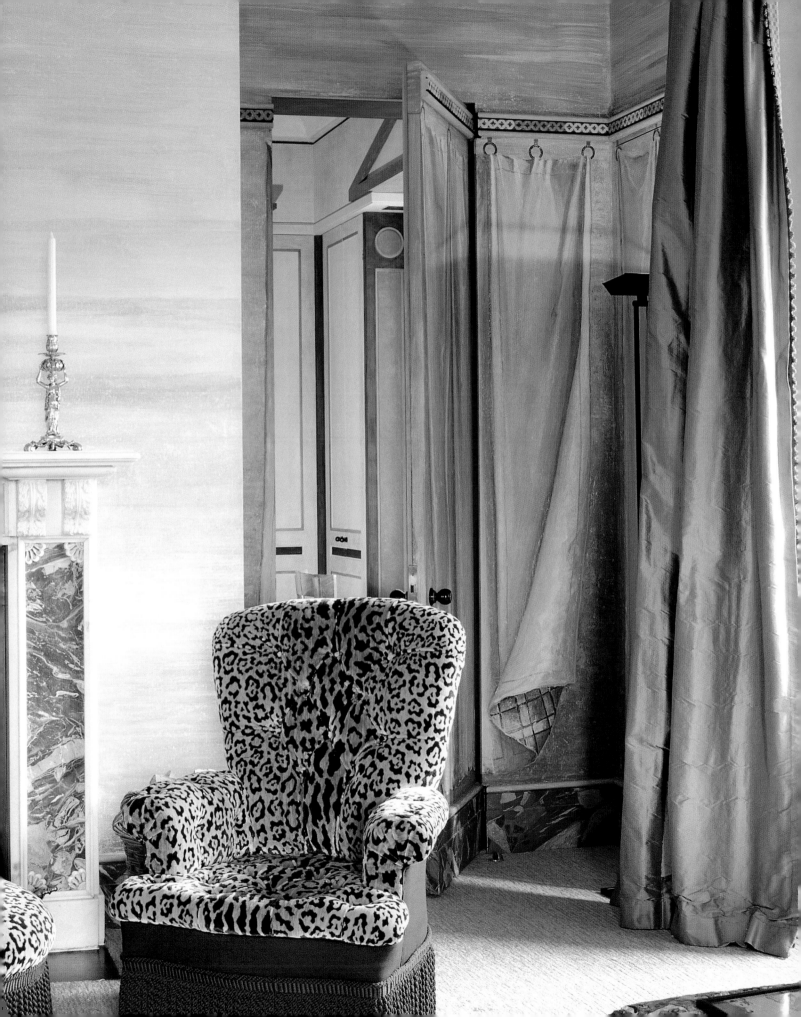

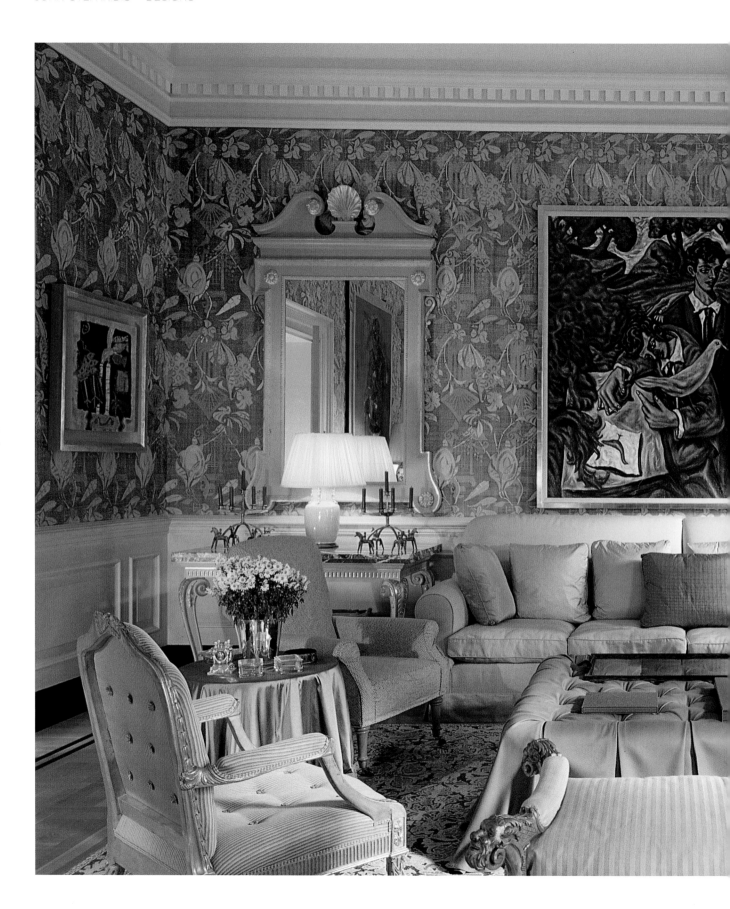

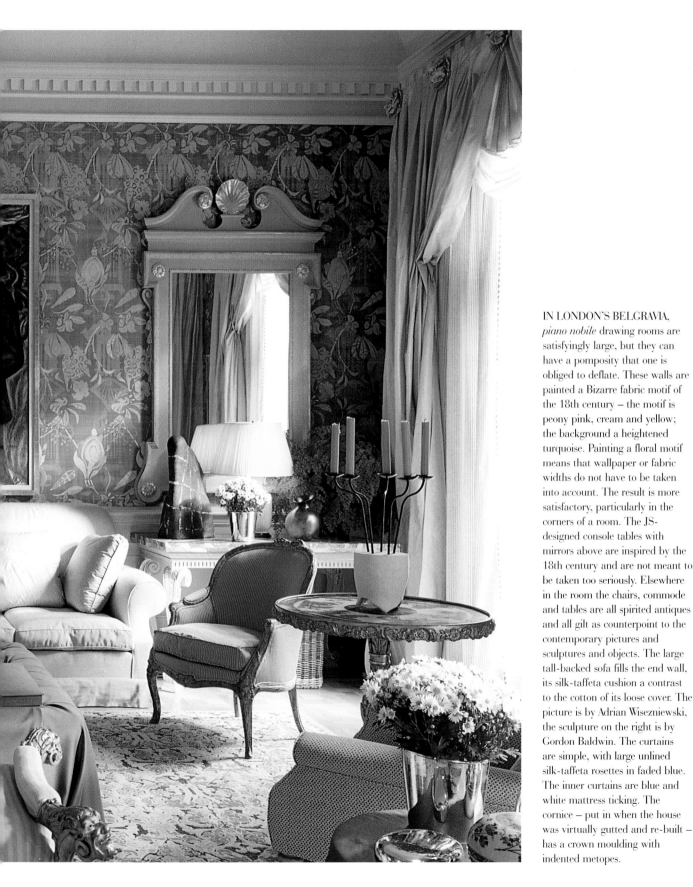

IN LONDON'S BELGRAVIA, *piano nobile* drawing rooms are satisfyingly large, but they can have a pomposity that one is obliged to deflate. These walls are painted a Bizarre fabric motif of the 18th century – the motif is peony pink, cream and yellow; the background a heightened turquoise. Painting a floral motif means that wallpaper or fabric widths do not have to be taken into account. The result is more satisfactory, particularly in the corners of a room. The JS-designed console tables with mirrors above are inspired by the 18th century and are not meant to be taken too seriously. Elsewhere in the room the chairs, commode and tables are all spirited antiques and all gilt as counterpoint to the contemporary pictures and sculptures and objects. The large tall-backed sofa fills the end wall, its silk-taffeta cushion a contrast to the cotton of its loose cover. The picture is by Adrian Wiszniewski, the sculpture on the right is by Gordon Baldwin. The curtains are simple, with large unlined silk-taffeta rosettes in faded blue. The inner curtains are blue and white mattress ticking. The cornice – put in when the house was virtually gutted and re-built – has a crown moulding with indented metopes.

DETAILS: Repose

A CORNER OF A BEDROOM with a predominantly blue and white colour scheme in an American house (*right*). The JS bedside tables are painted blue with pleated fabric panels; a modern Venetian mirror is also painted blue. A pair of Louis XV gilt chairs stand either side of a table with a blue-panelled cover, blue tassels between the panels. On the table is a collection of Delft china.

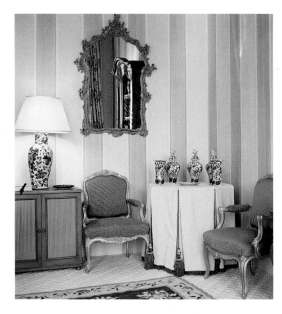

A LONDON SITTING ROOM adjoining the bedroom on page 194 (*right*). A bookcase is painted ochre and picked out in red. It is placed against a mirrored wall; above are samples – also painted – of precious and semi-precious stones. A giant armchair is covered in a pink and yellow woven cotton stripe. The table is a Regency burr oak with an inset white and grey marble top; on it a Burmese lacquer bowl. A homage to Borromini surmounts an architrave that frames a mirror set on the floor. The Canova head of Helen of Troy is on a scagliola plinth. The carpet is a Regency archive pattern with JS colours.

192

A LARGER VIEW of the same tall-ceilinged bedroom (*right*). The soothing louvred shutters are painted cream and a white embossed carpet covers the floor. The walls are painted in stripes of French blue and aqua green edged in yellow – wide and broad to suit the room. The 1930s table and chair are blackened oak. The chaise longue is covered in a woven grey stripe. Behind it is a large 18th-century commode with fine handles below an 18th-century Venetian gilt wood and green glass mirror. The exquisite white china chandelier looks as if it came from a stage set for Richard Strauss's *Der Rosenkavalier*, and in fact is from Max Reinhardt's house, Leopoldskron, outside Salzburg. It hangs to one side of the room to be admired from the bed.

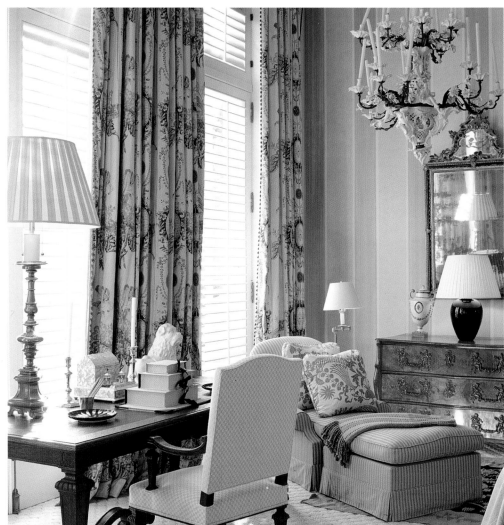

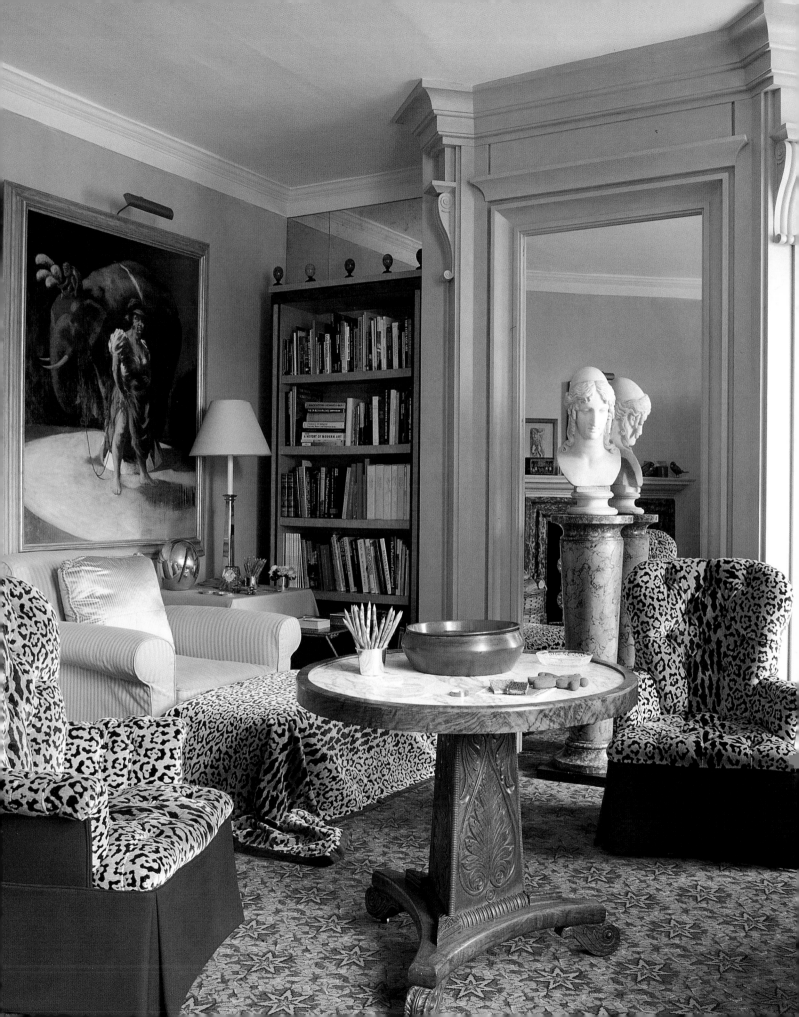

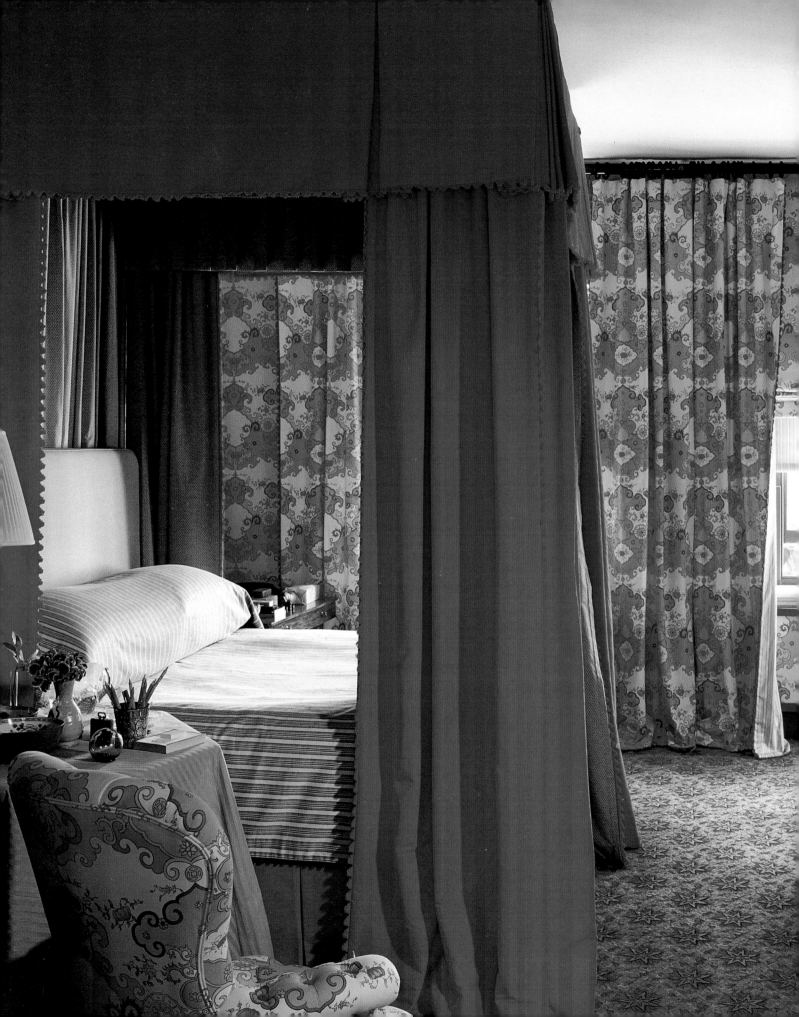

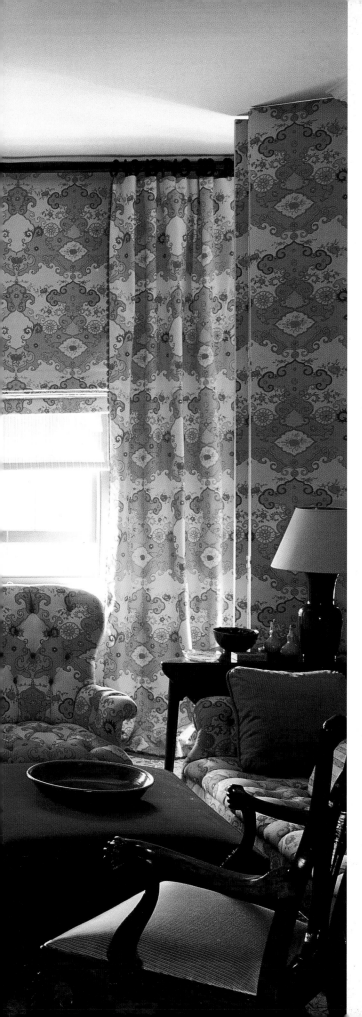

THIS BEDROOM (*left*) adjoins
the sitting room on page 193. The
walls, buttoned chairs and sofa are
covered in Netherton, based on an
archive design of chinoiserie scroll
shapes and flowers by Frederick
Grace from the Brighton Pavilion.
The curtains are lined in a JS
stripe in pink and blue which
matches the roller blinds behind
the Roman blinds. The four-poster
bed has a pleated valance with
kick pleats; the curtains are in
vermilion moiré. The headboard
and lining of the curtains as well
as the inside of the tester are in a
JS Delft fabric in blue lozenges.
The bedcover is in a JS blue-on-
blue stripe. The ottoman is
covered in magenta wool.

A GREEN BAIZE DOOR and
partition studded with brass nails
(*below*) leads from the back stair
landing into a lobby between the
bedroom and sitting room that
hides a small kitchen. The mirror
divisions and panels are painted in
a naïve *faux bois* to simulate
walnut. The JS chair has classical
affiliations – it is covered in
magenta wool cloth and buttoned
with red shaving brush tufts.

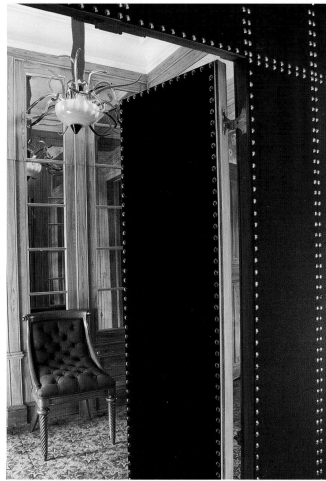

DETAILS: Stairs and hallways

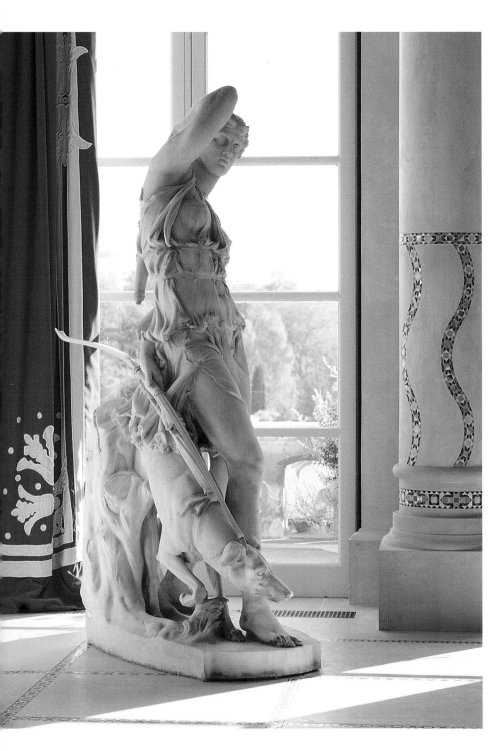

FRENCH WINDOWS in this hall open onto an English terrace and lush garden *(far left)*. The statue is of Diana with an elegant greyhound, holding a bow made of ivory. The curtains are in pillar-box red baize and the leaves and borders are stitched and appliquéd in white. The column has a multi-coloured and gold mosaic circling and snaking to a quarter of its height. The same coloured and gold mosaic strips divide the cream-coloured stone of the floor into squares, or form spirals *(bottom left)*.

THE SPLENDID CURVING staircase *(right)* has a bronze balustrade made by the artist Philippe Anthonioz which leads to the top of the house. The balustrade has a wave of mosaic with round blue stones on the newels. To the right of the curving stairs is a rope held by bronze brackets *(top left)*. The rope ends with a serpentine bronze finial, also by Anthonioz.

AN ACCENT TO A PASSAGE, this
circular lobby has a wooden floor
with a star motif (*top left and
right opposite*). At the centre of
the lobby stands a marble plinth
holding an elegant 18th-century
bust. There is artificial light but,
thanks to the skylight in classical
style and carefully placed mirrors
in the roof, there are unexpected
shafts of daylight, which brighten
the space and reflect on the
worthy gentleman.

SIMPLICITY was the aim for this
Dorset mill house (*bottom left and
right opposite*), while achieving a
level of comfort and sophistication
that would please a cosmopolitan
owner for whom 'shabby chic'
would have been anathema. The
hall fireplace has a stone bolection
moulding with an outsize opening
both welcoming and rustic. The
floor is made of local Purbeck
stone. The bobbin chair is covered
in broad white and dusty blue
stripes enlivened with a narrow
coal black line – a Florentine
fabric known as *spinato* which is a
mixture of flax and cotton, hand-
woven in this way for centuries.
The two JS banquettes with
carved S-shaped oak legs are
covered in the same fabric. A plain
JS oak table stands between them.
Against the wall is an outsize
Renaissance bronze urn.

THE MAMMOTH MARBLE balls
– two with mosaic spirals, one
ringed with circles – were made
to sit on top of the 19th-century
white marble fireplace in this hall
(*left and below*). The double-
height hall can be looked down
upon from the floor above.

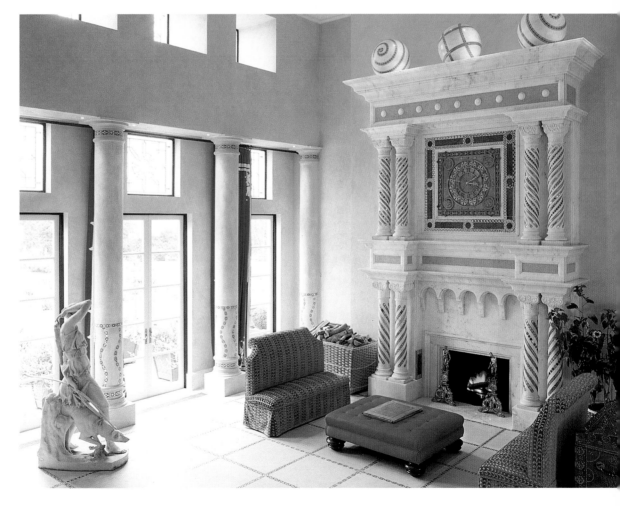

200

A STAIRCASE IN GREECE (*left*). These simple steps have been whitewashed over three centuries, almost obliterating the stone beneath. Hand-made terracotta tiles are on the floor, and the sides of a wide stone arch sweep across this enclosed courtyard. The serpentine trunk of a vine bursts into leaf on the terrace above.

IN COMPLETE CONTRAST, the staircase of a house in London's Belgravia (*right*). This neo-classical balustrade is a tracery in metal. It was made for a new stone staircase in this 1840s house that had held offices for more than 40 years. The first-floor landing has been embellished with columns; a sliver of one can be seen on the right. The two Regency chairs have lion heads, claw feet and a key-pattern design on the curved back. The large picture in transit is by Rainer Fetting. To the left of this on the staircase is a Peter Howson painting; on the curve is an Adrian Wiszniewski. The owner of the house can be seen carrying a picture up the stairs – a not unusual occupation for serious collectors.

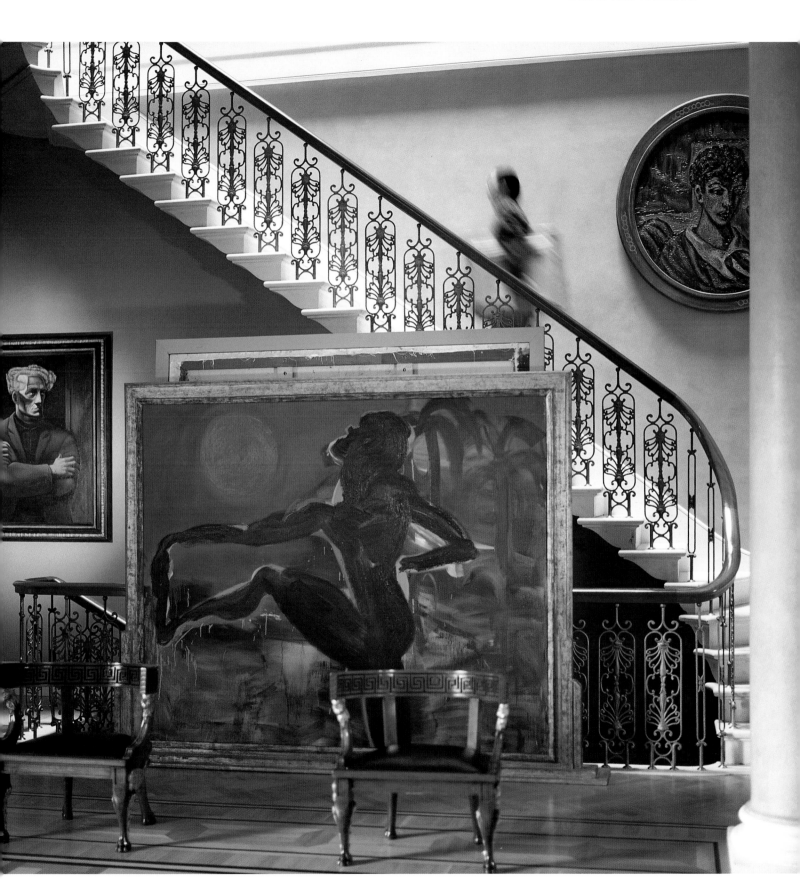

DETAILS:
Cleanliness

202

IN A ROUND TURRET of this
English country house is a drying
and folding area off the laundry
(shades of Federico Fellini). A
plain cedar wood top has shelves
painted sage green. On the floor
are squares of linoleum in grey
and beige.

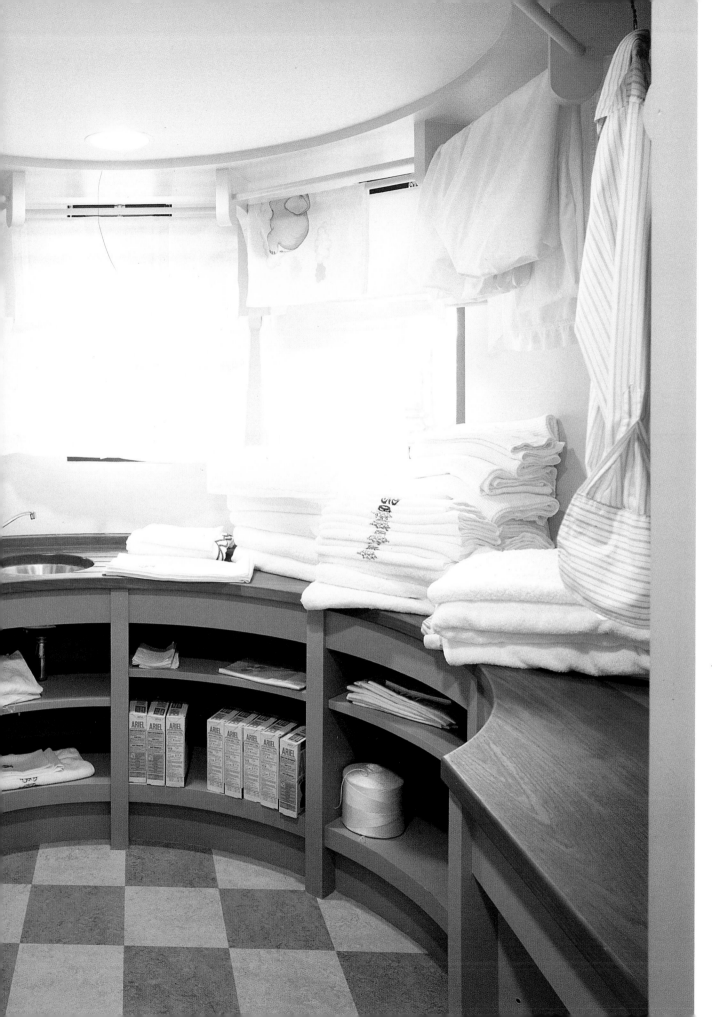

DETAILS: Bathrooms

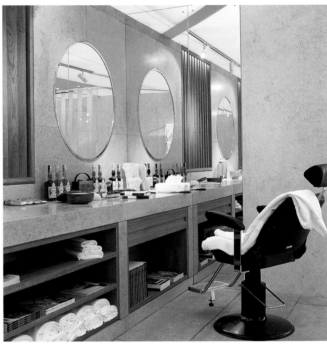

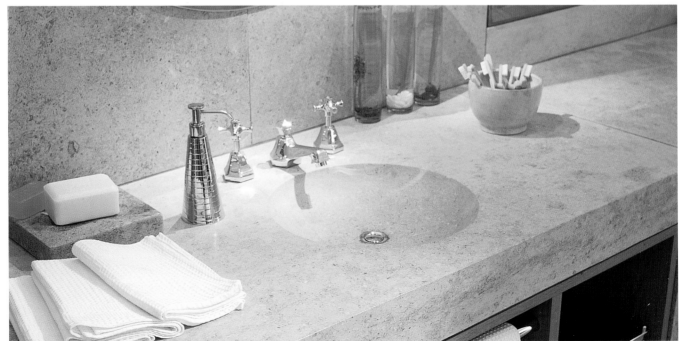

THIS BATHROOM ON A GREEK island is as simple as it is practical (*right*). Rough stone floor slabs are whitewashed around their perimeters. The high ceiling has pine beams with bamboo slats behind – an island tradition that all but expired but happily has been revived. One wall of the bathroom is trellis wood painted sap green; over the lower part are cream-coloured curtains with a thin terracotta red edge made from South Indian cotton saris. The trellis lets in light to create patterns day and night. The simple cut-out mirror is painted bright pistachio green.

A SHOWER in the centre of a bathroom has glass on two sides (*top left opposite*). Water runs down the glass on demand from a giant shower-head above. The cedar wood duckboard floor is friendly and not slippery.

AN ENGLISH ANCASTER stone counter-top runs along one wall of this bathroom (*top right opposite*). The floor is in the same stone. Two round mirrors hang above two round shallow basins carved in the slab (*left*). A mirror at the end of the shelf gives further depth. Generous shelves provide space for towels and other bathroom luxuries. The barber's chair speaks for itself – haircutting and beauty treatments take place at home.

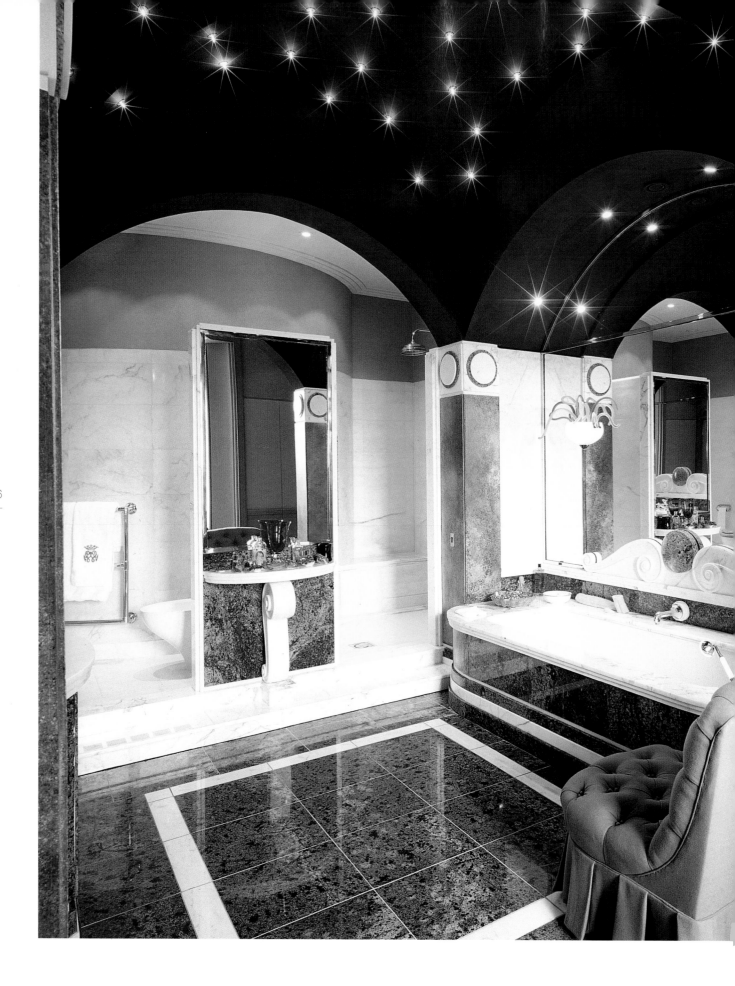

THIS GROTTO BATHROOM has a dark ceiling studded with tiny lights, giving it the magical appearance of a starlit sky (*left*). The blue Brazilian marble edged in white and exuberant wall lights by Simon Moore add to the exotic look. The marble shelf with a mirror above divides two alcoves – one has a lavatory and a bidet; the other a commodious shower. Best of all, unlike most grottos, it is not cavernous. Light pours in from a large window which overlooks a quintessential English country house view – a formal garden and noble park with rolling farmland beyond.

A SIMPLE ARRANGEMENT of a shower lined in marble (*below*). The ceramic pot by Fiona Salazar is an apt adornment.

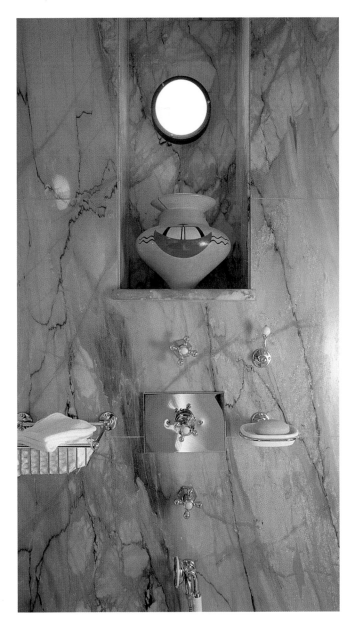

207

DETAILS: Swimming

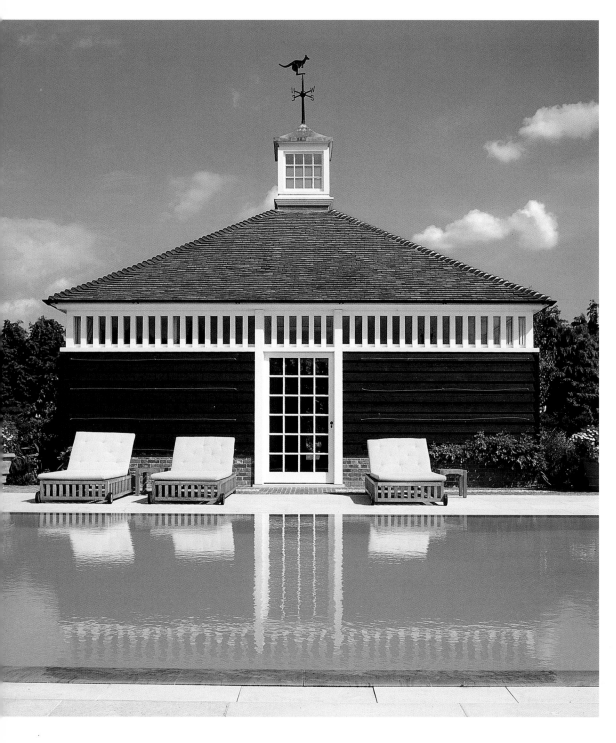

IN DORSET, England, we accommodated global warming with its hot summers by building this generous pool and simple, deceptively small, shingle-roofed pavilion (*left*). The black-painted clapboard pavilion has a full-height glazed door; the vertical white wooden frieze alternates with glass. The skylight is topped by a flying kangaroo – a tribute to the owner of the house. The pool has a concealed cover that is automatically controlled. The chaise longues around it are a JS design.

A ROTUNDA (*right*) with four glass mullioned doors facing each other. Four wooden painted seats are cantilevered from the walls. The floor is brick. Off this round space is a stone dressing room with curved benches; there are curtains instead of doors. On the axis are a marble-lined steam room, a kitchen with a curved work surface and shelves above. The fourth space houses a changing-room and bathroom.

THE TRIUMPH of this pool in the very centre of London is its abundance of natural daylight. The light above the columns comes from a tall glazed roof, which is reflected in the pool. The space for repose has an ochre terrazzo floor, JS chaise longues with lilac cushions, and painted JS Patmos tables. The cupboard houses a sound system, bar and other items. The skirting board, as elsewhere, is white marble. The Doric columns are white plaster, as are the walls and ceilings. The wave motif on the steps, black rubber set into marble, keeps you from slipping. The waves carved into the marble are dotted with holes to drain the overflow of water from the twelve-metre pool.

INDEX

212

ACKNOWLEDGMENTS

PHOTOGRAPHERS
Fritz von der Schulenburg/The Interior Archive
Photography by Fritz von der Schulenburg. Courtesy of Architectural
Digest/Condé Nast Publications Inc.
All rights reserved. Used with permission.

Tim Beddows/© World of Interiors/Condé Nast Publications Inc.
Eric Boman © British Vogue/Condé Nast Publications Inc.
Michael Boys
Tim Clinch
Robert Harding
Pascal Hinous
Min Hogg
Horst/© Vogue, Condé Nast Publications Inc
James Mortimer
Jean Bernard Naudin
The photograph on page 55 of the Hôtel Lambert by Jean Bernard
Naudin first appeared in *Visite Privée* by Mme Christiane de Nicolay-
Mazery. It is reproduced with her kind permission.
John Stefanidis

Definitions from New Oxford Companion to Music (1983) © Oxford
University Press 1983. Used here with permission of Oxford University Press

Thanks due: to Susanna Moore the novelist who sets standards of excellence
and is a Parnassian editor; Alexander di Carcaci; Charlotte Mosely for her
skills of organisation and imagination (the title is hers or was it her
husband's?); Katherine Hesketh for her enthusiasm at the beginning; my
editors at Cassell and the designer Nigel Soper who always got it; Stephen
Morrison, Gael Camu, chief designer, and my assistant Martin Harvey who
so patiently saw me through every draft, and all at John Stefanidis Limited.
The craftsmen, artisans — too numerous to mention each one, but thanks in
particular to the team of specialist painters headed by Tony Alcock and
Antoine Bursacchi who materialise on three continents to practice their skill.
Fritz von der Schulenburg, Karen Howes, Min Hogg, Christiane de Nicolay-
Mazery. Last but not least, the clients and friends who are by necessity
anonymous and whose houses appear in the book.

First published in the United Kingdom in 2002 by Cassell & Co.
Published in the USA by The Vendome Press
Distributed by Rizzoli International Publications
through St. Martin's Press
175 Fifth Avenue
New York, NY 10010

ISBN 0-86565-223-6

Art director David Rowley
Editorial director Susan Haynes
Designed by Nigel Soper
Edited by Jinny Johnson
Typeset in Bauer Bodoni
Printed and bound in Italy

The Vendome Press
1370 Avenue of the Americas
New York, NY 10019

VILLA MADAMA.